# DECORATIVE FOLDING
# SCREENS

# DECORATIVE FOLDING SCREENS

## 400 YEARS
### — IN THE —
## WESTERN WORLD

# JANET WOODBURY ADAMS

A STUDIO BOOK  THE VIKING PRESS  NEW YORK

First published in 1982 by The Viking Press
625 Madison Avenue, New York, N.Y. 10022
Published simultaneously in Canada by
Penguin Books Canada Limited

LIBRARY OF CONGRESS CATALOGING IN PUBLICATION DATA
Adams, Janet Woodbury.
Decorative folding screens.
(A Studio book)
Bibliography: p.
Includes index.
1. Screens—Europe—History.  2. Screens—
America—History.  I. Title.
NK2910.A3    749'.3    82-70178
ISBN 0-670-26287-0    AACR2

GRATEFUL ACKNOWLEDGMENT IS MADE TO THE
FOLLOWING FOR PERMISSION TO REPRINT
COPYRIGHTED MATERIAL:

*The Connoisseur:* Selections from the article "An
Eighteenth Century Screen" from the April 1953
issue of *The Connoisseur.* Copyright 1953 by
*The Connoisseur.*

*Country Life* magazine: A selection from the
article "Byron's Pictorial Screen," by H. Clifford
Smith, which appeared in the November 1945
issue of *Country Life.* Used by permission of the
editor of *Country Life* magazine.

*The Metropolitan Museum of Art,* New York:
Selections from *The Wrightsman Collection,* by
Francis J. B. Watson. Published by the Museum
of Modern Art, 1966.

*Phaidon Press Ltd.:* Selections from *Bloomsbury
Portraits,* by Richard Shone, 1976.

*Thames & Hudson Ltd.:* Selections from *An
Illustrated History of Interior Decoration,* by Mario
Praz, translated by William Weaver, 1964. A
new edition of this title is to be published by
Thames & Hudson Ltd.,
New York and London, 1982.

Printed in the United States of America
Set in Baskerville

# CONTENTS

# Acknowledgments

It is a pleasure to be able to acknowledge the assistance of all those who helped me either by aiding me in the research required for this book or by providing photographs, and to have an opportunity to publicly thank them.

My research was conducted in the libraries of the Victoria and Albert Museum in London and The Metropolitan Museum of Art, as well as in the New York Public Library and the Marquand Library of Art and Archeology of Princeton University. I am deeply indebted to the staffs of those institutions for their interest, professional skills, and many kindnesses.

Extensive correspondence was necessary in order to locate a number of the screens and to obtain photographs, and I am indeed grateful for the generous response. Those who have kindly responded to my inquiries and requests are grouped according to their locale and not ranked for the merit of their contribution. In London: Mr. John Murray; Mr. Richard Shone; Dr. Roy Strong and Mr. John Hardy, of the Victoria and Albert Museum; Mr. Martin Battersby; Miss Susanna English, Mrs. Wendy Robinson, Colonel A. R. Waller, and Mr. Robert Gore, of the National Trust; Mr. L. M. Synge, of Mallett & Son Ltd.; Miss Gabriel Naughton, of Thomas Agnew and Son; Mr. Philippe Garner, of Sotheby Parke Bernet; Christie's; Miss Norah Gillow, of the William Morris Gallery; and Mrs. Eileen Harris. Others in England to whom I am grateful are Mr. Richard Hobbs, the Honourable George Howard, The Countess Spencer, Professor Quentin Bell and his sister Angelica Garnett, and Mr. Simon Bargate.

In New York, I am most appreciative of the cooperation of Mrs. Enid Haupt; Mr. Harry Brooks and Mr. Gerard Stora, of Wildenstein and Co., Inc.; Mr. James Parker, of The Metropolitan Museum of Art; Mr. Wendell Garrett, of *The Magazine Antiques;* Pierre Matisse; Mr. Martin Zimet, of French and Co.; Dr. Baird Hastings; Mrs. Edgar Worch; John Winthrop Aldrich; Mrs. Flora Irving; Miss Gail Levin, of the Whitney Museum of American Art; Mr. Charles Ryskamp and Mr. Francis Mason, of the Pierpont Morgan Library; Mr. Charles Baskerville; Didier Aaron, Inc.; Brooke Alexander, Inc.; Washburn Gallery, Inc.; and The Petersburg Press Ltd.

In Washington, Mrs. Marjorie Phillips, Mr. Laughlin Phillips, and Mr. Michael Green, of the Phillips Collection, were most helpful, as were Mrs.

John A. Pope, of the International Exhibitions Foundation; Dr. Thomas Lawton, of the Freer Gallery of Art; Rachel Allen, of the National Collection of Fine Arts; and Miss Nancy Hanks.

Aid from Paris came through M. Jean-Claude Bellier; Mme. Madeleine Jarry and M. Jean Coural, of the Musée Mobilier National; Mrs. Florence Gould; M. Bernard Dunand; M. Alain Blondel; and the Galerie André-François Petit. From other distant locales help came from Mario di Valmarana; Dr. Ernst W. Mick, of the Deutsches Tapetenmuseum, Kassel; Dr. Auke van der Woud, of the Kröller-Müller Museum; Ralph T. Coe, of William Rockhill Nelson Gallery of Art; Maebetty Langdon, of the Art Institute of Chicago; Doris B. Littlefield, of Vizcaya Museum and Gardens; the Palazzo Reale, Turin; Miss Catherine Jestin and Mrs. Joan Hall Sussler, of the Lewis Walpole Library; Mr. Sven Nilsson, Stockholm; Miss Gillian Wilson, of The J. Paul Getty Museum; and many private collectors and their staffs who wish to remain anonymous.

Several friends have shown such sustained interest in the subject and progress of this book that they deserve a special note of appreciation. Those who have helped in innumerable ways are Sir Francis Watson; David Revere McFadden, the curator of decorative arts of the Cooper-Hewitt Museum; and Alfred Bush, of Princeton University.

Since 1978 two scholars, Michael Komanecky, the assistant to the director of the Yale University Art Gallery, and Virginia Fabbri Butera, have been doing intensive research concerning screens made by European and American artists from 1850 to the present in preparation for an exhibition. They and I have done our research completely independently but have met several times to discuss the exhibition. During these discussions, we have been able to exchange much useful information, and I am indebted to them for their contributions. I have great admiration for the thoroughness of their research and the contribution they are making to the study of the screen and its relation to other art forms.

My last acknowledgment is the most deserved of all. The publication of this book is due in large measure to the sustained enthusiasm and encouragement of my family, especially my husband, to whom I dedicate this work.

# INTRODUCTION

The reason I wrote this book is as simple as it is surprising. Several years ago I became interested in some unusual screens and wished to know more about them—when and where they were made and who had made them. Much to my amazement, although much has been written about Oriental examples, I could not find a book on the history, design, or use of decorative folding screens in the Western world. This aspect of the decorative arts, surpassing most others in its extraordinary diversity of materials, styles, and works by distinguished artists, had been sadly neglected. Fascinated by my subject, I decided to write a history that started with the screen as it was made in the East under the Western influence, and then to follow its development after its arrival in Europe and later in America.

To do so required searching through style books and dictionaries of furniture, books on interior furnishings, inventories, genre paintings, and the work of any individual artist suspected of having made screens. Few art books listed screens in their indexes, even when examination of their texts revealed much information and a number of references. Magazine research was not much more fruitful, as most of the articles dealt with Oriental or architectural screens, or placed too heavy an emphasis on decorative screens of this century.

Given such a broad subject, arbitrary goals and limits had to be set, and my aims in writing this book became threefold. I wished to determine something of the history of screens—their origins, how they became fashionable in Europe, what types were made at various periods, how they might be identified, and what materials were used in their construction. Interwoven with this goal was a desire to examine how the screen functioned in interior space, with reference to its antecedents in Europe; its relation to the architectural screen; its use as a device to divide space, create intimate enclosed spaces, and obscure unsightly objects; and its part in creating illusions of enlarged space through the employment of scenic, photographic, or imaginary views. Contemporary descriptions and quotes clearly indicate that the basic function of early screens was to ward off unwelcome drafts, a fact that is obvious from its French name, *paravent,* and the Italian equivalent, *paravento.* As more advanced heating techniques made interior environments more comfortable, the screen's value as a utilitarian object decreased, but instead of becoming relegated to the attic, it developed an artistic life of its own. Thus my third purpose here is to increase recognition of the screen as an independent art form and to pay tribute to the artists who have seen the screen as a new means of expression, using it to create some superb paintings.

Although screens have been in existence for over

two thousand years, it is only the last four hundred that fall within the scope of this book. The history of Chinese and Japanese screens has been extensively studied and recorded by Oriental scholars and art historians, and I would not presume to intrude in that area. The logical starting point for this study seems to be the establishment of an active East-West trade late in the sixteenth century. *Namban* art was the manifestation of this interchange; it signaled the beginning of a new commercial reciprocity. The discussion and illustrations here proceed from that point, starting with the early Oriental exports to the West, followed by the chinoiserie screens that were made in response to the impact of this trade, and then continuing on to the screens that developed in a vastly expanded array of materials and styles in Europe and the United States. Like any decorative object or piece of furniture, the screen fluctuated in interpretation and favor, suffering a low point during the middle years of the nineteenth century and enjoying its time of greatest versatility and creativity from the end of that century to the present day.

During the seventeenth and eighteenth centuries screens were the creations of individual craftsmen, furniture makers, or artists. However, it was an anonymous trade, and with a few notable exceptions the work remained unsigned. For the nineteenth and twentieth centuries, many more are by known makers whose work can be positively identified, partly due to greater communication and exchange of information, but, more important, because major artists and designers began to perceive the screen as an artistic medium worthy of their most serious efforts. Having shed its meaner utilitarian role, the screen of the present century is being fully realized as an art form.

The material selected to represent this span of several hundred years has been carefully chosen, but since the subject is vast, the records exceedingly sparse, the variations endless, and the objects themselves of a perishable nature, any attempt at a definitive work is impossible. A self-imposed limitation has been to contain the discussion within the framework of the domestic folding screen, only hinting at its versatility in theatrical or operatic stage sets. I have refrained from including painted panels and murals that though often of a size and shape suitable for screens were not known to have actually been used in that way.

It is my hope that this book will be a stimulus to others to uncover much more material on this unaccountably ignored subject. In the same way that the opening of Nagasaki to the Western world encouraged the production of the screen, perhaps this introductory book may open the way to further enjoyment of this highly decorative art and contribute to its continuation as a viable, exciting art form.

# 1. Finest Lacker and Works Procurable

It has been reported that the duke of Marlborough was so attached to a great Coromandel screen given to him by the Holy Roman Emperor that he carried it with him on his campaigns.[1] There is no doubt that the duke lived in high style even in the shadows of the battlefield, for he enjoyed the services of his valet and carried with him great "pilgrim bottles of silver for wine and a vast wine cooler, all beautifully engraved with his coat of arms."[2] This well-traveled screen of Chinese work, decorated with figures dressed in European clothes of the period, was given to him by the grateful emperor after the victory at Blenheim in 1704. It is still in his family's possession, and The Countess Spencer informs us that the screen was one of a pair commissioned by the Jesuits in China and given to Leopold I on the occasion of his election as emperor in 1658, and that he in turn gave it to the duke. This story of the attachment of an English general to his Chinese screen, carrying it into Dutch territory while engaging in combat with the French, is significant here because it involves several of the countries that played key roles in the history of the decorative folding screen.

The year 1571 is an appropriate point of departure for considering this history, as it signals the beginning of regular trade between the Orient and Europe, bringing the screen from its ancient origins in China to Europe, where it would continue to exist and be reinterpreted in an infinite variety of designs and materials devised by the imagination, technology, and ingenuity of the Western world.

European nations, intrigued by tales of returning travelers, were, on one hand, eager to exploit the resources of those distant rich and wondrous lands and, on the other hand, zealously wished to Christianize the inhabitants. The Portuguese, after first establishing a base in Malacca in 1511, then a later one in Macao, sailed the first European ships into Japan in 1543. Their efforts were successfully climaxed in 1571 by the opening of Nagasaki to what was to become an established East-West trade. For the next two hundred years, those ports were to be the key to Portuguese, and later Dutch, commerce.

The opening was followed within a few years by the arrival of the first Jesuits, and from that time the fates of the followers of St. Francis Xavier and those of the traders were to be intertwined. The Jesuits' primary goal was to spread the faith, but of far greater importance to the Western world was their role in the exchange of cultural information.

The interest aroused by the arrival of the European ships with their foreign crews and unfamiliar cargoes, and especially by the establishment of the Jesuit communities, contributed to the creation of a new type of Japanese art called *namban*.

The term, literally meaning "southern barbarian," simply refers to work that mingles elements of both Japanese and southern European cultures. It does not signify one single style; it is at once both a Western and a Japanese style, and the result of their interaction. The screen was the principal though not the exclusive form of *namban* art; many decorative Oriental objects such as lacquer boxes and porcelains were also ornamented with illustrations of European subject matter. Screens decorated in this manner were made during a

**H**arbor scene showing a newly arrived *nao* being welcomed by the Jesuit priests. Painting by Kano Naizen in color on gold-leaf paper. Kobe Municipal Museum of Namban Art. Photograph courtesy International Exhibitions Foundation.

relatively brief period, between 1590 and 1630. They were usually done in pairs of six panels each and left unsigned by the artist. They were painted in the genre tradition of the period, but it is their subject matter that distinguishes them from all other screens made at the same time.[3]

A pair of the most representative type would portray the harbor and the arrival of the ship. One screen might feature the arrival of the Portuguese ship, perhaps showing the richly clad captain preparing to leave his ship followed by his retinue. The sailors would be dressed in bombacha pantaloons, their exceptional height and their strange-appearing physiognomy would be clearly represented, and they might be surrounded by traders bearing their wares. The majestic *nao*, then the largest merchant ship in the world, would be shown in detail with its cargo, one that possibly included tigers, deer, or monkeys that were intended as gifts, plus more conventional freight—crates of guns, books, clocks, and tobacco. The mate to such a screen would typically show the Japanese and the Christian missionaries coming out to greet the ship. In the background one might see a chapel or the house of the Jesuits filled with all the details of lives that were so strange and fascinating to the artist. The ship would be set in elegant rhythmic waves, and above all clouds would float, both uniting and partially concealing the various pictorial elements. These screens did not attempt a Western perspective, chiaroscuro, or realism. They were strictly in the Japanese tradition, with a careful arrangement of decorative detail covering most of the surface, placed against a gold background, outlined in black india ink, and accented with rich reds, blues, and greens.

Within ten years of their arrival in Japan, the Jesuits numbered seventy-five and had established two hundred churches. Attached to these churches were *seminarios* for the instruction of future clergymen. The priests, having to operate with an enormous linguistic handicap, relied heavily on visual instruction. Here, with the aid of religious paintings, engravings, and books, the Easterners received their Christian instruction, learning at the same time a great deal about the European style of painting, and the geography, dress, customs, and architecture of that unvisited continent.

A screen entitled *Four Major Cities of the World,* a series of eight panels showing aerial views of Rome, Lisbon, Constantinople, and Seville, was probably based on George Braun's *Civitates Orbis Terrarum,* published in Cologne in 1572. In these views many landmarks are clearly visible. In the view of Rome, the Pantheon, the Colosseum, Castel Sant'Angelo, and the obelisk of St. Peter's can be identified. The view of Lisbon is particularly interesting because it was the port from which the *naos* had set sail for their two-year journey to Japan. The mate to the cities map is *World Map,* based on Abraham Ortelius's *Theatrum Orbis Terrarum* (published in Antwerp in 1570), and it shows remarkable cartographic knowledge.[4]

In a pair of screens entitled *Social Customs of Foreigners,* Europeans are seen engaged in the everyday activities of conversation, reading, and playing musical instruments, pictured against a background of

ships, Italianate buildings, and a panoramic landscape. The screen *European Genre Scene with Water Mill* is such a successful imitation of European style that it is hard to realize it was painted by a Japanese within fifty years of the arrival of Europeans.

The Jesuits enlivened their teaching of Scripture and doctrine with tales of battles against the heathens. In 1571, the same year as the opening of Nagasaki, the Christians fought the Turks in the Battle of Lepanto. Since no engraving was yet available and the priests needed visual material as a teaching aid, they substituted for Lepanto an engraving copied from a painting by Giulio Romano (c. 1499–1546) of the Battle of Scipio against Hannibal. This engraving accommodatingly altered the event from a naval engagement to a land battle. Philip II was dressed as a Roman emperor, and elephants and mounted warriors clashed in battle. This fanciful European scene, painted on a screen in brilliant colors, was placed in front of an unmistakably Oriental sea.

The Japanese highly valued these screens with scenes of Western civilization, and most of them have remained in collections in Japan. Inversely, the Europeans, caring little for how the Japanese saw them, eagerly sought screens portraying life in the Orient that arrived on the returning *naos.*

During the sixteenth century, other nations, most notably Spain and the Netherlands, were competing with Portugal for the new trade routes. The Spaniards had enlarged their domain in the New World and had conquered Mexico in 1521, soon following it with the conquest of Peru. By 1565 they had control of the Philippines and were expanding their trade with China. Meanwhile, the Dutch were posing a major threat to the Portuguese supremacy, and pursuit by one of their ships was a potential danger during the long voyage from Lisbon. After 1618 the Portuguese, in order to minimize this risk, discontinued the huge *nao,* substituting smaller, more maneuverable ships, which appear on screens made after that date. The Dutch continued to gain in this rivalry and were to become the chief merchants trading with Japan, while the Portuguese and Spanish kept control of China. By the turn of the century, ships bringing Chinese silk were entering the port of Nagasaki, and trade was accelerating between China and Japan.

A few episodes that provide a skeletal outline of the chronology of the folding screen and its development in China, its introduction into Japan, and its later refinement there are important as background to its history in the West. However, no attempt will be made here to trace the entire history of the screen as an art form through its early centuries in the East, leaving the fuller discussion of Asian styles of painting, the works of the individual artists, and their aesthetic and intellectual considerations to Oriental scholars and art historians.

The screen, a Chinese invention, is first known through literary sources dating from as early as the end of the late Chou dynasty (4th–3rd centuries B.C.) and from representations on Han tomb paintings and stone reliefs (200 B.C–200 A.D.) showing two- and three-fold screens.[5] The earliest surviving screens, dating from the eighth century, are in the Shoso-in repository in Nara, in Japan, having arrived there via

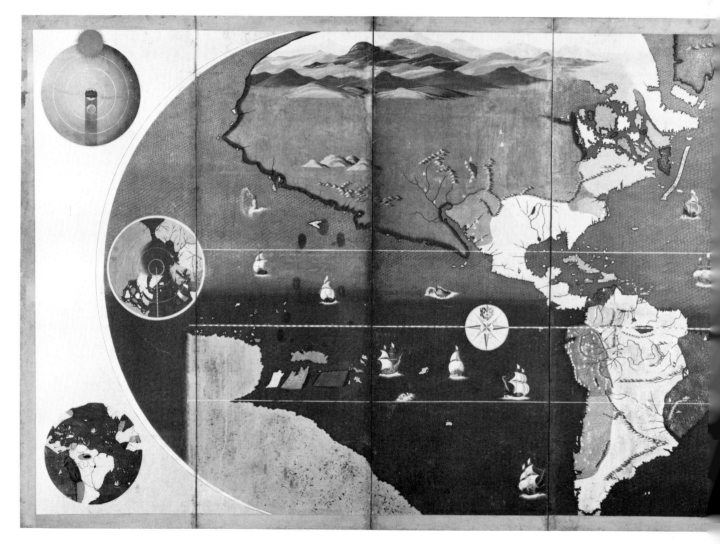

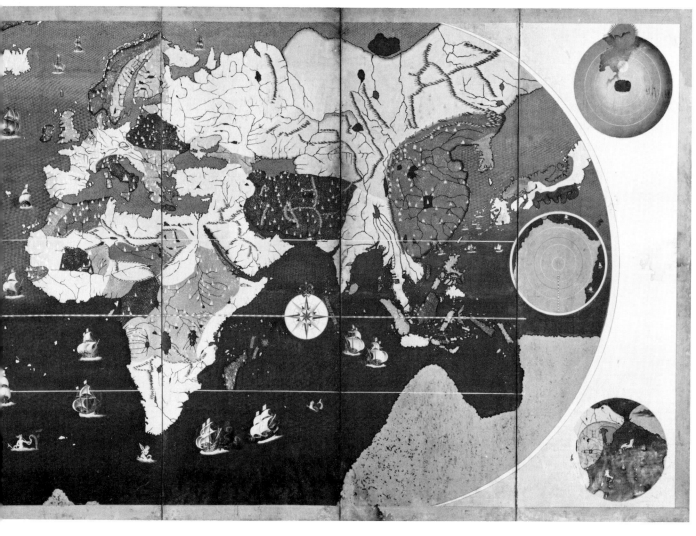

*World Map.* This eight-fold screen, the mate to *Four Major Cities of the World,* is presumably copied from *Theatrum Orbis Terrarum,* published in Antwerp in 1570. Painted in color on paper. Collection Mr. Nagataka Murayama, Kobe. Photograph courtesy International Exhibitions Foundation.

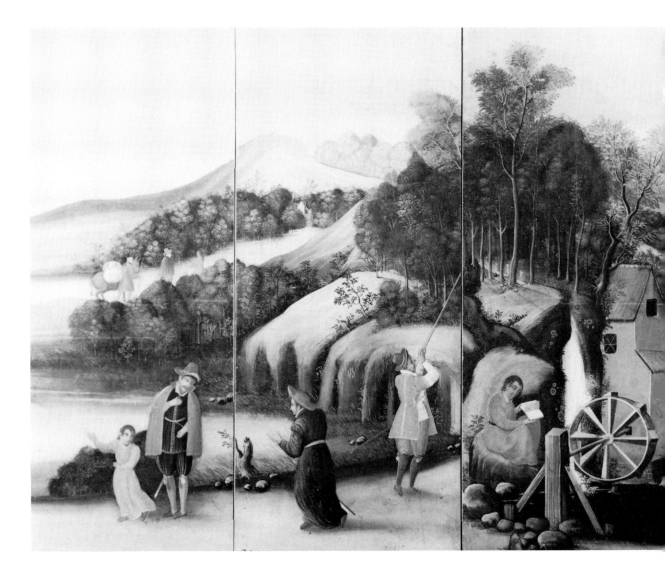

*E*uropean *Genre Scene with Water Mill.* Japanese screens depicting Europeans against beautiful landscapes were based on engravings made in Europe. First half of the seventeenth century. Collection Mr. Ichio Kuga, Osaka.

Korea. An inventory of 756 A.D. listing Emperor Shomu's possessions mentions some hundred screens.[6] These are made of silk or paper painted with secular subject matter such as landscapes, flowers, poems, people, animals, birds, and palaces. One of these screens is described as being composed of six panels, each with a painting of a Chinese lady. The faces are tinted a pale shade, while the rest of the form is outlined in ink and then colored with bird feathers pasted over the entire costume, as was fashionable at that time.[7] All the Shoso-in screens have a self-contained design of related subjects in each panel and are edged with brocade and framed, which emphasizes their verticality and individuality. The decorative effect is superb, but the technical craftsmanship is poor. The panels are hinged together with thongs of leather or with cloth pulled through holes near the edges of the panels.

The heaviness of a Chinese screen and its clumsy hinging is partially due to the way it was used. Unlike Japanese houses, Chinese dwellings have stationary walls, frequently decorated with murals, and screens were not moved with the same frequency. The screen was viewed aesthetically as a source of beauty, inspiration, or intellectual stimulation, with less importance attached to flexibility and mobility.

Until the Sung dynasty (960–1279) screen painting was a serious art form, but soon thereafter it deteriorated into a decorative art. A split developed between the "literati" painters and the professional artisans, who put more emphasis on the gilding and carving and on the inlay of semiprecious stones, ivory, and mother-of-pearl than on the content.[8]

Soon after its arrival in Japan the screen flourished and acquired added forms and functions. Japanese houses may contain three types of screens: one placed at the entrance to deflect evil spirits; a sliding interior wall panel called the *fusuma;* and a *byobu,* a folding screen of several panels that stands on the floor without support. *Byobu* literally means "protection from wind." It made its way into English diaries and inventories as "beoubes" or some other spelling approximating it. The virtues of the *byobu* were its mobility and adaptability, its protection and versatile functioning in the daily environment and activities. Small screens were part of tea room ceremonies, while large ones were used on the stage or as a background for a concert or dance. *Byobu*s were necessary accoutrements at imperial coronations, were used in outdoor processions, and provided an enclosure for Buddhist rites. In addition, they served as conversation pieces among members of the family and as stimuli for literary or poetic discussions.

The concept and craftsmanship of a Japanese screen are of particular interest because they reveal an extraordinary sensitivity to the problems resulting from the unique form of the screen. Europeans would emulate some of the techniques but frequently ignored the extreme subtleties of the angular form. Since the Japanese screens were to be moved with great frequency, lightness was not only desirable but a requirement. As screens grew larger, this became even more important. Whereas the Chinese frame was of a relatively heavy wood, the Japanese were able to use a lighter one because the strength of their constructions lay in the paper itself. It was handmade

of gampi and other vegetable fibers, and its quality and durability were superb. Several layers of paper were stretched over the frame and overlapped and interlocked from panel to panel to form the hinges. No other material was needed. This ingenious hinge had several merits, its most important being that it provided an almost unbroken surface. The individual panels were separated by only the thinnest line, and the artist could conceive in terms of a continuous horizontal design instead of the vertical forms imposed by frames linked by awkward metal or leather devices. The hinge allowed folding the screen in an accordion fashion, making it easier to handle. Proof of the strength of the hinge is that today there are still in existence a few screens of this construction that are five hundred years old, as well as a very small number dating from eight hundred years ago. Often the outer edge of the screen was protected by a narrow lacquer frame that was reinforced at the corners with very lightweight, decoratively chased metal strips.

The real triumph of the Japanese was the artistry of the design and the quality of the painting itself. In a culture where there was neither wall painting nor pictures, screens were a medium for fine art. As all but the poorest houses had screens, there was the usual enormous variation in quality found in all domestic furnishings and decorative art.

A distinguished screen conveyed an idea or concept expressed through pattern, spacing, linear rhythms, and color. Its success depended on the skill with which these elements were integrated and interwoven. Designing a screen presents unique, challenging problems that the Japanese artist sought to solve. By its very nature a folding screen presents a series of angles and must remain angled in order to stand unsupported. If a screen has separate vertical panels, the design is not a problem. Each leaf is self-contained, with designs that are repeated or related in form or subject matter. However, with the development of the paper hinge, the area became virtually an unbroken space, and the design could sweep across the sections. In viewing a conventional flat painting, attention is drawn to a focal point, usually near the center of the painting. In contrast, a screen's angular relationship of panels makes the viewer aware of these divisions, and the design of each leaf must have something of individual interest while still relating to the overall composition. The Japanese artist was acutely sensitive to the fact that one always views a screen, or some part of it, obliquely, and that the angle of vision is constantly changing as either the viewer or the screen changes position. It is precisely at the center, especially in a two-fold screen, that one has the poorest vision, that being the darkest area and the one of greatest distortion. The best of the artists solved this compositional problem with an intuitive sense of asymmetrical rhythm, a repetition of curve and line, and the superb use of color. Once the artist had worked out the details, he proceeded to paint directly on the paper, a technique that permitted no alteration or correction. Paper was generally preferred to silk, as it was more receptive to the water-soluble paints and offered a greater variety of textures. The artist painted the papers while they were laid out on the floor, and the paintings were attached to the

frame upon completion.

Unfortunately, there are wide gaps in the history of the screen. Those at the Shoso-in repository predate the eighth century, but there are no existing screens for the next three hundred years and very few that predate 1450.[9]

The art of screen painting had reached its finest development in Japan at the time that the Western world was making its first intrusions there. The zenith was reached during the Momoyama period (1568–1615), with *namban* paintings representing one aspect of the style.

While the painted screen was being created in Japan, another type of screen was being made in China, the lacquer screen, a type that was to have vastly greater impact in Europe for the next two hundred years.

Chinese lacquer began to come into Europe in the early years of the seventeenth century, and in 1614 the first English ship returned from Japan with "Japanese ware, scritoires, Trunkes, Beoubues, Cupps, and dishes of all sorts, and of a most excellent varnish."[10] From that moment on one finds numerous notations of screens. Charles I possessed "two China screens, gilt, one being broken," and Oriental lacquer screens brought into England in Charles II's reign were often of large size, containing as many as twelve folds. In 1689 the earl of Bristol purchased twelve leaves of "cutt Jappan skreens," buying a complete pair of screens, also made of "incised lacquer," a few years later.

When an inventory was drawn up of the contents of Queen Mary's lodgings at Kensington Palace in 1697, there were several India chimney screens in her bedroom and a note explaining that one of very large size with twelve leaves "was in two but the Queen had put it together."[11]

In July 1682 John Evelyn recorded a visit to his "good neighbor Mr. Bohun, whose whole house is a cabinet of all elegancies, especially Indian; in the hall are contrivances of Japan screens instead of wainscot. The landskips of these skreens represent the manner of living, and Country of the Chinese."[12] Evelyn, who shared his contemporaries' difficulty in distinguishing between the products and geography of India, China, and Japan, clearly regarded this style of paneling as novel, but it was soon to become widespread. Before the end of the seventeenth century many an English house, including Burghley, Chatsworth, and Hampton Court, boasted a lacquer-paneled room. Since the Chinese did not make lacquer boards for the express purpose of wainscot, screens were dismantled and adapted for this use.

These accounts raise two key questions. What precisely was this lacquer and how did it get to England in such quantities? Part of the answer is found in the history of the East-West trade. After the Dutch had been successful in wresting from Portugal the largest portion of the Japanese trade, they established in 1602 the Dutch East India Company. These two countries conspired to keep out any further rivals, but the English did establish their own East India Company. Although they were officially permitted to trade, the English were forced to take circuitous routes and to transfer their goods en route, because the earlier arrivals maintained control of the

Screen presented to the first duke of Marlborough by Leopold I after the battle of Blenheim. The imperial eagle of the Hapsburgs appears in the carvings above the red lacquer Coromandel panels. The screen is one of a pair. K'ang Hsi period, 1662–1722. Photograph courtesy The Countess Spencer, Althorp.

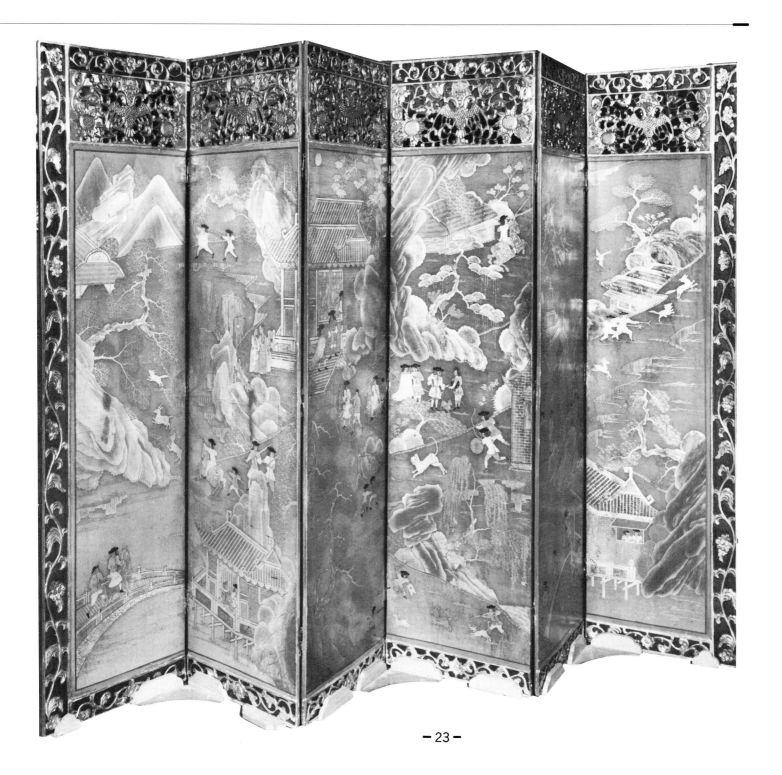

established key routes. Wares were shipped partway by the Chinese and then transferred to the European vessels for the major part of the voyage. Coromandel, a section on the Madras coast, and Bantam in Java were two of the points at which goods were collected and exchanged. It is curious that the word "Coromandel" would soon become so identified with a ware that its original significance as a place name would be obscured, and this is even more illogical when it is considered that the coast of India played no role in the creation of that product. By the middle of the seventeenth century, France had also obtained trading rights, and Oriental goods were being received at ports all over Europe.

The Records of the English East India Company in 1697 ask the Chinese factory to provide ". . . 20 sets of screens, 12 leaves to a set, 8, 9, & 19 feet high by 20 to 24 inches broad; black & gold, with Landscapes & figures engraved on a gold ground."[13] Another document from the same Letter Book lists the "goods proper to be invested in the ship Trumball, at Amoy, Oct., 26th, 1697. . . . 'If any fine lacquer or Right Japan cabenetts or skreens to be had you may bring some. All sorts of useful things in fine Japan lacquer but bring little or no ordinary lacquer ware . . .'" Further instructions state, "What tonnage will yet remain to be completed you may partly supply, with some more boards of sufficient thickness (three-quarters of an inch or there abouts) lacquered on both sides, fit for screens, or pannels to be done by the best artists, and of the finest Lacker & works procurable, or else none at all."[14] Toward the end of the seventeenth century three ships—the *Sarah,* the *Martha,* and the *Dorothy*—arrived with China goods valued at £150,000 including the following:

| Boards | 178 pounds |
| Boards for screens | 174 pounds |
| Screens set in frames | 54 pounds.[15] |

This indicates that many of the screens were assembled upon arrival and that extra boards not necessarily related or in sequence for a screen—perhaps to be used for wainscot—were included. The prices are not too revealing, as the number of boards is not given.

The question must now be answered as to the exact nature of the lacquer and why it was so desirable. The "varnish" mentioned in the records of the English ship that returned in 1614 was indeed excellent, if not actually varnish. It was true Oriental lacquer, not to be confused with the later European imitations. Lacquer was first known to the Chinese over three thousand years ago and was introduced into Japan in the sixth century A.D. By the fifteenth century the Japanese had developed the art of lacquer techniques to such a degree that even the Chinese emperor admitted the superiority of their work. It could only be done in the Orient, as that is the source of the lac, the resin from the *Rhus vernicifera.* The trees are tapped and the saplike liquid is drawn off into wooden tubs. Crude lacquer is a grayish fluid that must be strained through linen and then simmered over a slow fire to remove its impurities. Since lac hardens and darkens upon exposure to air, it does not keep well and therefore could not be sent to Europe in its liquid form.

Making this exceedingly hard surface, with its inimitable deep luster, is a long and laborious process. The board is selected and then covered with a layer of linen, paper, or silk. One source reports that the craftsmen of the Ming dynasty (1368–1644) took great pains preparing the surface by covering it first with clay, then grasses, then more clay. The liquid lacquer is applied with a brush and then allowed to dry for several days. Ironically, it must dry in a moist atmosphere.

As one Chinese craftsman explained, "When a good workman brushes on lacquer juice, if he does it very slowly then it is too hard when it dries. If he does it too quickly then it is not hard enough or smooth. He does it not too slowly and not too quickly." He recommended thirty-three steps with repeated periods of drying time of from twelve hours to three days, while another artisan said thirty-six coats of lacquer gave the best finish.[16] By either account, it was a task requiring equal amounts of skill and patience. It was generally thought that the finest lacquer came from Tonking or Nanking and not from Canton, which was the center of commercial activity and export. The demands of the material and those of commerce did not coincide.

After drying, each coat must be polished with pumice to a satin finish. Both sides of the board must be prepared to avoid warping. Once properly prepared, the surface has a metallic hardness and is waterproof. A remedy for restoring the luster of the lacquer was to bury the boards in snow. Boards removed from wrecked ships after years under salt water come out unharmed.

Although practically indestructible, lacquer does continue to need moisture, and as a caveat emptor it must be said that dry, overheated houses can do irreparable damage, causing the layers to crack and peel.

When the board was ready for decoration there were numerous ways the artist could proceed. He might choose to incise the surface or ornament it with a gesso overpainted with color and distempers or gilding, or apply shell, gold dust, or a wide array of stones.

The true Coromandel screen is considered the finest of all lacquer screens and is distinguished by its dominant characteristic of incised decoration. The design was scratched on the surface, and the board was then incised, following precise instructions given to the carver. Various kinds of knives were used, and the carver was advised that the cuttings should be V-shaped, with clean, direct lines to be carried out with restraint. Sometimes the sharp edges left by the cutting were polished smooth. On other occasions a crisp edge might be preferred. The hollowed-out space was then filled with a glutinous water-soluble substance mixed with colors or gilt. When new, these colors bordered on the garish, but they become subdued by time and fading. The rather startling colors to be seen in a protected area, such as the inside of a cabinet, show the original state.

The motifs of Coromandel screens were Chinese and followed the style of contemporary paintings, so the dates can be fixed with some certainty. They were first made for the Chinese market during the Ming dynasty, often commissioned for presentations at

**B**uddhist themes and figures in colors and gilt decorate a twelve-fold Coromandel screen. Seventeenth century. Victoria and Albert Museum.

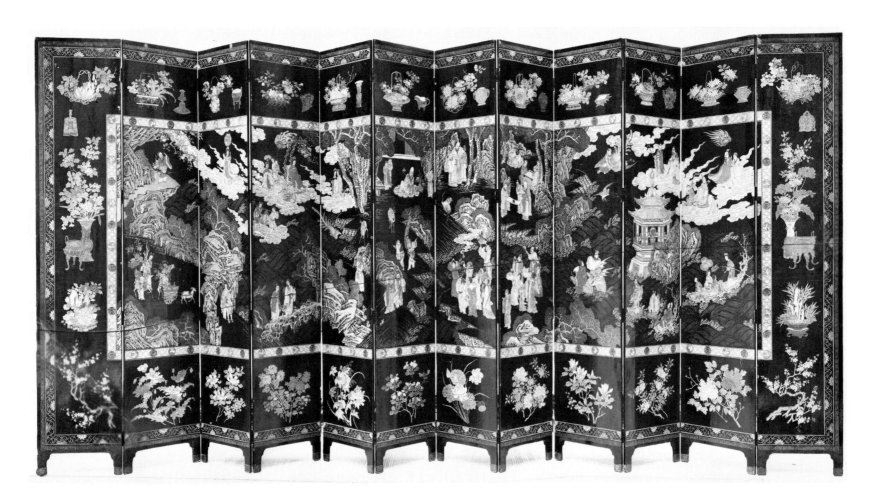

**S**mall paintings of landscapes, figures, vases of flowers, blossoming trees, plants, birds, animals, and domestic objects cover the reverse of the screen shown opposite. Seventeenth century. Victoria and Albert Museum.

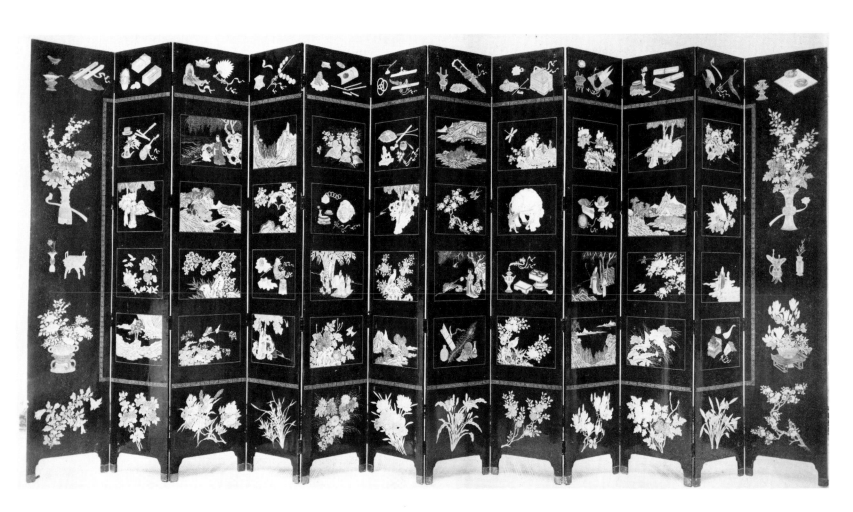

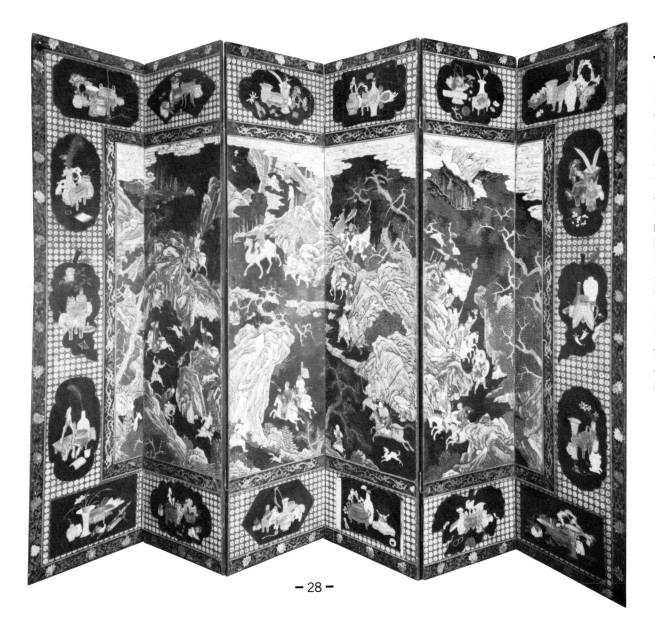

**C**oromandel screen obtained by Elihu Yale while he was governor of Fort St. George in India. Its polychrome design depicts travelers, hunters, and soldiers in a mountainous landscape. The border contains images of flowers and utensils. The reverse side of the screen shows exotic birds and waterfowl. Erddig Park, Clwyd, Wales. Photograph courtesy The National Trust.

Flowering shrubs and almond trees dominate the landscape on this twelve-fold Coromandel screen. Objects believed to be needed for the next life appear in the border. Plate II shows the reverse side of the screen in color. Private collection, New York. Photograph courtesy Mallett & Son Ltd.

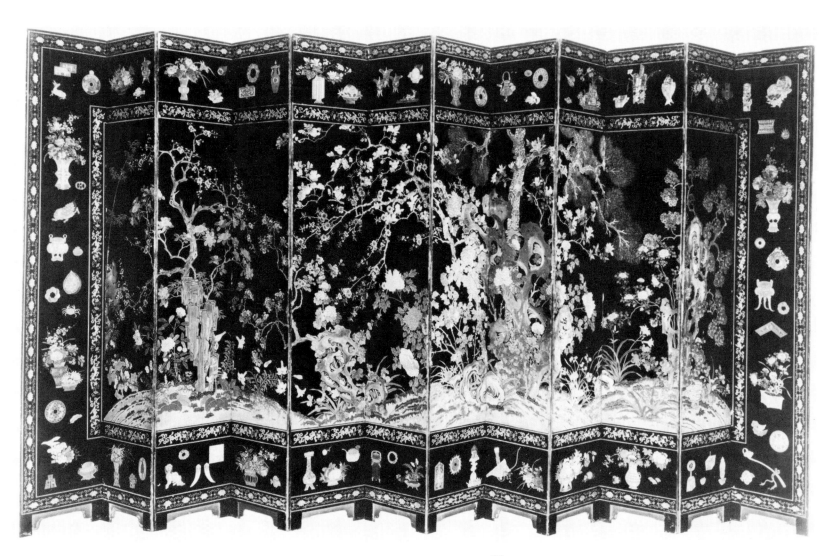

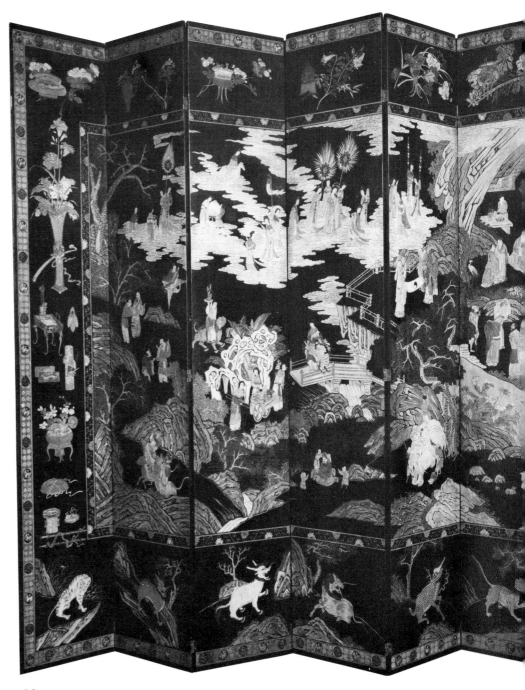

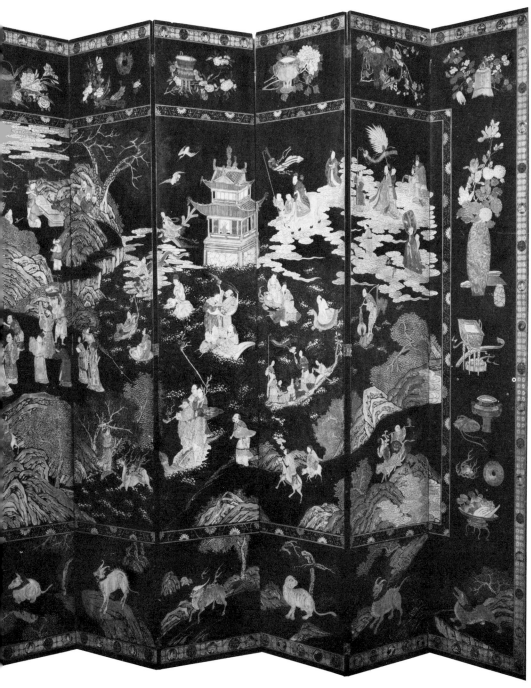

Twelve-fold Coromandel screen depicting a festive celebration. The lower border of fantastic animals is of particular interest. Seventeenth century. Photograph courtesy Mallett & Son Ltd.

birthdays or other festive occasions. Perhaps they represented the occasion itself or commemorated other events in the honoree's life. Typically, the honoree might be seen seated in the pavilion, possibly being entertained by musicians, dancers, or poets.

In a splendid example representing the celebration of a Buddhist rite, the priest stands in the middle offering prayers of thanks while those standing nearby offer baskets of food and incense. Animals, real and imaginary, are scattered throughout a landscape peopled with all varieties of living persons, while departed souls drift aloft on clouds. The screens record the setting of an occasion, often depicting detailed architectural features—houses, temples, pavilions—linked by bridges used as unifying devices. The Chinese did not employ Western perspective, and the lines of the walls and bridges lead the eye from one plane to the next, each with its fascination of detail. Most often the screen was bordered by a wide band containing a number of objects, each one either set in a variously shaped surround or juxtaposed at random in the border. The border depicted the "Hundred Objects" that were considered necessary for the life beyond. Emblems of the twelve months, all sorts of blossoming shrubs and plants, bowls of fruits and flowers, and household objects, such as lamps, incense burners, and pieces of jade, appear. Archaic dragons or the phoenix, symbol of royalty, might be incised in the border or the end panels. It was not unusual for these motifs, set in rows, to cover the entire reverse side of a screen that would have a continuous scene on its front side.

The six-fold Coromandel screen presented by Leopold I to the duke of Marlborough is one of a pair. Both have warm red backgrounds decorated with graded tones of gold. The figures enjoying various sporting activities are dressed in late-seventeenth-century European costume. Although the costume is European, the facial features and poses betray the Chinese artist. At the top of the screen is a wide gilt border, each panel displaying sunflowers, foliage, and the intricately carved Imperial Eagle of the German Empire. The entire screen is edged with a narrow band of carved scrolls, and the back is decorated with a floral ornament on a dull red ground. The two screens went separate routes. One was taken by Leopold's son, Archduke Charles, to Palermo during the Austrian occupation of Sicily (1720–1734), where it passed into the possession of the Airoldi family. The one that was presented to Marlborough now rests at Althorp,[17] the ancestral home of the Spencers in Northamptonshire.

A large screen, nine feet high by twenty feet wide and consisting of twelve panels, shows what must have been considered among the finest of Coromandel screens, as it was formerly in the Imperial Palace at Peking. This screen (shown in Plate II) was presented originally by those named on its left-hand side to the person named on the right-hand side on his sixteenth birthday, circa 1690. During the Boxer Rebellion in 1900 the screen was looted from the Imperial Palace. It was later brought to France and thence to England, where it was exhibited in the Royal Academy in London. One side shows the site of the birthday celebration with the guests approaching in small boats, while the other side has a design of almond

Screen made in China for export during the first half of the eighteenth century. The form, technique, and borders all differ from earlier work. Black lacquer with gold gesso design. Victoria and Albert Museum.

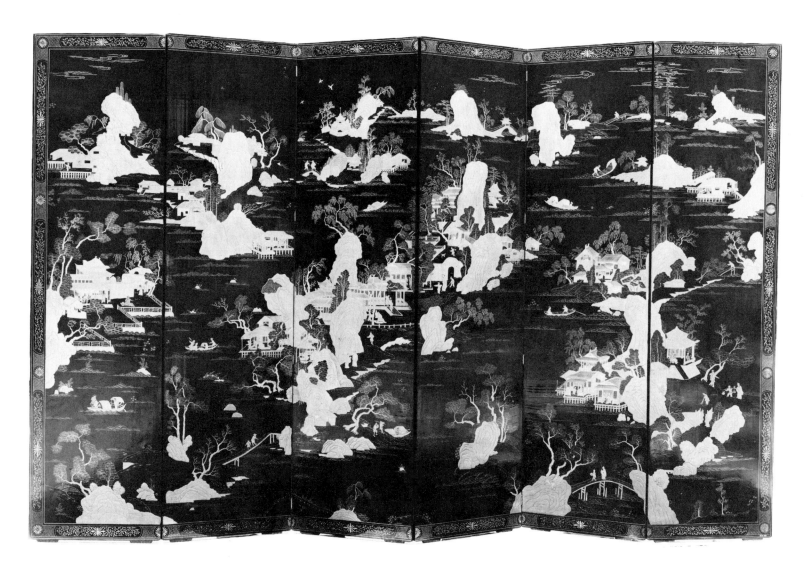

trees, magnolia, and various other plants. The colors are dull blue, cream, and coral on black.[18] The flowering trees and plants are placed in a more horizontal plane than is frequently found, leaving some of the background area relatively bare. As usual the design on the reverse side has no relation to the one on the front. It is as though they were two separate works of art, with only one side intended to be seen at a time.

As the demand for imports from the Orient continued to grow, the Chinese, while maintaining the making of traditional screens, increasingly produced screens designed expressly for the European market. As early as 1670, Europeans interested in commercial development were going to the East to introduce patterns to be made in China for the Western market. These patterns, combined with the teachings and engravings supplied by the missionaries, gave the craftsmen ample materials to copy and reinterpret. A nine-fold screen, *View of Amsterdam,* is a good example. The Chinese artist, following the example of the engravings, has used Western perspective: all lines recede along the canal, yet the boats, the bridge, and the platform definitely have Chinese flavor. Those elements with which the artist was familiar are infused with an Oriental quality, while the architecture, unknown to him, remains purely Dutch. The ornate framing is similar to some of the elaborately carved and gilded furniture of the period. The presence of an uneven number of panels is the result of European influence; for their own use the Chinese would have made one with an even number of panels. The screen dates from the Ch'ien Lung period (1736–1795).[19]

The Coromandel screen was just one of the many kinds of lacquer screens made by the Chinese. Black was the most usual color and considered by many the most desirable. As lacquer is exposed to air it darkens, and as the layers are laid one upon another, the result is a natural, deep, lustrous color. Various powders and dyes could be added to the lacquer as it was applied, resulting in a wide range of colors. Among the most popular were vermilion and cinnabar red, turquoise, slate blue, several shades of green, ivory, aubergine, brown, and a brilliant yellow. Gold dust could be added to the lacquer after the first layer had been applied and dried, but the Chinese did not use this ornamentation nearly as much as the Japanese. Inlaid shell had been used as long ago as the eighth century, as some of the screens at Nara bear witness. The nautilus was used, as were the pear shell and abalone, the latter giving an iridescent blue and green effect. The abalone decoration might be enriched with gold and silver and delicately engraved. This particular kind of decoration, called "misty brocade," was praised during the Ming dynasty. Mother-of-pearl was also much favored, as were soapstone and ivory. Semiprecious stones and rocks such as jade, turquoise, malachite, lapis lazuli, or coral might be applied in relief or inlaid, giving infinite range to the fancy, skill, or resources of the creator.

During the eighteenth century, the Chinese continued to make lacquer screens, as indeed they do to this day. The technique of incising remained in use, but new forms of decoration appeared along with

*View of Amsterdam.* Slightly concave panels distinguish this rare nine-fold Chinese-export lacquer screen. The gilt frame projects forward at the top and is elaborately carved with scrolls and acanthus leaves. Ch'ien Lung period, 1736–1795. Collection of Herbert Black, Montreal, Canada. Photograph courtesy Mallett & Son Ltd.

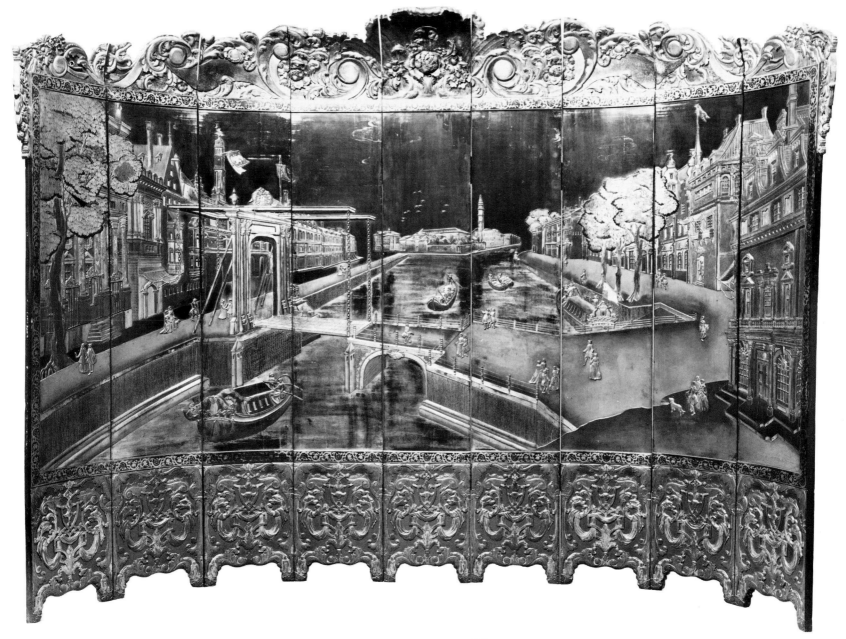

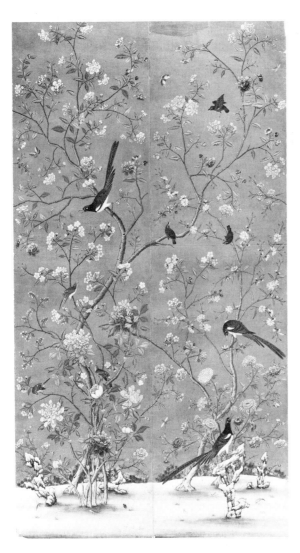

**C**hinese wallpaper showing birds and flowering trees. Mid-eighteenth century. Victoria and Albert Museum.

the continuation of earlier ones. Eighteenth-century screens are generally smaller, the huge twelve-panel ones often being replaced by six or eight panels, with the heights correspondingly reduced.

Frequently, a series of related but distinct panels replaced the continuous scene. Another screen from the Imperial Palace, dating from the Ch'ien Lung period (1736–1795), represents the Eight Immortals. The lacquer boards are ornamented with inlays of four kinds of jade, coral, lapis lazuli, agate, and crystal. The end panels and border retain floral arrangements and objects, but their ornamentation has been modified. Other screens of this later date showed the effect of screen board being used for paneling, as the screens themselves have been divided into rectangular areas. Thus a screen might look like a paneled wall, an interesting twist to the old trick of cutting up lacquer boards to create paneling.

In Japan, lacquerwork, called *urushi,* was flourishing. After transplanting the *Rhus vernicifera* from China, they mastered the art of handling lacquer, and everything from boxes to paneling to leather armor was covered with its glossy protective coating. While craftsmen in both countries were using many of the same materials, there was a basic distinction in technique—Japanese screens were rarely incised. The Coromandel technique was known to Japanese artists, but they rejected it, preferring either to work on the flat surface or, more often, to make a raised decoration of gesso, called *gofun.* This was delicately modeled into reliefs of pagodas, tea ceremonies, rocks, exotic birds, and landscapes, and then gilded.

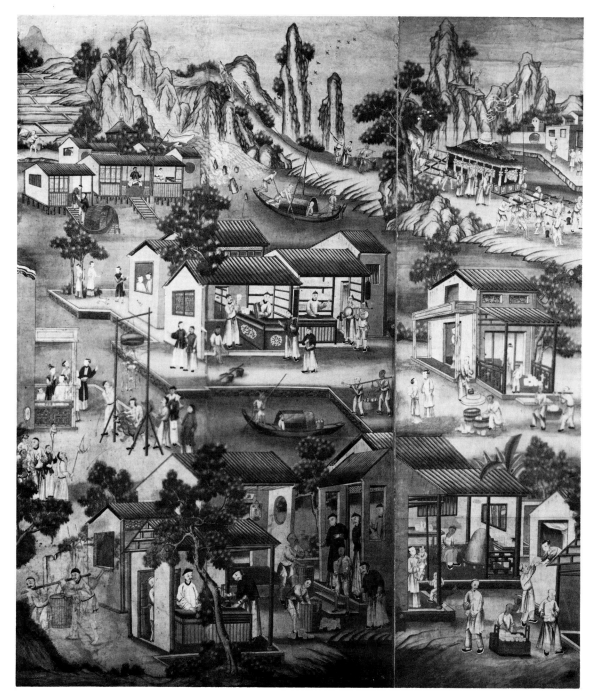

Leaving lacquer for the moment, we shall turn to one of the most decorative of all forms of screens, those made of paper. An inventory of 1683 at Ham House near London mentions innumerable China, Japan, and India screens, listing specifically an "India Paper screen in the Queen's Bedchamber" with another one in the "anteroom to ye Queen's Chamber."[20]

An advertisement in the London *Gazette* of 1694 shows the newer taste in Oriental art, announcing that "at the Warehouse for new-fashioned hangings, at the White Horse and Black Boy in Newgate Street, are made and sold strong paper hangings, with fine Indian figures in pieces about 12 yards long and about half ell broad, at 2s, and 2s 6d a piece. Also fine screens and fine figures for sash windows."[21] A London auction records sixty-six and a half pieces of Japan papers for hangings. Recalling Mr. Evelyn's confusion, it must again be emphasized that Europeans used the terms "China," "Japan," and "India" interchangeably and indiscriminately, thereby making any description imprecise.

The decorations of Chinese papers fall into three main categories: natural subjects, such as birds, flowering shrubs, and plants; industry and daily life; and figures in a landscape.

Papers with designs representing industry cost seven shillings a yard, while those with birds, trees, and flowers—the more common patterns—could be had for 4d.

A representative screen made from this paper would show peonies, roses, blossoming shrubs, bamboo shoots, and tangled roots rising from a gently molded strip of ground. Among the foliage and in the interspaces are brilliantly colored birds, either perched on the branches or in flight between them. Reference to this type of paper in England dates from the reign of George I. The realism of the rendering of the plant forms was noted by Sir Joseph Banks in his *Journal,* in which he commented that "some of the plants which are common to China and Java, as bamboo, are better figured there than by the best botanical authors that I have seen."[22]

Similarly, the butterflies and birds are painted with such accuracy and detail that they can be biologically classified by lepidopterists and ornithologists. The "best bedroom" at Erddig Park in Wales still has paper of this type, installed there in 1771. The same room displays a Coromandel screen that is thought to be one of the few pieces that were bought with the house when it was sold in 1685. The screen is traditionally associated with a letter to Joshua Edisbury, the building and original owner of Erddig Park, from his friend and neighbor Elihu Yale, then governor of Fort St. George in India, writing of a present of a "Japan Skreene" for Edisbury's wife.

Diaries of the eighteenth century testify to the widespread use of China paper and its favor. In 1746 Mrs. Mary Delany, who corresponded with many of the leading literary figures of her day, had a dressing room "hung with the finest Indian paper of flowers and all sorts of birds."[23] Another diarist of fame, the peripatetic Mrs. Philip Lybbe Powys, visits a fashionable English country house and comments on "the most curious India paper of birds, flowers, etc.

put up as different pictures in frames of the same with festoons, India baskets, figures, etc. on a pea green paper . . . with an effect wonderfully pleasing."[24]

These much admired papers were costly, more expensive than all but the finest damask. There can be no doubt, when papers were bought in such large lots, that there were remnants from most orders. The papers were sent in long strips, some as long as twelve yards, rolled in boxes. They were mounted upon arrival at their destination, and much piecing was necessary to achieve the desired effect.

The eighteenth-century method of hanging wallpaper is interesting because it shows immediately the close relationship between wall hangings and screens. At that time, paper was not attached to the wall, which explains why some of it has survived so well. Instead, the paper was strengthened by a backing of canvas or linen, then stretched and hung on a frame. The frame was then attached to wooden pegs driven into the brick or stone. This allowed an air space so the paper did not become moldy from wall moisture or crack as the walls shifted or settled. Using this technique, preparing paper for wall hanging was very closely allied to making a screen, and, as noted, both tasks were performed by the same craftsmen. An artisan in St. Paul's Churchyard advertised, "Have the greatest choice of paper Hangings and Paper Mache ornaments . . . to suit all sorts of Furniture Rooms fitted up with Gilt Leather, Indian Pictures, or Prints, etc. Great variety of screens, Looking glasses, Brackets, Girandoles and Picture Frames, Gilt or Plain, at the lowest prices. Indian Pictures and Paper Hangings for Exportation."[25]

In Paris in 1753 the *Mercure de France* informed its readers that "one will find in the shop of Sieur Prudhomme, dealer in paper, Rue de Lombards . . . an assortment of Chinese papers of different sizes, of wall hangings, over-doors, fire-screens and paravents [folding screens]."[26]

In France in 1781 a Chinese set of thirteen rolls representing arts and industry was advertised, and three years later a set of twenty sheets representing tea cultivation was available. Several versions of this subject are known, with a set of forty sheets sent to America from Canton in 1770.

The Victoria and Albert Museum has two portions of wallpaper dating from the early eighteenth century from the "scenes of everyday life" category. A city is shown as a number of small islands, each with its inhabitants engaged in various callings. The islands are linked by boats in the intervening water and the connecting bridges. These papers are of historical significance, as they show the trade of silk weaving, the processes of china making, and entertainments. By this date the art of printing had been long known in China, but it was rarely used in making wallpaper. This particular paper is an exception, the outlines having been printed and then hand-colored with various kinds of gouache and tempera. The reverse side of a screen faced with this paper was covered with a fabric having a large floral design in two shades of green.

During the eighteenth century, the Coromandel boards were to make another appearance, assuming a new guise, this time incorporated into furniture. The exchange worked both ways. In 1688 several English

artificers were being sent to teach "the Indian" how to manufacture goods, a step considered necessary by some who felt the Japanese cabinetmaking was not acceptable. A critic claims that "the joyners of this country [China] may not compare their work to that the Europeans make, and in laying on the lack on good or fine joyned wood, they frequently spoil the joynts, edges or corners of Drawers and Cabinets."[27] At the same time, some finished cabinetwork was being sent to the East for lacquer.

Still another variant was sending lacquer boards to Europe to be manufactured into tabletops, cabinets, and brackets. Miniature screens were frequently converted into mirrors. John Stalker and George Parker, the authors of *A Treatise of Japaning and Varnishing,* published in London in 1688, scorned this practice, scoffing at it by saying that Coromandel was "almost obsolete and out of fashion. No person is fond of it or gives it house room except some who have new cabinets made out of old skreens, and from that large old piece, by the help of a Joyner, made little ones . . . torn, and hacked to joint a New Fancie . . . the finest hodgpodg of Men and Trees turned topsie-turvie."[28]

This description of fashion was premature, but the evaluation might be just in describing some of the work carried out in the Orient by craftsmen unfamiliar with Western style and methods. It could not possibly be more inappropriate for the French, who during the eighteenth century created some of their finest furniture incorporating panels of old screens. Examination of several pieces will show how this transformation occurred and how Europeans interpreted the Oriental design.

A pair of corner cupboards in the Wrightsman Collection, made by Bernard II Van Risenburgh between 1745 and 1749, shows a fascinating combination of style created by one of France's finest *ébénistes.* They are described in the catalogue of the collection as "veneered on oak with ebony, inlaid with Coromandel lacquer." The mounts are of chased and gilt bronze, and the top is of yellow brocatelle marble with a molded fore edge. The panels are cut from a screen and are particularly curious to the twentieth-century eye because they do not match. On the right-hand door of one of the cupboards there are girls playing musical instruments while on the left-hand one figures are engaged in domestic affairs. Similarly, on the right-hand door of the other cupboard there are women strolling in the garden, while on the left-hand door there is an outdoor scene featuring a swing. Sir Francis Watson, cataloguer of the collection, says that "the wayward fashion in which the designs of the lacquer on adjacent doors of each of these corner cupboards are cut so that there is, for instance, no continuity in the architectural background is not due to carelessness. It would doubtless have been just as easy to have disposed panels cut from the same Coromandel panel in a meaningful fashion on the doors. Rather, it illustrates the importance for the creators of the rococo in France of what appeared to be the totally arbitrary perspective used by Far Eastern artists, so that here it is exaggerated even though actual Oriental materials are being used."[29] Soon after their completion, they were sold in 1750 by Lazare Duvaux, the most

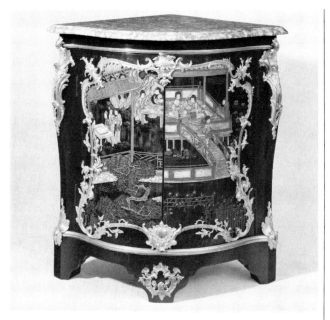

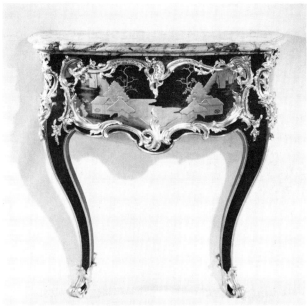

famous French dealer in antiques. It is interesting to note that all of his sales of furniture veneered with Coromandel lacquer occurred in a two-year period.

A side table, again by Van Risenburgh, illustrates another way the combination could be achieved. This lovely table has a black-and-gold drawer panel on the front, framed in gilt bronze scrolls, acanthus leaves, and shell motifs. These surround the landscape panel, which is partly Japanese yet has an overlay of European lacquer. Sir Francis says that "the practice of adding features in European lacquer in order to adapt the pattern of Oriental lacquer to the shape of European rococo

panels was not uncommon in eighteenth-century France."[30] Similarly, if some part of the object had too rococo a form, that section would be done in European lacquer, using the Oriental panels for the relatively flat surfaces. As the century progressed, the Coromandel boards would lose favor, fulfilling the wishes of European detractors.

These elegant, supremely French masterpieces, so far removed in time, distance, and style from the early Ming screens, are expressions of one of the many ways that Europeans occasionally incorporated but increasingly imitated and reinterpreted the Orient during the epidemic of chinoiserie that was spreading rapidly during the eighteenth century.

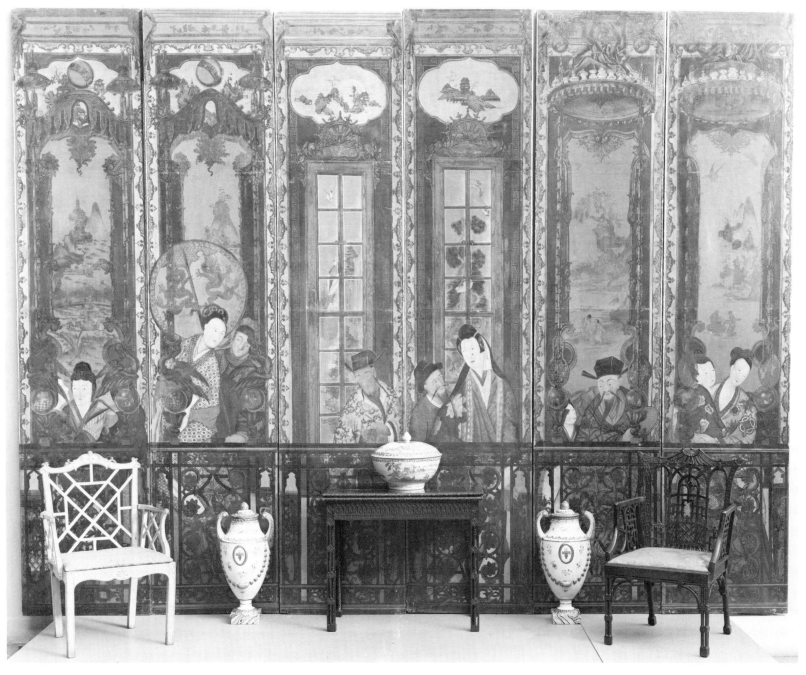

# 2. SPLENDID DEFORMITIES

Within one hundred years from the time the first *nao* arrived at Nagasaki, the impact of the Orient was being felt throughout Europe. This trade with the East continued to escalate in a crescendo that was to peak in the mid-eighteenth century and then rather suddenly subside.

By the end of the seventeenth century, designs and actual furnishings were sailing eastward for completion, while lacquer boards and screens were arriving in Europe in large quantities, as the records of the East India Company attest. Upon arrival in the West, these imported goods were usually sold at auction. The headquarters of the East India Company, called East India House, were located in Leadenhall Street, London, a frequent site for the sales. A merchant named Solomon de Medina advertised in the London *Gazette* and supplied William III with Indian goods in 1694. A Mrs. Medina, perhaps Solomon's wife, sold the first earl of Bristol some "Indian cut Japan" screens. Another widely known merchant named Motteaux had an Indian warehouse located in the same street.[1]

By 1700 the quantity of imported goods had increased to the point of causing serious competition between furniture made from lacquer boards in China and the work of the London joiners. The English cabinetmakers petitioned Parliament, saying that trade in England was in danger of being ruined. To support their claim, they reported that within four years the following had been imported:

244 cabinets

6582 tea tables
428 chests
70 trunks
52 screens
589 looking-glass frames
655 tops
818 lacquered boards
597 sconces
4120 powder, comb, and dressing boxes[2]

During the next few years other trade guilds throughout Europe would be following suit by petitioning their governments for protective trade laws and tariffs.

From the beginning there were writers as well as craftsmen who did not favor these imports. In 1697 a *Discourse of Trade Coyn and Paper Credits and of Ways and Means to Gain and Retain Riches* was published in England, saying "as Ill Weeds grow apace so these manufactured goods from India met with such a kind reception that from the Greatest Gallants to the meanest Cookmaid nothing was thought so fit . . . to adorn . . . for the ornament of Chambers like Indian screens, Cabinets, Bed and Hangings, and for closets, like China and Lacquerware."[3]

Still, the goods poured in. In 1702 the frigate *Fleet* arrived from Canton bringing seventy packing cases of screens.[4] As the spiral continued, enterprising European craftsmen concluded that the obvious solution for reducing imports and capturing their share of the market was to develop their own lacquer. The necessary books supplying designs were already in existence. Engravings such as those that appeared

in the *Martin Martinbus Atlas,* published in 1655, or *China Monumentis Illustrata,* published in Amsterdam in 1667, provided this information.[5] "Lac-werk" was not new to the Dutch. Since 1610 there had been a guild of lacquerers in Amsterdam. From the Netherlands patterns began to spread across the Continent.

The biggest problems facing European manufacture was the absence of the essential ingredient, the resin of the *Rhus vernificera.* Various substitutes would be tried, but they were all made from combinations of gum-lac, shell-lac, or seed-lac. None of these was as successful as the true lac, not having in the finished product its deep polished luster, smoothness, or hardness. The earliest and most widely read and detailed work on the subject was *A Treatise of Japaning and Varnishing* by John Stalker and George Parker, published in 1688. It was an "Epistle to the Reader and Practioner . . . that by these means the Nobility and Gentry might be compleatly furnish't with whole Setts of Japan Work, whereas otherwise they were forc't to content themselves with perhaps a Skreen, a Dressing Box or Drinking Bowl, or some odd thing that had not a fellow to answer it."[6] The authors claimed a need for this treatise because of the scandalous "stuff and trash" palmed off on customers. One needed to distinguish between "good work and rubbish, between the ignorant knave and the Artist, and to put a stop to all the Cheats . . . of those whiffling, impotent fellows who pretend to teach young ladies that art in which they themselves have not been instructed, and to the disgrace of the Title, Lurk and shelter themselves under the notion of Japaners, Gilders, etc."[7] In addition to the thorough explanation of the lacquer process, the treatise supplied the novice with designs adaptable to almost any object. This craft became exceedingly popular and an acceptable part of a young lady's limited education. Most of the designs were small, suitable for boxes, hand mirrors, and objects of small dimensions. Screens, similar to those imported, were not often japanned at this early date. This was partly due to the scale of the designs, but the ready availability of the Oriental ones was a more important factor.

Others followed Stalker and Parker in the pursuit of a substitute lacquer. A Venetian Jesuit, Father Filippo Bonanni, was the first to scientifically analyze Chinese lacquer and, in 1720, publish an accurate study of it. Understanding that the tree could not be grown in Europe nor its lac successfully imported, he properly concluded that an imitation must be devised. One of the earliest recipes was provided by a Frenchman named Antoni d'Emery.[8] After developing a satisfactory substitute, the craftsman was ready to proceed. The basic technique was to cover a board with muslin, then with a layer of gesso, molding in relief the figures, the elements of the landscape, and the clouds of the design. The gesso relief was painted with tempera, then covered with layers of the man-made lacquer. There might be as many as twenty layers of imitation lacquer, but it did not have to be applied with the same care as the Oriental lacquer, dry as long between coats, or be as carefully polished between applications. Before the last coat, silver, or most often gold, would be applied to the relief. The last step was burnishing the surface with a dog's tooth or a pebble. Black was the preferred

► **C**orner of a room in Schloss Nymphenburg, refurbished in 1763 with Coromandel screens and supplemented with lacquer panels executed by J. G. Höringer. Photograph courtesy Hans Huth, *Lacquer of the West,* University of Chicago Press.

►► **F**our large Coromandel panels given by Frederick the Great to his sister Margravine Wilhelmine about 1740. The lower panels are her own handiwork. Photograph courtesy Hans Huth, *Lacquer of the West,* University of Chicago Press.

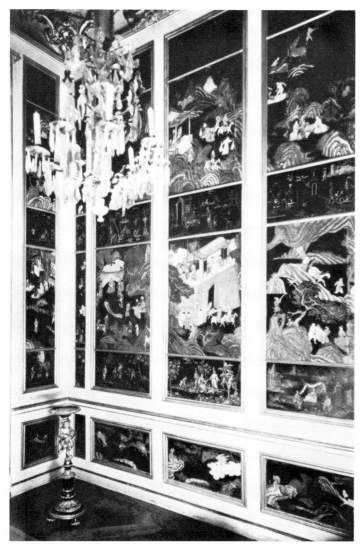 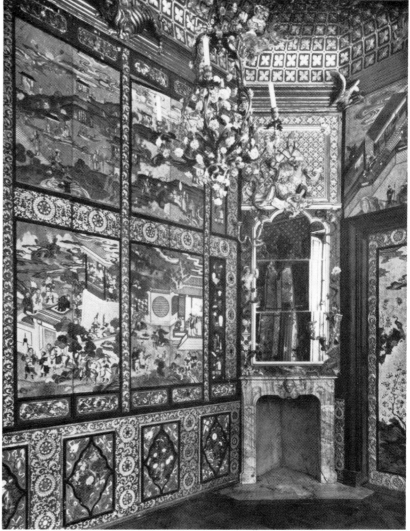

color and red second in demand, while yellow, white, blue, and green were used more rarely. Time has altered the white to yellow and changed blue to green so the present viewer must make these mental adjustments. Another technique was to carve into the gesso—but not into the wood—and then apply color. Although called Bantam work, it was not favored because of the ready supply of true Coromandel screens.[9]

One of the best-known japanners was Gérard Dagly (1651–1726), born in Spa, in Belgium, a health resort since the sixteenth century, then a center of the lacquer industry. He went to Berlin, where, with his brother, he set up a large workshop and was appointed official Kammerkünstler by Friedrich I. One of his known assignments was the creation of a japanned dado for a room in the Royal Palace that was paneled with large Coromandel screens.[10]

Another lacquerer of note was Martin Schnell, who had been an apprentice to Gérard Dagly from 1703 to 1709. In 1710 he was hired as court lacquerer to Augustus the Strong, elector of Saxony and king of Poland. Augustus's partiality for chinoiserie was such that during his life he built or remodeled three palaces in that mode: the Japanese Palace, the Indian Pleasure House, and the Turkish Palace.[11] The Japanese Palace, erected in Dresden in 1715, was one of the earliest chinoiserie palaces and was built primarily to house Augustus's special passion, a collection of Chinese porcelain. His enthusiasm so exceeded his practicality that he envisioned a palace with porcelain walls and ceilings, enclosing a room furnished with porcelain tables and chairs. The quality of the porcelain was superb, and it was

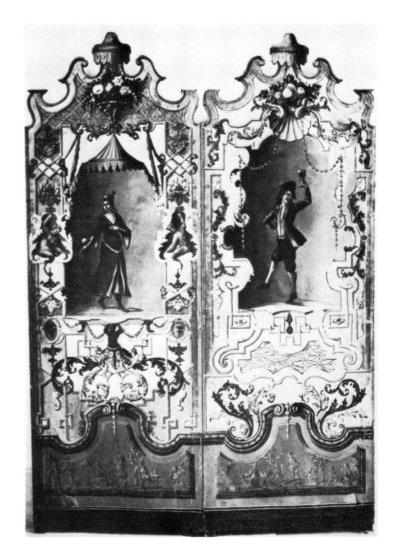

complemented by a lavish display of lacquer furniture. The Metropolitan Museum of Art had an exhibition in 1941 called "The China Trade and Its Influence," which displayed a painted screen attributed to Gérard Dagly that was commissioned by Augustus for his Indian Pleasure House.[12] Schnell is known to have lacquered six leather screens between 1731 and 1735 as well as linen hangings decorated with Chinese figures for the Japanese Palace. However, since Schnell, like Dagly, never signed his work, identification is extremely difficult. Hans Huth, a leading lacquer authority, reports that none of Schnell's screens still exists, but presumably this screen came from his workshop, possibly executed under his supervision by one of his anonymous workers. Schnell branched out from the usual lacquer on wood and developed techniques for applying it to leather and linen. Even with a coat of lacquer the leather remained sufficiently pliable to enable its being used for chair coverings, wall hangings, and screens. An inventory of a hunting lodge shows that it contained sixty rooms hung with leather and furnished with twenty-four dozen lacquered leather chairs. The panels of a leather screen that were painted in oil by Johann George Näcke and decorated with figures from the Italian commedia dell'arte are also examples of japanned leather. Leather chairs, decorated with the same figures, accompanied these panels.[13] One further note on Schnell comes from the Dresden archives and reveals that in 1717 he produced cabinets, clavicembaloes, and screens worth 1,145 talers [thalers] for Augustus's palace.[14]

The German princes were among the most avid builders in the chinoiserie style. Elector Maximilian II Emanuel (1662–1726) of Bavaria built Schloss Nymphenburg, and in 1763 his grandson Maximilian III Joseph (1727–77) had a corner room there refurbished with Coromandel screens. As was often the case with furniture and as demonstrated by the work of Dagly at the Royal Palace, paneling might be created by using Oriental screen boards or, more often, it might be supplemented with japanned boards. At Nymphenburg they were supplemented by lacquer panels made by the artisan Johannes George Höringer, patterned on earlier prints and showing a style of chinoiserie by then out-of-date.[15] Wilhelmine, the favorite sister of Frederick the Great, lived at Bayreuth, and in recognition of her artistic work Frederick presented her with four Coromandel panels that she described as of "enormous price and possibly unique in Europe."[16] Since there were not enough Coromandel boards to cover the entire wall, she arranged to have stucco applied to the lower part. This coating was then incised and polychromed.

The list of chinoiserie palaces could be extended to include almost every ruling house on the Continent. Foremost among these would be Frederick the Great's teahouse at Potsdam, Catherine I's Mon Plaisir at Peterhof, Catherine the Great's complete Chinese village in the grounds at Tsarskoe Selo, and the Chinese Pavilion at Drottningholm in Sweden. At Drottningholm the walls of the Yellow Room are paneled with leaves of a lacquer screen that have been split lengthwise. On one side of the screen there is a seaport scene showing the loading of the merchandise destined for Europe. It is a view of

Stamped and painted leather screen decorated in the Chinese taste with flowers and birds on a gilt background. Dutch, seventeenth century. Victoria and Albert Museum.

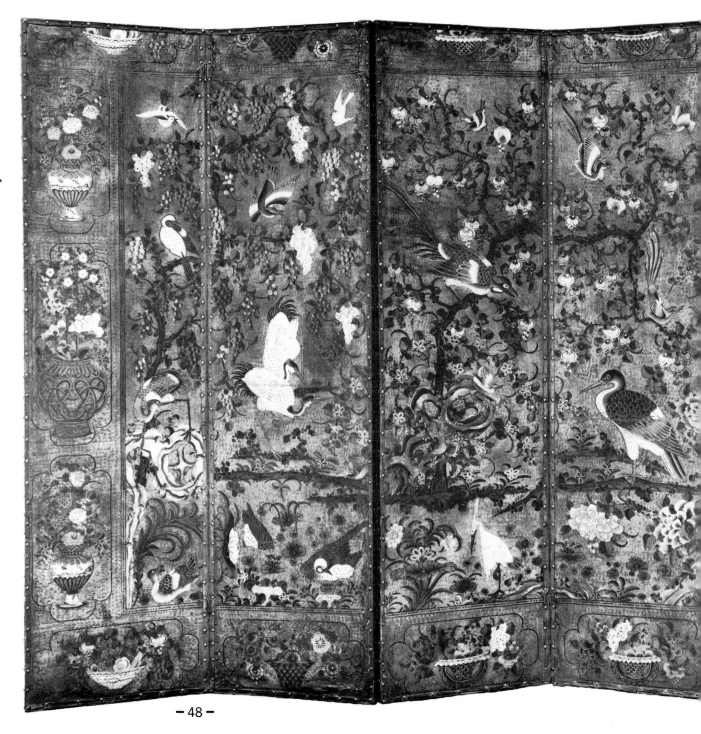

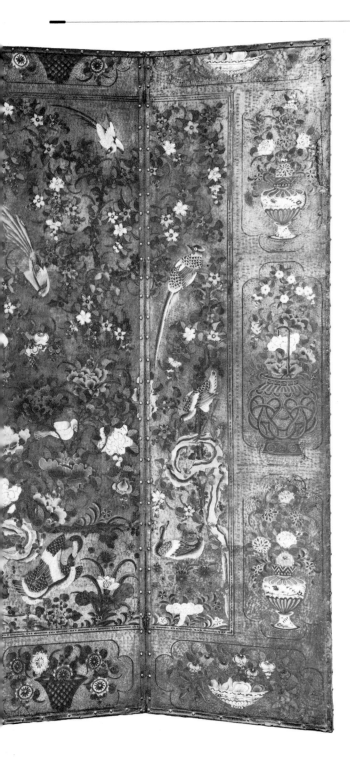

Canton and the Pearl River; the screen cannot have been made prior to 1748 because of the presence in the design of European-style buildings built there after a fire of that year. The reverse side shows the preparation for the dragon boat festival, an annual event. The panels are painted in gold, silver, and red on black lacquer with mother-of-pearl inlay. In the Blue Salon of the Pavilion is a seven-fold black lacquer screen decorated with gold, silver, and a few colors. On the front is a river scene with islands, pavilions, and arched bridges, while the reverse is ornamented with green peonies, hollyhocks, and butterflies. Without detailing the contents of the other royal extravagances built in imitation of the Orient or later as products of sheer European fantasy, one can be sure that they contained every object that evoked the essence of the Orient—and no object had more association with the East than the screen.

Frequently, lacquer served as a background for a screen, but the decoration might be a mixture of European and Oriental designs. Such a screen has been described in *The Connoisseur* as a "six-fold screen with red lacquer ground painted with eighteen views, the accepted number for screens in leather or paper. The top and bottom rows show European subjects, the dress being that of the early Eighteenth Century, and the scenes including figures in a landscape, a Royal group strolling in a park, a lady at her toilet seated in a garden, a gentleman at a balustrade, a hunting scene, subjects suggesting the theater," all in genre groups giving intimate suggestion of the life of the time.

It is the middle row of Chinese paintings of

ladies that poses a question of origin, however, since they are "obviously and unmistakably done by a Chinese artist and are not European adaptations by some student of Stalker's *Treatise* or other publications of Oriental designs. Nor are the Chinese panels inset within the gesso borders, as close scrutiny shows. It would seem that a Chinese artist travelling in Europe must have executed this charming series."[17] Even after the middle of the eighteenth century a Chinese traveling in Europe was an oddity, but a few did make the journey, and in 1769 an artist named Chitqua visited England and exhibited in Pall Mall. Similar screens were made in Holland, which may in fact be the origin of this particular one. There is a Dutch quality in the landscapes and interiors that further illustrates the difficulty of stylistically giving positive identification to any screen.

An early Dutch screen, dating from the late seventeenth century, is in the Victoria and Albert Museum. The screen has six leaves and a gilt background with a stamped and painted design employing the same techniques that had been used in leather wall hangings since the sixteenth century. Here the Oriental flowers and the birds, so foreign to the Netherlands, are painted in great detail and in a style closely allied to the highly prized Chinese wallpapers that were arriving in European ports at that time. When the Chinese imports first began to arrive, European makers tended to imitate them by closely copying the style. In this screen, the border, with its vases of flowers and other objects, is an imitation of those found on Coromandel screens.

The Netherlands had been the center of the gilt leather industry during the seventeenth century, but in the eighteenth century England rivaled her for this distinction. In 1666 a leatherworker named Hugh Robinson petitioned Charles II for permission to settle in London, having "learnt to make leather more bright than gold" in Amsterdam.[18] From that time English chinoiserie gilt leather began to be much in demand. The fundamental technique for making leather screens was to dry and size the pieces and then to cover them with gold leaf. Upon completion of these steps, the pieces were glued together, the silver burnished, and the surface coated with yellow lacquer. The design was applied in oil paints, and the background was distressed with tools to give the gold a glittering effect. The history of and techniques used in making leather wall hangings and screens will be more fully discussed later, so our concern now is only for those made in the chinoiserie style.

The attribution of leather hangings is virtually impossible. John Waterer, the late director of the Museum of Leathercraft in England, said that of the hundreds he examined only one was dated. There are only two known signed leather screens: one is by "Holford," and the other one is signed "Coventry, London," referring to either the maker or place of manufacture. The latter one was found in a small castle in Wilhelmshöhe near Kassel. During the nineteenth century, part of this hanging had been removed from the wall where it had been placed in the previous century, parts had been cut off, and the rest had then been converted into a screen. The design shows an ideal landscape with houses, stairs, railings, gardens, people, and fences. The figures are

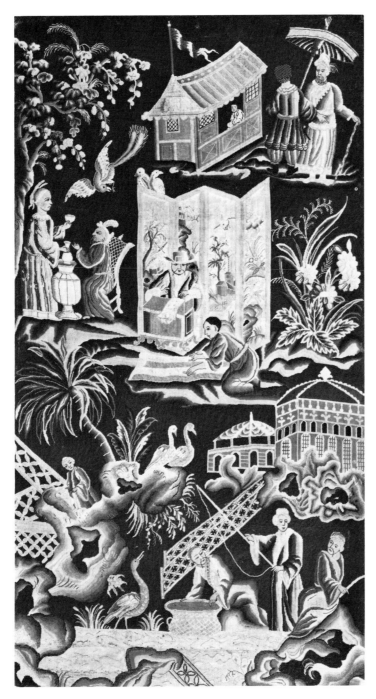

**C**hinoiserie motifs embroidered in tent stitch with wool and silk threads on a linen panel. English, eighteenth century. Victoria and Albert Museum.

**S**ix-fold screen japanned on both sides in black and gold in slight relief. The four central panels have a continuous design, while the end panels seem unrelated except for the lower sections. English, circa 1680. Photograph © The Hamlyn Group.

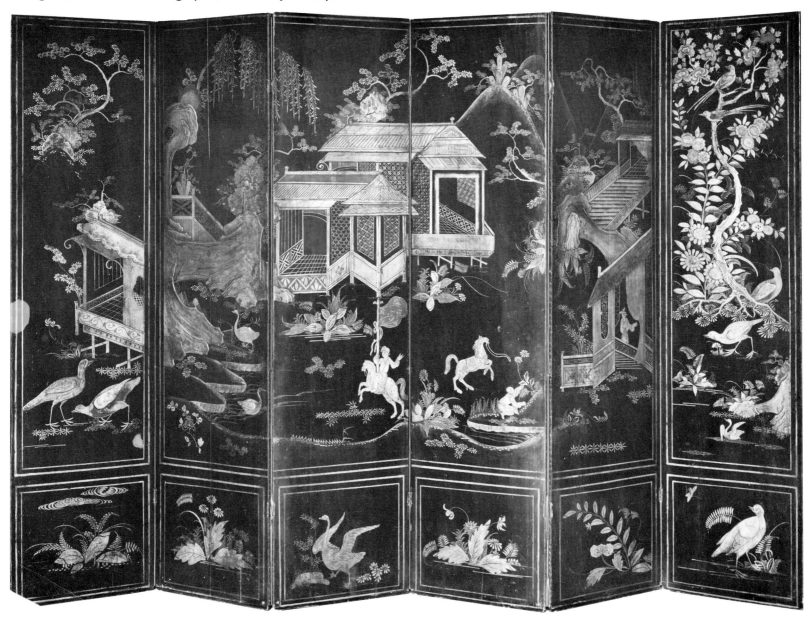

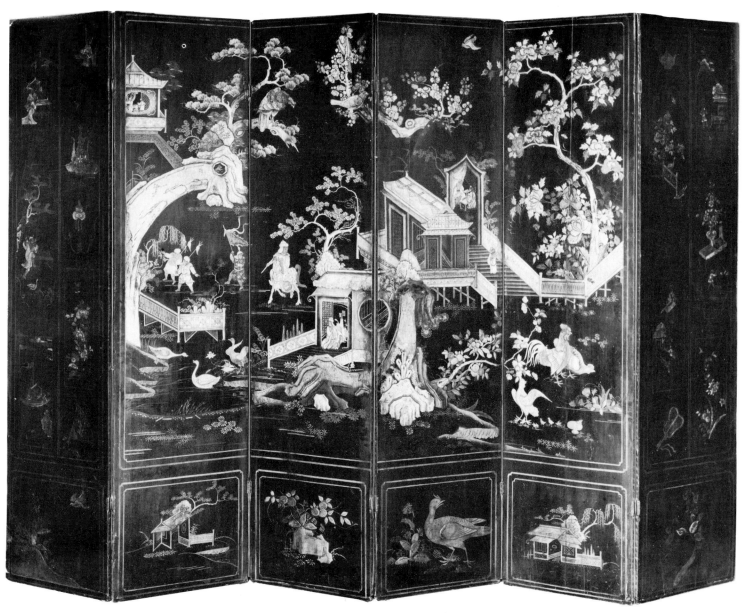

treated in the Oriental manner in that all the spaces were filled with motifs; the artist was apparently more concerned with the images and pattern than with the spatial relationships. The borders are decorated with the typical vases of flowers. A similar screen from the same workshop is to be found at the Palace of Charlottenburg at Berlin.[19] Wilhelmshöhe, the site of this discovery, is a complete Chinese village where one could retreat into fantasy. It consisted of a house, bungalows, barns, and a building housing two dining rooms and a ballroom. There the occupant could make believe he was Chinese. He could dress in loose-fitting robes, enjoy fishing with a bamboo pole, contemplate nature, and yet have the entertainment facilities the social life of Europe required at that time.

Often leather screens were in complete imitation of Coromandel screens. In spite of the number of Coromandel screens available and the scorn that some persons were beginning to show toward them because of their abundance, they remained very popular and very expensive. Only the wealthy could afford them, while those in less affluent circumstances could aspire to own a leather imitation. The leathercrafter could copy a lacquer screen of his client's choice. Besides having the advantages of economy and selected design, the imitation possessed the additional advantages of being lightweight and of a more convenient size.

The earl of Cork and Orrery, upon arriving in Italy in 1754, noted that at the Palazzo Reale at Turin "amidst all these exquisite decorations not one effeminate toy, not one Chinese dragon, nor Indian monster is to be seen; I mention this because many of our finest houses in England are disgraced by the fantastic figures with which they are crowded."[20] The earl spoke too quickly; Italy was just as enthusiastic for the products of the Orient as her neighbors were. Augustus the Strong had been in Venice in 1716, where he was entranced by the spell of gondolas, carnivals, processions, and musicians. The classicism of Rome had long passed, and the baroque was now being succeeded by the excesses of the rococo. The earl was to find, right in the Palazzo Reale, a magnificent lacquer room designed by the baroque architect Filippo Juvarra (1678–1736), architect for the duke of Savoy. The room is decorated with sixty pieces of Oriental lacquer bought in Rome in 1732 on Juvarra's advice and augmented by a number of similar panels japanned at Turin. The panels have a black ground colored with red, blue, and gold Chinese motifs set within rococo scrolls on a vermilion wall.[21]

At the Reale Palazzina di Caccia at Stupinigi is a splendid Italian chinoiserie screen dating from the last quarter of the eighteenth century. The framework rivals the decoration in its splendor and craftsmanship. There are four panels, each of which contains two scenes within an ornate gold frame. The entire frame is carved and gilded, and at the top of each panel is a carved decorative element. The panels contain beautifully painted scenes with Chinese pavilions and pagodas, people, and trees painted on satin. The influence of the French upon the artists and craftsmen of the Piedmont is evident in this example.

"Nowhere, outside of France, was the chinoiserie

style treated in a more enchanting manner than in Italy, providing the rococo designs with endless entertaining motifs. In Venice, the vogue was fully established between 1710 and 1730, and temples, grottos, and little Chinese figures began to appear on cabinets, tables, chairs, screens and other household articles. Artists began to specialize in this mode, and in 1725 in a Venetian register appears a craftsman classified 'depintor alla Chinese.' "[22]

The cabinets and screens were frequently decorated with lacquer and raised figures but more often were painted in a wealth of light, gay colors. A splendid example was a screen that was, regrettably, destroyed in World War II but that was earlier at the Museo Civico in Milan. There remains a description of panels with medallions containing baskets of flowers in the Chinese taste. The screen, painted in peacock blue, green, lemon yellow, and red-violet, produced such a harmony of color that it was judged to be "one of the finest Venetian products of the eighteenth century."[23]

One of the earliest personal notes of Chinese furniture seems to have been made by the duchesse de Montpensier, "La Grande Mademoiselle" (1627–1693), who visited Cardinal Mazarin in 1658 and reported that he was a passionate collector.[24] The first official record appears in *Le Journal du Garde-Meuble de la Coronne* (The Journal of Records, Royal Furniture), which notes that in 1662 Anne of Austria had two large Chinese screens of twelve leaves each, with leather on one side and green satin on the other. From our present-day perspective, this combination of leather and satin seems incompatible, but it appears repeatedly

in screens dating from early times. Few such screens have survived, but one was advertised at the Grosvenor House Antique Fair in London in 1935 as a "4-fold leather in Chinese manner with birds in a flower landscape on gold background. Reverse panels covered with original painted silk."[25] While it is very questionable whether this was the original silk, it is reasonable to assume that any screen of quality would have been finished on the back side with a material such as silk, linen, or paper. Close inspection of the reverse side usually shows the small tack holes, evidence of a back covering that has perished.

Another early entry, made before June 20, 1666, is for an eight-leaf Chinese screen, sparingly described as having gold on one side with animals and plants, the other side being covered with black and white *papiers peints.*

This sudden influx of Oriental imports and French interest in the East had a commercial basis. Up to the last quarter of the seventeenth century the Spanish and Portuguese had successfully kept France out of the China trade, and the Dutch kept her from trading with the Indies. However, by this time France, through Colbert's influence, had established routes for the Compagnie des Indies, and goods from the Orient were pouring in by way of Siam. The inventories mention numerous paravents, yet "not a single example of these chinoiseries is known to survive. To account for their disappearance is a little difficult, for it can hardly be supposed that all the *façon de la Chine* furniture and textiles in all the royal palaces was destroyed by accident, burnt during the Revolution, or sacrificed to subsequent changes in taste."[26] A suggested explanation is that the nature of

these was so restrained that they now pass unnoticed as chinoiseries. This does not seem like a wholly satisfactory explanation, but for want of a better one, it is offered.

While their disposition is in doubt, there can be no doubt as to their existence and abundance. There is a seeming paradox between the fervor with which Louis XIV embraced chinoiserie, with all its irregularities and exuberance, and the rigidity and formality of his own court. The paradox is more apparent than real because there was much in the Chinese court for Louis to endorse, such as its ancient civilization and art, its stability, and the supremacy of its emperor. The entertainments and gaiety expressed in the designs appealed greatly to the king, who could enjoy their spirit yet, due to their exotic nature, did not feel threatened by their spontaneity and lack of discipline.

In celebration of the flow of the trade, the ambassador of Siam paid two visits to the court of Louis XIV, each time laden with gifts. The second trip, in 1686, was the more important. The inventories show the gifts received. The king of Siam sent the king of France two Japanese lacquer screens of six leaves each. Other gifts from the ambassador included a silk screen that had a blue background with several birds and flowers in relief. One screen was described as being taller than the others and was of twelve leaves of Peking—presumably Coromandel—work. Another was of two large leaves *en forme de perspective,* in which there were all kinds of flowers on one side and all kinds of birds on the other.[27]

After the visit of the ambassador of Siam, the screen became so fashionable and its characters so well known that it spawned a fashionable saying. To describe an absurd person one could say, *"C'est un Chinois de paravent."*[28]

During 1667 to 1689 the inventory showed a twelve-leaf Chinese screen with a gold background and figures of birds and people, and in November 1673 a screen of six leaves, *façon de la Chine, papier peint,* and a screen of eight leaves of white satin embroidered with Chinese figures were added to the rolls.

The first voyage of the *Amphitrite,* the Compagnie's trading ship, had a cargo of 36 screens, *"395 feuilles de papier avec douze grands fleurs"* embroidered on Nanking silk, and 336 leaves of Canton embroidery. Whether these embroideries were to be used for screens or other purposes is uncertain, but the cargo seriously alarmed the French manufacturers and led them to seek protection from foreign competition. A second voyage of the *Amphitrite* in 1700 brought back 45 packing cases of screens.[29]

The 1708 inventory of Versailles mentions a suite of twenty Chinese screens. These were of gauze, lacquer, wallpaper, raised embroidery on white satin, or Coromandel lacquer in shades of green, blue, red, and gold. Some had gold paper, others Indian fabric or a material striped like the bark of a tree. H. Belevitch-Stankevitch, who supplied much of this information in *Le Goût Chinois en France* (published in 1910), said at the time that it was impossible to know where any of the above were or to specifically identify them. The value of the inventories lies in their

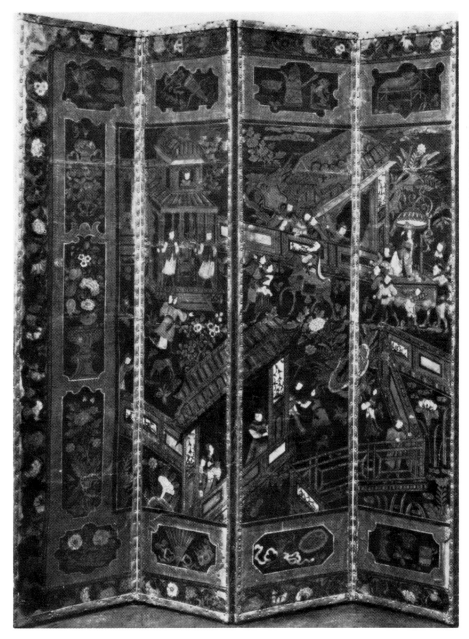

Polychrome leather screen signed ''Coventry, London,'' formerly at Schloss Wilhelmshöhe, Kassel. English, mid-eighteenth century. Photograph courtesy Hans Huth, *Lacquer of the West,* University of Chicago Press.

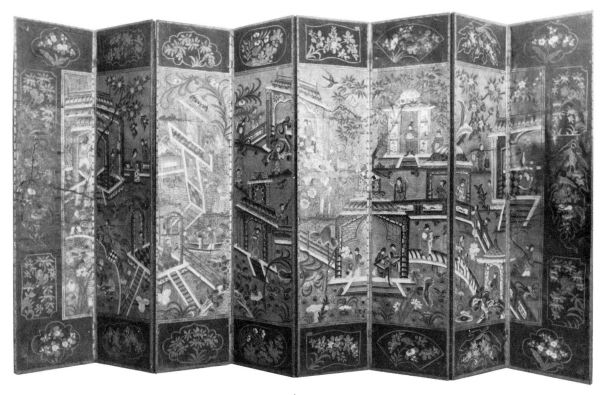

Eight-fold screen with chinoiserie scenes painted on a hand-tooled ground. English or Dutch, first half of the eighteenth century. Deutsches Ledermuseum, Offenbach-am-Main.

disclosure of the varieties of materials used and their combinations.

One screen in the collection was identified as of European origin because of its subject matter and materials. It was an eight-panel screen, painted on fabric, with designs representing birds, people, and a Chinese fete; at the top of each leaf was an illustration of a fable surrounded by festoons of flowers. Below each fable was a painting of a city surrounded by cartouches. The back was of green velvet with gold braid. A final description, from the inventory of 1681, is of a screen painted on one side with themes taken from the *Metamorphoses* of Ovid, and several figures in grisaille on the other side.[30] Certainly, the missionaries in the Orient had engravings of classical and mythological subjects with which to instruct the Chinese, but the figures in

grisaille would indicate the screen's fabrication in France. It is indeed frustrating that although the inventories provide so much information, no visual or tangible evidence of these screens survives.

Paris was a center for lacquerwork in the eighteenth century, with one of the most important families of lacquer craftsmen located there. In the same way that Dagly and Schnell were the leading lacquerers in Germany and the Low Countries, the Martin family held the undisputed title of French masters. Robert Martin was the most famous, although he had four brothers who worked with him. They and their workshop enjoyed a virtual monopoly. Martin took out a patent in 1744 for japanning *"en relief dans le goût de Japon et de la Chine"* and in 1753 received a patent on *vernis Martin*, his own formula for lacquer. This was to become so famous that the term

Panel by Christophe Huet. Detail of "La Toilette," Salon des Singes, Musée Condé, Chantilly. Photograph by Giraudon.

became synonymous with lacquer. Madame de Pompadour was a patron of Robert Martin's and gave him a large order for her palace at Bellevue. After the death of Frederick, Jacques Dagly, brother of Gérard, went to Paris and worked with the Martins. Voltaire expressed his delight in *vernis Martin* with the lines:

*Et les cabinets ôu Martin*
*A surpassé l'art de la Chine.*[31]

The vogue for lacquer paneling seems to have survived only until the 1730s. After that date it was the fashion to have painted decorations.[32]

The style of chinoiserie changed over the decades. By the early years of the eighteenth century European artists no longer tried to imitate the Chinese strictly. They began to paint *façon de Chine*, or *à la Chine*, using Western imagination and fantasy in adapting Oriental objects. Following this period the ultimate chinoiserie emerged. This was a stage in which fantasy had diverged so far from reality that the images made no pretense of existence. They created fairylands of gardens, graceful pavilions, pagodas, parasols, and fishermen pursuing idyllic lives. Sometimes the artist painted the Chinese figures in a Western-style landscape and in European poses, making use of arabesques, shells, and cartouches, and of the curious invention called "singeries," in which figures of monkeys dressed as people play human roles in society. As respect for Chinese culture and decoration began to diminish after 1700, Europeans began to paint these monkeys in colorful costumes and fanciful, exotic, or comic poses, sometimes replacing the Chinese man or frolicking with him.

The chinoiserie style attracted some of the most esteemed artists of the day, who altered painting in this mode with a distinctly French style. Painted panels began to replace the lacquer boards that had decorated walls of the noble houses and pleasure palaces. Jean Pillement painted numerous *panneaux chinois* and Christophe Huet decorated the *grand* and

*petit salons* at the Château de Chantilly with singeries. A detail of a paravent attributed to Huet shows a monkey posing as a teacher while the cat and fellow monkey prepare their lessons. A panel he painted for the same château shows a female monkey being attended by her maids as she primps before her mirror. A large screen, decorated with chinoiserie motifs, forms the background of this panel.[33]

A beautiful Savonnerie screen (c. 1740) is in The J. Paul Getty Museum in Malibu in California. The four panels are designs by the painter Alexandre-François Desportes (1661–1743), who brought a new style into French art with his painting of animals and the hunt. The colors are vivid blues, greens, and cream against a gold background. The monkeys sit on a rail, surrounded by rabbits, fruits, and birds. On alternating panels are parrots, fowl, and flowers. Another screen, in the Waddesdon Collection assembled by Baron Ferdinand de Rothschild, is painted canvas with both sides covered with singeries, the birds and animals placed in sylvan settings. Once more monkeys are occupied with their musical instruments—drums, bagpipes, and violin—while one dressed in the latest fashion is playing with a doll or marionette. These paintings predate the carved gilt nineteenth-century walnut frame in which they were later placed. In all probability the canvases are the same ones that made up a screen of like description that was sold in 1769. The panels were slightly reduced to fit into the curved frame.[34]

As the century progressed, chinoiserie decoration with its many fanciful forms pervaded almost all decorative items, and its influence was felt in writing and conversation. Alexander Pope rhymed:

> One speaks the glory of the English Queen,
> And describes a charming Indian screen.[35]

About the middle of the century the saturation point was reached. Satirists mocked the fascination with the Orient and writers such as Lord Shaftesbury spoke out against the denial of the classical sense of order and beauty. Joseph Warton, in sympathy with Shaftesbury, wrote, "What shall we say of the taste and judgment of those who spend their lives and their fortunes in collecting pieces, where neither perspective nor proportion, nor conformity to nature are observed; I mean the extravagant lovers and purchasers of CHINA and INDIAN screens. I saw a sensible foreigner astonished at a late auction, with the exorbitant prices given for these SPLENDID DEFORMITIES, as he called them, while an exquisite painting of Guido passed unnoticed, and was set aside as unfashionable lumber. Happy should I think myself to be able to convince the fair connoisseur ... that no genuine beauty is to be found in whimsical and grotesque figures, the monstrous offspring of wild imagination, undirected by nature and truth."[36]

During the latter half of the century, chinoiserie would have to compete with the Gothic Revival and neoclassical styles that would gently but firmly push it aside. The Orient and the rest of the world could enjoy a respite of about one hundred years, until, with the reopening of Japan, there would be a vigorous revival of interest in the East.

**S**ingerie motifs decorate a screen, circa 1760, attributed to Alexis Peyrotte. Collection Baron Ferdinand de Rothschild, Waddesdon Manor. Photograph courtesy The National Trust.

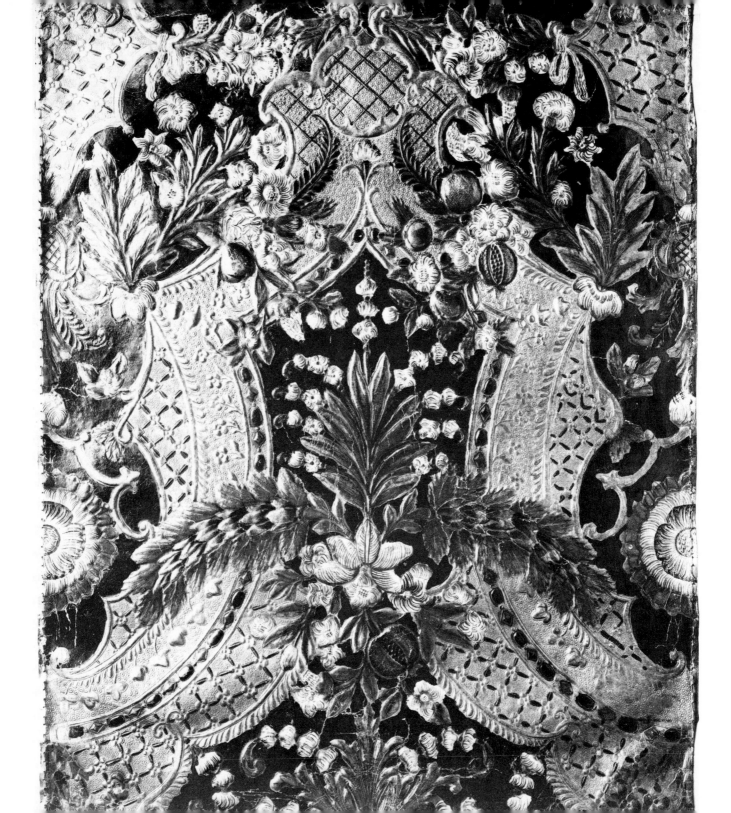

# 3. "In the Newest and Genteelest Taste"

**N**ot all heads had been turned by the Oriental influence. Even though it was of extreme importance, other decorative styles had been developing from Western origins. While some were fascinated by and imitative of a fanciful world, architecture, tradition, and the realities of a cold world were contributing to the development of the screen in Europe.

The basic form of the folding screen indisputably comes from the East, but the idea did not emerge in the West fresh from the sea. For centuries prior to its importation, Europeans had been contriving devices to perform the same functions as a screen, seeking privacy and the formation of intimate space in rooms that were often cavernous and too cold and drafty to be vividly imagined in the twentieth century. While the forms of these devices were gradually altered and eventually evolved into folding screens, the basic concept goes back to medieval times, and recognition of these antecedents must be made.

The earliest references to screens in England are to the ecclesiastical screens and the architectural screens found in the great medieval halls. During the Middle Ages the immense hall dominated the manor house, reflecting the power, wealth, and prestige of the owner. In this space the lord of the manor entertained lavishly by holding festive celebrations that lasted several days, during which hundreds of guests of all ranks would be served. The lord and his most distinguished guests sat on an elevated dais that indicated his position and enabled him to be viewed by his household and guests. Facing him on the opposite wall was an architectural screen with three arches. The two side arches led to the pantry and the buttery, while the larger one in the middle led, via a long corridor, to the kitchen. The arches performed a ceremonial as well as a practical function because the center one formed a triumphal arch through which the procession carrying the lord's food emerged, sometimes accompanied by the sound of trumpets. "Later on in the Middle Ages, however (but seldom before the fifteenth century), the arches began to be concealed from the rest of the hall by wooden screens. Screens were originally designed to exclude the draught from the kitchen passage and from the entrance door, which usually opened straight onto the courtyard from the kitchen end of the hall. The earliest screens were moveable, but they soon became fixed and took over the function of the arches as a triumphal entry."[1]

A detail from a domestic oak screen from an old manor house of circa 1500 shows a nine-panel linenfold section. Although this is a stationary panel, the linenfold served as a pattern for later folding screens that were created with many variations of this motif. The architectural screen, with its arches and panels, was to disappear as dining habits and the function of spaces changed, and the desire for privacy and separation from servants increased. Yet today, in our radically simplified and informal houses, the most common placement for a screen is still in the dining room, shielding from view a kitchen that may be reduced in staff to a lone servant or that possibly even is vacant.

Increasingly during the fifteenth century, artists placed their subjects against secular backgrounds that

revealed interiors and their furnishings. Perhaps the earliest painting to show a screen is *The Virgin and Child,* which was painted before 1430 by the Flemish artist Robert Campin (c. 1378-1444).[2] The Virgin is seated in front of a circular fire screen made of wicker. At first glance it appears to be a halo because she is placed directly in front of it, but closer inspection confirms it to be an object of woven material. One of the most famous of all Flemish paintings is Jan Van Eyck's *Jean Arnolfini and His Wife,* painted in 1434. Here the figures are painted "as rigid as wax statues . . . in harmony with the immobile life of the things surrounding them . . . ,"[3] such as the bed, the brass lamps, the coffer under the windows, and the carved Gothic wooden screen in the background. The details of the screen are too limited to make the scene very explicit.

Inventories, usually taken upon the death of the householder, provide an excellent documentary source for the existence of screens, but, regrettably, the listing usually lacks description of form, dimensions, materials, and decoration. One of the earliest inventories of a great English house is that of Hardwick Hall, built by Elizabeth, countess of Shrewsbury (1520-1608), better known as Bess of Hardwick. Bess's marital career was chronicled by the following epitaph, composed by Horace Walpole:

> Four times the nuptial bed she warm'd,
> And every time so well perform'd,
> That when death spoiled each husband's billing,
> He left the widow every shilling.
> Fond was the dame, but not dejected,

> Five stately mansions she erected
> With more than royal pomp to vary,
> The prison of her captive Mary.[4]

Because of her extraordinary longevity and her marital and material bounty, the inventory made at her death is very helpful. It discloses that Bess's withdrawing room was hung with tapestry to help keep out the cold from the walls and that the curtains were made of darnix, described as "warm material." Part of the room could be divided by a "Travice like a skreyne covered with violet Colored Cloth layde about with black lace."[5] The screen's chief function was to reduce drafts and conserve heat, the gravity of this concern confirmed by the exceptional number of hangings, covers, and blankets to be found in the room.

To understand the contents of the withdrawing chamber, some familiarity with the functioning of the house is necessary. The word "withdraught" first appeared as a term for any small room leading off from a chamber—scarcely more than a closet in some cases. In 1496 there was one at Charlecote between the great chamber and the owner's own chamber, containing little more than an old bed, a mattress, and blankets, that was occupied by the servants of whoever was in the adjoining chamber. During the sixteenth century the withdrawing chambers gradually took over some of the functions of the chambers, becoming private sitting, eating, and reception rooms.[6]

The inventory of Hardwick shows that the withdrawing room was richly appointed but

somewhat cluttered. Lady Shrewsbury's bedchamber (a term that became common in the mid-sixteenth century) had a "wicker skreyne," as did several other rooms; these were presumably fire screens, since they were listed with the fireplace equipment. In the gallery were many tapestries and hangings and "a skreyne, a Cloth for the skreyne of Crimson velvet with a brode perchment lace of golde through the middest and rownde about and with a golde frenge about lyned with Crimson taffetie sarcenet." In the best bedchamber was a "skreyne with a cover for it of Carnation velvet imbroidred with golde and a golde frenge."[7] In the eighteenth century, when Walpole made his *Visits to Country Seats,* he noted that the great apartment as it was furnished for the Queen of Scots had "Screens like Stands to brush Cloaths, with long piece of Carnation velvet hanging over them, fringed with gold; the velvet now yellow." He added that the house had "vast rooms, no taste."[8] Some of the above were probably of the folding variety, since the Hengrave inventory of 1603 lists "one great foulding skrene of seaven foulds."[9]

Among the goods, cattle, and chattels of the countess of Leicester that were inventoried in 1634 is an "embroydred skreene gould lace."[10] Other inventories of the period are merely repetitive, offering little more information than that they existed.

The goods of Charles I were catalogued before their dispersal, and due to the quantity of his possessions, they were listed in greater detail for clearer identification. Some of these are made of more regal materials, one being of silver lined with flame-colored taffeta trimmed with gold, silver, and lace, while another is lined with orange-colored taffeta fringed with gold and silk. A particularly splendid one had green silk stars on a silver ground trimmed with silver lace, silver and green silk fringe, and a green taffeta lining. In all cases, those listed as screen cloths have the unexpected dimensions of 3¼ by 1½ yards and presumably were unmounted. Another room contained four old screen frames, but the inventory does not indicate if their size could accommodate the long cloths. A white satin screen embroidered with gold and silver, as well as with the colors of England and Scotland wrought in a circle with the arms of the Knights of the Garter, brought £5 when sold.[11]

Ham House contained a number of screens by 1683, but the majority of these were Japan screens. There is an occasional mention of "grey cloth," or buckram, or of an elegant fire screen crafted of silver, or of the ever-present humble wicker screen. The perusal of inventories from after the middle of the seventeenth century is unnecessary, as screens proliferated and a whole new trade prospered, and many of these screens were recorded in detail or are still in existence.

In France the precursor of the screen went by several names—the *clotet,* the *éperon,* the *ote-vent,* and the *ruelle.* Viollet-le-Duc, writing in his *Dictionnaire Raisonné du Mobilier Français,* describes *éperons* dating from the thirteenth century. They consisted of partial drums stationed inside an interior door and were composed of two curved parts plus a ceiling. A curtain positioned above fell in front of the opening. A different version was the *escrinia,* or *écran*—what we

Scenes of hunting, cock-fighting, cardplaying, horseback riding, game shooting, dice throwing, fishing, and bathing are shown in details of an English screen dated 1746. Victoria and Albert Museum.

now call a fire screen. The *escrinia* appears to have been wooden guards mounted on the side of the doorpost. The dictionary further explains, or confuses, by stating that the paravents were sometimes wallpaper hangings suspended from the ceiling and were pulled across the room by means of poles, rings, and cords. The screen composed of leaves, similar to present-day ones, was developed at a later date. Viollet-le-Duc reports that Louis XI mentioned an old *ote-vent* that stood in his room, which establishes it as having existed by the mid-fifteenth century, and that it formed some type of enclosure.[12] The *ruelle* (literally a "lane" or "alley") was another type of enclosure. This was the space between the bed and the adjacent wall; it was made into a small compartment by pulling a curtain across the open end.

This area, designated for special functions, had been in use since the fifteenth century. Its development came about partly as a result of the cold French winters, with the accompanying need for a small draft-free enclosed area, and from the necessity of having an escape from the public functions of the bedchamber. In the homes of the nobility, the bedrooms served as centers of activity, where the occupants slept and ate and also received visitors. The bedroom was a very public space, made vivid by accounts of the king's levees at Versailles. In the seventeenth century the nobility spent a great deal of time in bed, partially because that was the warmest spot in the house. Since so much activity took place in the bedchamber, the *ruelle* became the area for the most private and privileged exchanges. It was large enough for seats and benches, and in function was the

French equivalent of the English withdrawing chamber. Various reports of intimate scenes occurring in this space have been recorded: Louis XIII played in the *ruelle* of his mother; Mazarin and La Grande Mademoiselle exchanged confidences in such a space; Louis XIV retired to his for prayer; Madame de Maintenon used hers for dining; Catherine de Vivonne, marquise de Rambouillet (1588–1665), describes receiving guests in her *ruelle*.[13] These enclosures were pieces of furniture made by a *menuisier* (a carpenter or cabinetmaker) with doors that were hinged or made of tapestry mounted on a frame. Some idea of how this may have looked is supplied by an engraving entitled *The Blood-Letting*, by Abraham Bosse (1602–1676), who was famed for his accurate and detailed engravings of seventeenth-century bourgeois life. In the background is a screenlike enclosure with one section hinged, forming a sort of door, while borders and matching perpendiculars suggest other panels.

Some of the earliest accounts of the leaved screen include the note that Madame de Rambouillet is credited by one authority on French furniture as having been the originator of her country's screen by using one in her blue chamber, site of her famous salon, and that the marquis d'Effiat (1581–1632) had one composed of six leaves that were covered in velvet and silk; this latter screen is housed today at the Musée de Cluny in Paris. Mazarin possessed at least two crimson screens, one mounted on a beechwood frame and the other of serge decorated with silver braid.[14]

The art of decorating leather to be used for wall

hangings goes back at least to the fourteenth century. The earliest reference to gilt hangings appears in a 1380 inventory of Charles V of France, and the earliest surviving specimen dates from the fifteenth century.[15] Several stages of development and refinement separate these early hangings from the magnificently patterned gilded and painted hangings that were mounted on frames and adorned seventeenth-century walls. Since medieval times, the naturally white-skinned sheep had been highly esteemed for use in hangings, seat and bed coverings, and cushions. After proper preparation the skins provided a soft, smooth surface that was then covered with gold or silver foil and varnished. The varnished foil provided a protective coating and a better foundation for the layer of paint. Following the surface preparation, the design was superimposed. In the fourteenth century the motifs had a Moorish character, reflecting the Libyan origin of ornamented leather. Sometimes the leather was distressed by small holes punched all over the surface, with the resulting uneven texture causing the leather to glitter and reflect light—a highly desirable effect in the dimly lit interiors. The early leathers were stamped by hand in a slow, laborious process. This technique was replaced by the use of heated plates set in a screw press in order to produce a low relief with sharp detail, but this method had the disadvantage of requiring both heat and pressure. In the seventeenth century the embossing was done on moistened leather pressed between wooden molds. This raised a much bolder relief, which was further articulated by paint. During the seventeenth and eighteenth centuries the amount

of paint used was increased to such an extent that the entire surface might be colored with an oil glaze that only allowed the gilt to "bleed" through, giving the leather a dazzling effect. The art of leather gilding spread from Spain to Italy and then to the Netherlands, which dominated the field by 1600.

Unfortunately, it is very difficult to determine the date or provenance of any specific gilt hanging or screen because there was not a steady stylistic progression. During later years the earlier techniques might be reemployed to achieve a particularly desired effect. Nor is the technique of painting a reliable indication of origin. Both Flemish and Spanish hangings have been found to be similar to Dutch still lifes in their veining of foliage and sensitive shading of fruits and flowers. The craftsmen left their work unsigned, and in his study of the subject John Waterer stated that of the hundreds of hangings he had inspected, only one bore a date, 1681. In the Leathercraft Museum is a four-fold screen that is probably of eighteenth-century Spanish leather, which was done in coppery gilt on a chestnut ground and includes scrollwork, quadrilateral ornamentation, flowers, and fruit. Even here identification by the expert in the field can only be tentative because there are known to be four different plates of this design, which means that its origin might be French or Dutch, Spanish or English.[16]

During the early years of the seventeenth century the craft spread to England, and the London Leather Gilders membership shows Buckett and Paul Dickinson, Philip Onslow, and Christopher Hunt established there by 1640.[17] By 1700 the ranks had

multiplied, as had the services they offered. Joseph Fletcher advertised in 1712 as a "Leather gilder to His Majesty" who made "all sorts of hangings for Rooms and Stair-Cases, Settees, and Screens of newest fashion."[18] Thomas Bromwich of the Golden Lyon proclaimed that he made and sold "all manner of Screens, Window Blinds, and Covers for Tables, Rooms, Cabins, Stair-Cases etc. Hung with Guilt Leather, or India Pictures, Chints, Callicoes, Cottons, Needlework and Damask Matched in Paper to the utmost exactness, at Reasonable Rates," although Horace Walpole and Mrs. Powys considered his prices very dear.[19] St. Paul's Courtyard was the center of the trade, and there could also be found William Barbaroux, "maker of all sorts of Gilt leather, and screens in the newest and Genteelest taste," John Conway, Robert Holford, and John Hutton, who "makes and sells all sorts of Gilt Leather . . . screens, with a variety of right Indian screens."[20] Many others had shops in the Courtyard, Ludgate Hill, or Cheapside, vying for their share in a lively trade. These advertisements not only show the interrelation of leather hanging, leather screens, and paper screens but also reveal how widespread the manufacture of European screens had become by the beginning of the eighteenth century.

Toward the end of the century, wallpaper hanging and screenmaking again became interrelated. At that time there arose a fad for paneled wallpaper, which in turn necessitated moldings or borders of some type. Thomas Rowlandson (1756–1827), the noted British caricaturist, engraved a set of vertical borders that consisted of a succession of entirely unrelated caricatures. Under each was a caption or quotation. These sketches were colored with Rowlandson's typical pale blue and pink washes. The entire set consisted of twenty-four sheets, with three rows to a sheet. They were published by R. Ackermann in 1800 under the title *Grotesque Borders for Screens, Billiard Rooms, Dressing Rooms etc. etc., Forming a caricature Assemblage of Oddities, Whimsicalities and Extravaganzas. With appropriate labels to the Principle Figures.*[21]

*The British Museum Catalogue of Political and Personal Satires* contains an engraving with the caption "A True Picture of the Famous SKREEN describe'd in the Lond[n] Journ, March 11, 1721." The engraving shows a screen placed across the middle of a handsomely furnished room. In a mirror are reflected three gentlemen concealed by the screen, which partially hides a lady, standing under a map of Antwerp, on the right. The concealed figures were some of those implicated in the South Sea Bubble, a scandal that touched some personalities at the highest levels of government and society, who were accused of receiving large bribes. The writings and drawings on the eight segments of the screen, as well as the map of Antwerp, are allusions to the causes and consequences of the South Sea Bubble. The screen is described as follows: "A Famous Screen now to be Sold to the best Bidder. Whereas it is Maliciously reported that the said Screen is something the worse for wearing; This is to satisfie those who have occasion to buy it, that tho it can't be deny'd, but it has been much us'd, yet for Strength and Goodness is not to be match'd, being inlayd with the purest impenetrable Metal . . .

It commodiously contracts and opens as Occasions offer, and . . . represents divers Antique and Modern Rarities."[22]

The stamped-leather fashion lost its importance in early-eighteenth-century England and was succeeded by a vogue for ornaments painted on leather or canvas. These paintings usually reflected the style, taste, or surroundings of the person commissioning the screen or of its prospective buyer. A four-panel screen dated 1746 and painted on both sides presents eight vignettes of the sports and pleasures of an English country gentleman. The painting has the primitive quality of the work of an untrained artist, which gives great charm to the details of game hunting, fishing, and dice throwing. The cockfighting episode is particularly interesting, showing "F. Wren Esqr 4" victorious over "R. Brandling Esqr 2, Mr. Bates 3, and Mr. Dunn 1." Perhaps the fifth and most vigorous of all the cocks represents the artist, because in the painting the date and maker are inscribed near this bird. Another primitive screen of the same period is painted on wood with panels enclosed in marbleized frames. In the top half of each panel is a female figure in fashionable dress; three of them hold flowers or fruits that suggest the seasons, while the fourth lady stands more warmly dressed beside a tree stripped bare by winter. In the winter scene, skaters skim over the frozen stream, while the panels representing more productive seasons show fields under cultivation or harvest. Richard Roper, a minor sporting artist, painted a six-leaved screen for John Knox of Castle Rea, high sheriff of Sligo. The screen bears the painter's name and the date 1759. Knox is represented in several of the panels, which are in part derived from the series of large hunting scenes painted by John Wootton (1688–1765) for the hall of Longleat, Wiltshire, one of England's great country houses. The spandrels of the arched headings are carved with rococo ornaments, and the framework is painted in olive-green parcel gilt. On the reverse are eighteen oil sketches of racehorses, which are uniform in size, and the frames, more elaborate than those in front, are colored in red and gold.[23]

The English love of the countryside and its inhabitants was the inspiration for screens of all levels of sophistication. A painted leather screen with trees and fowl is a poor country cousin in comparison with the Savonnerie screen of similar subject matter. In the English screen the sections of leather are rather crudely overlapped and the edges left plain, unadorned with garlands or cartouches. Whatever it may lack in terms of refinement of detail and elegant materials is more than compensated for by its freshness, originality, and vitality.

The English also had a fondness for painted screens displaying pastoral subjects of a more refined nature, with the themes copied or adapted from paintings by Antoine Watteau (1684–1721) and Nicolas Lancret (1690–1743). A very tall screen, nearly eight feet high, is an adaptation from Watteau's *Scenes Champêtre*. Among the recognizable paintings are *The Shepherdess, Boy with Birdcage, Gilles and His Family, Groups of Lovers, Milk Maids with Cattle,* and the *Country Dance.* Altogether there are twenty scenes painted on five panels, and the screen is dated

1739.[24] Another screen of the mid-century has eighteen pastoral scenes adapted from Lancret and other artists who worked in a similar style. The two English screens are painted in much the same manner, three or four scenes on a panel, and the plain rectangular panels are edged with a leather strip secured with brass nailheads. They form an interesting contrast to a French screen painted with adaptations of *Les Quatre Heures du Jour* by Lancret.

The French screen is much more elegant, with the four paintings set in shaped gilt panels. The scenes are titled "Le Matin," "Le Midi," "L'Apres-Midi," and "Le Soir," each showing figures engaged in social activities appropriate to that time of day. This screen bears a very close relation to panels actually executed by Lancret in 1731 for a house that stood at the corner of the Place Vendôme.[25] In this superb salon, where Lancret decorated all the wall surfaces, the distinctive style of the trellises is so similar that there can be no doubt of the inspiration for the screen.

There is no evidence that Lancret actually painted screens, even though his style was widely imitated. However, the catalogue raisonné of Watteau's work does show that he actually executed a four-panel screen, which has been lost. No further description of it exists.[26]

In the Frick Collection in New York is a seven-panel screen attributed to Jacques de Lajoue, an associate of the Academy in Paris from 1721 to 1753. This same screen had been previously attributed to Lancret due to stylistic similarities. The panels alternate in wide and narrow widths, and are possibly an incomplete set of an original twelve representing the months. The predominant colors are blue, gray, pink, and reddish brown, with accent colors of stronger blue.[27]

Not all screens were produced by professional craftsmen or painters. Some were done in needlework, providing a challenge to a lady's creativity and skill. One of the most astonishing displays of talent coupled with patience is the six-panel needlework screen done by Julia, Lady Calverly, for Wallington in Northumberland. Arthur Young, writing in his *Northern Tour,* mentions "a needlework screen of tent stitch." It is dated 1727, and some of the scenes are based on engravings by Wenceslaus Hollar (1607–1677) that illustrated a 1693 edition of Vergil's *Georgics.* The complexity of the design and the skill of execution are extraordinary. Nor was this her only accomplishment. Prior to this time she had worked on ten long panels with a "tree of life" design that were destined to grace the walls of the "needlework room."[28] Macquoid's *Dictionary of English Furniture* illustrates an equally beautiful, if somewhat less distinctive, screen executed in cross-stitch. It is a large screen, 8½ by 9 feet, of four panels of floral design. The exquisite and minutely worked floral designs resemble Chinese wallpaper and are enclosed in cross-stitch borders that simulate carved and gilded frames. The lower part of the panels have fretted arabesques and stylized acanthus leaves laid on a plain red material.[29] It is interesting that the English retained the plain rectangular form of the cross-stitch frame instead of inserting the needlework in a carved gilt frame, as the French would most likely have done.

**A**daptations of *Les Quatre Heures du Jour,* by Nicolas Lancret, painted in oil on canvas, portray "Le Matin," "Le Midi," "L'Apres-Midi," and "Le Soir" on a French screen. First half of the eighteenth century. Victoria and Albert Museum.

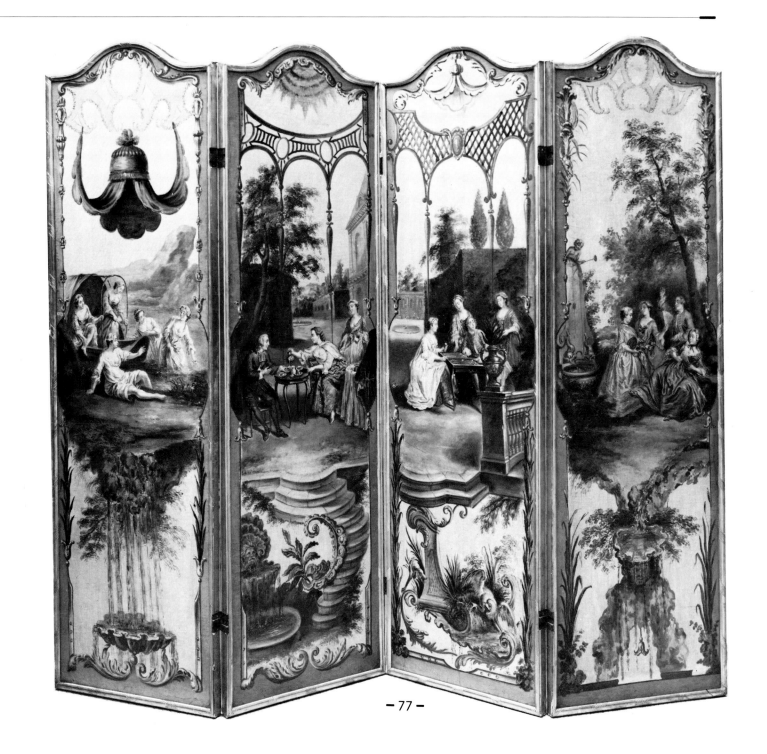

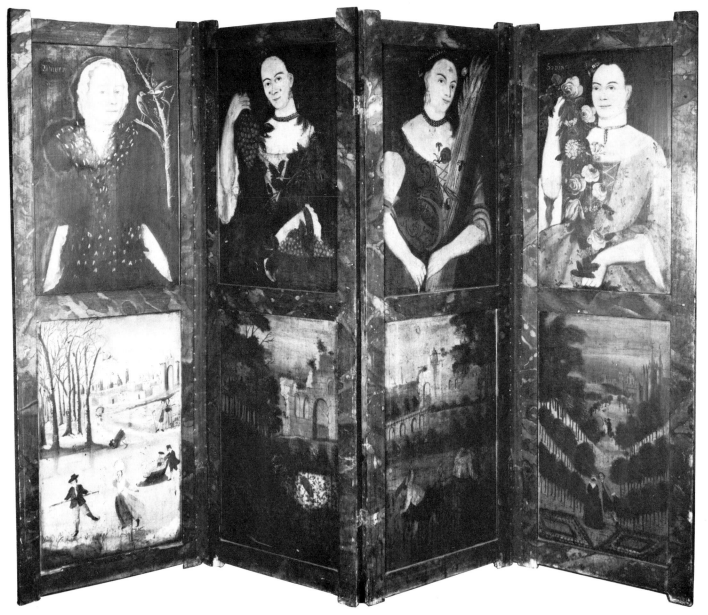

**F**emale figures represent the four seasons on a painted wooden screen. The eight segments are set within four marbleized frames. Scenes below the figures show appropriate seasonal activities. On the reverse, three panels are painted black and a harlequin figure occupies the fourth. Victoria and Albert Museum.

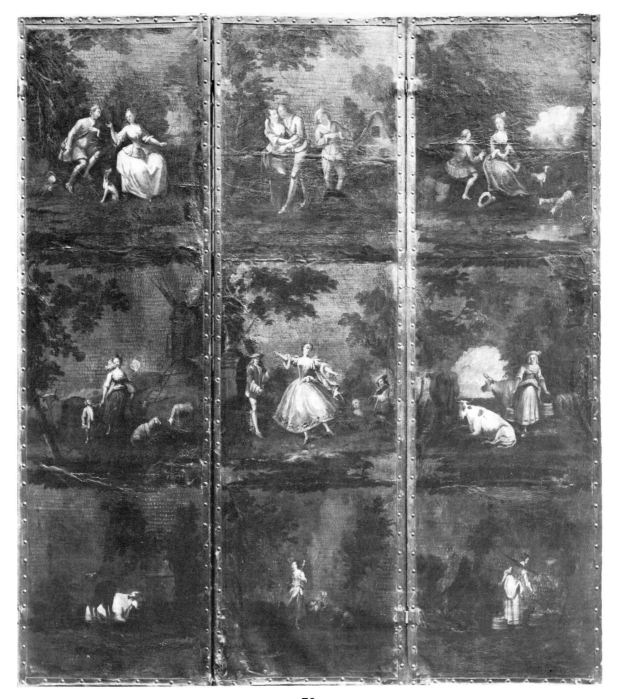

Part of an English six-fold leather screen. The pastoral scenes, painted in oil, are of subjects copied from pictures by Lancret and other French artists. Mid-eighteenth century. Victoria and Albert Museum.

The concept and use of the screen in France was quite different from what prevailed in England. Whereas the English screen was conceived as an independent, free-standing object, admired for its design, images, and color, the French thought of the screen more as a piece of furniture, very often part of a large suite designed for a specific chamber. It is tempting to make the oversimplified statement that the English screen reflected a more personal and individual taste, while the French screen was thought of as a part of a unified interior and that it therefore should not stand out as a focus of attention. The emerging popularity of the screen at the time of Louis XIV tended to make its style as it developed more formal and regimented than in the more relaxed, individualistic atmosphere of England.

Louis XIV took a keen and intelligent personal interest in the furnishings of the royal palaces, seeking innovation, formality, and, above all, perfection. It is known he had a passion for symmetry amounting almost to an obsession. He loved long symmetrical lines and receding vistas, and could not bear to have them interrupted by even a draft screen. Madame de Maintenon had no strong feeling for the maintenance of symmetry, but did, however, have an aversion to drafts. When the king was present she had to forego the comfort of a screen and, shivering with cold, protest that she would "die from symmetry."[30]

In order to understand the descriptions of fine French furniture one must know the definitions and distinctions between the various craft guilds, and the functions and limitations of each. The term *menuisier* refers to a carpenter or cabinetmaker who makes

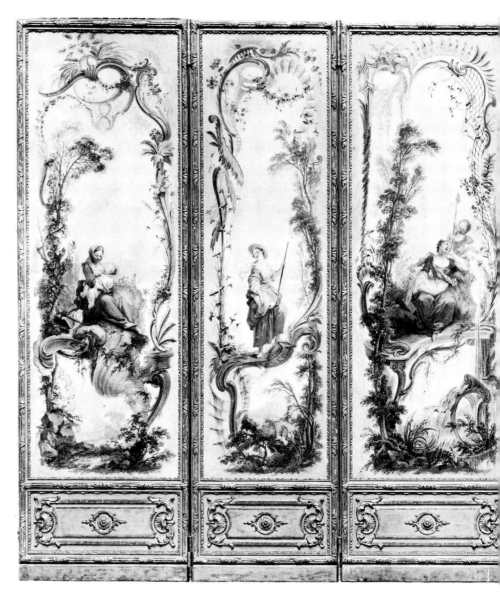

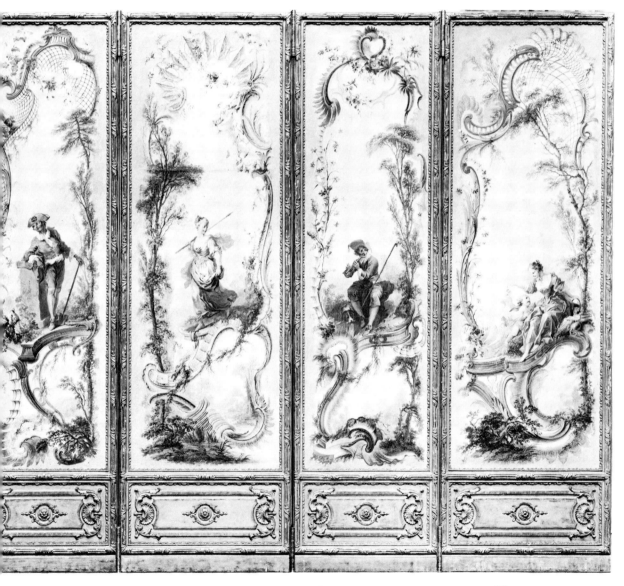

**S**even-fold French screen now attributed to Jacques de Lajoue but formerly to Lancret. Each panel depicts a popular pastoral theme such as "Shepherdess Asleep" or "Youth Playing Flute," all surrounded with fanlike trellises, canopies, or curving consoles. First half of the eighteenth century. Photograph © The Frick Collection, New York.

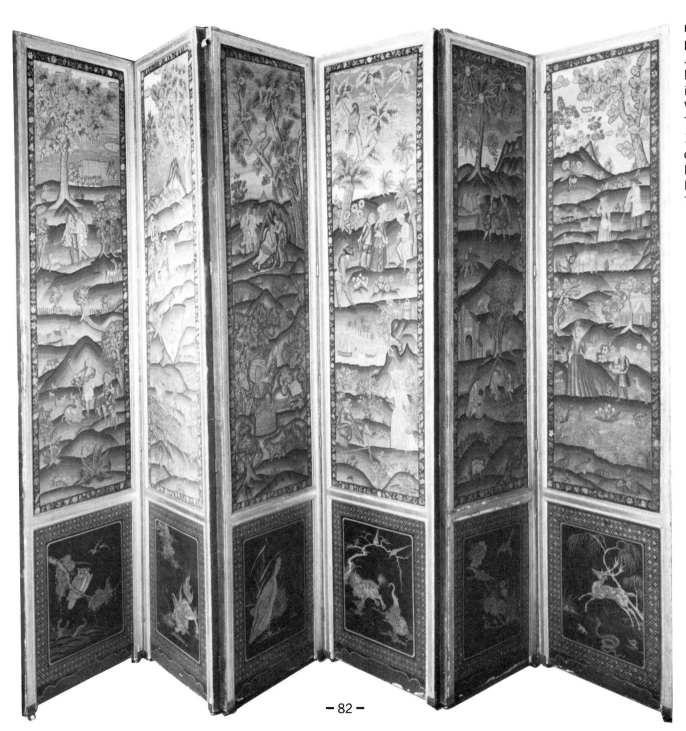

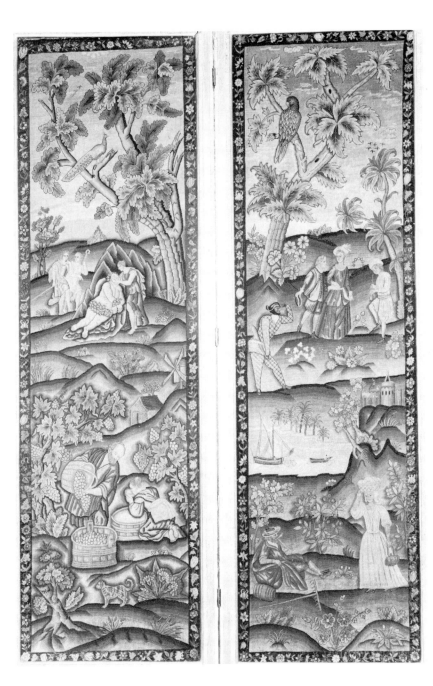

Details of
the screen on the
opposite page.
Photographs
courtesy The
National Trust.

carved furniture such as chairs, stools, screens, or side tables. In a relatively modest piece he would complete all the work himself. However, after the middle of the seventeenth century the *menuisier* was distinguished from the *ébéniste,* who did the veneering. The term is derived from the French word for "ebony," one of the earliest materials used for veneer. The *ébéniste* also did marquetry inlay and other elaborate ornamentation. Pieces destined for one of the royal châteaux often required the skills of other guilds, such as those of the sculptors, bronzeworkers, and gilders.

After a *menuisier* had assembled the frame, it might be completely covered with linen, moquette (a piled fabric), paper, Chinese paper, leather, silk, or tapestry. The choice of material was determined by the intended destination. Those meant for Versailles were frequently covered with the finest brocade, which was richly woven in a symmetrical, formal pattern. The factory at Lyons was in operation, and produced magnificent silks that were utilized as wall hangings and screens. The Savonnerie workshops made splendid tapestries that were used as rugs and also as upholstery material for stools, benches, and screens. Pierre Verlet says that these were almost always destined for anterooms or dining rooms and that their carcasses were extremely simple, intended to be completely hidden by the tapestry. Few of these Savonnerie pieces are on their original frames, though many have been preserved.[31]

Under Louis XV the style of the furniture and the contents of the rooms changed. The *meubles* (the term describes the whole complex of articles supplied by an upholsterer for one room, including curtains, wall hangings, alcove panels, chairs, bed, and screens) varied as the fashion changed and the desire for comfort increased. In 1737 Louis replaced some of the furnishings of the Petite Galerie and ordered the traditional pieces, but "alongside these items, . . . Louis XV accepted and sought the amenities of his century."[32] The number of folding screens increased, as did the number of fire screens filled with sliding panels that could be controlled by counterweights in order to adjust the heat from the fire.

A five-panel screen, once part of a larger screen by François Boucher, bears the fleurs-de-lis on the center panel, indicating that it probably was painted as a royal commission. The exact history of the screen is not known but the rococo decoration suggests that it was done about 1750. Boucher, a favorite of Madame de Pompadour and the court of Louis XV, was a master of voluptuous portraiture and decoration. He also did many tapestry designs and theater settings for plays and ballets. Boucher is equally well known for his intimate boudoir scenes. In one such painting, *La Toilette,* in the collection of Baron Thyssen-Bornemisza in Lugano, his subjects dress in front of a large gold screen bordered in red and decorated with finely detailed, brilliantly plumed birds and flowering trees.

Accounts of the royal châteaux list the items delivered to the royal apartment and provide a brief description. In 1755 two suites of furniture were delivered for the apartment of Louis XV's daughter, Madame Adelaide, at Versailles. The one for the bedroom was of the traditional type, with a bed ornamented with plumes of feathers at the corners of

**Center** panels of a four-panel English cross-stitch screen. Each panel has a different floral design. Needlework borders on the upper sections simulate carved wooden frames. The lower sections are covered with plain red material. Circa 1750. Photograph © The Hamlyn Group.

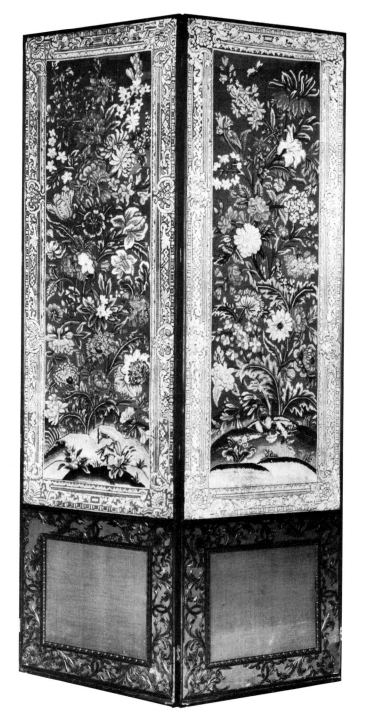

the canopy, two armchairs, twelve folding stools, a fire screen, a folding screen, and two door curtains. The other was for her private room and contained two small settees, a number of assorted chairs, a folding screen, and door and window curtains. At the very end of the reign of Louis XV types of furnishings became more diversified and less ceremonial. "In 1772 the upholsterer Capin delivered to la Comtesse Du Barry at Fontainebleau a suite of furniture of *gros de Tours* [a woven silk fabric, sometimes painted] that contained an enormous sofa, two easy chairs, two armchairs, with seat cushions, . . . the King's chair, a fire screen and a folding screen."[33]

The increasing number of *fauteuils* (armchairs) and the inclusion in the arrangements of both *courants* (circulating chairs) and *meublants* (chairs that were always placed against the wall) show the increasing concessions to comfort and greater informality. *Meublants* were carved to match the boiserie of the room, but the circulating chairs, which were meant to be arranged in a flexible manner, were more simply carved. As the chairs were rearranged to accommodate the guests or the occasion, so were the screens. Horace Walpole writes in his *Paris Journal* of 1765 that while he was dining in the elegant house of Monsieur La Borde, screens were placed around the dining table to keep the cold from the feet.[34] It is important to note the two different types of French screens and the function of each. Whereas the Oriental screens and Continental screens mentioned thus far have been tall, ranging from six to ten feet tall, the French developed a much shorter screen that was used to enclose seated guests in an intimate

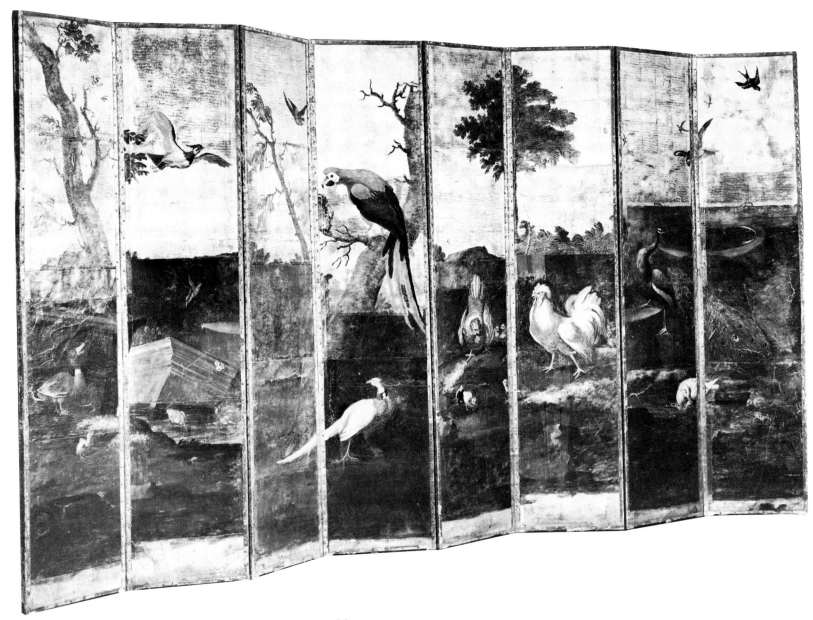

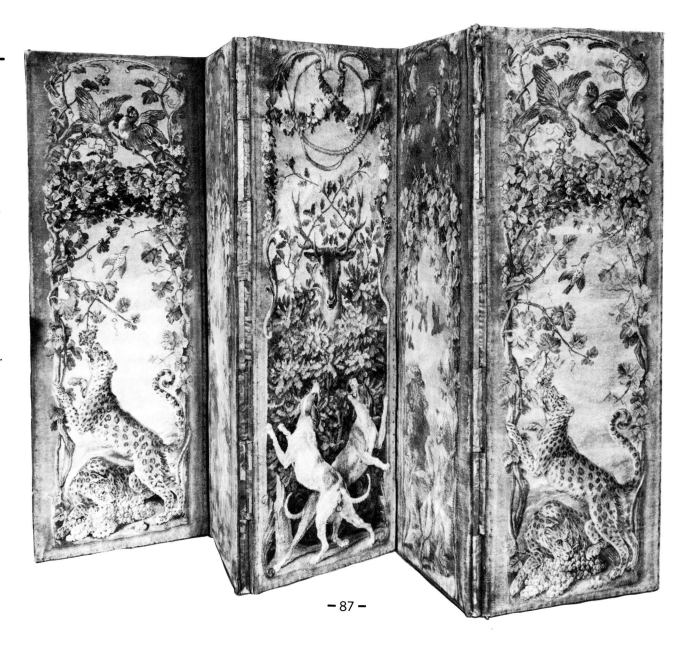

◄ **F**owl and exotic birds on an English or Dutch hand-punched and painted leather screen. First half of the eighteenth century. Dunster Castle, Somerset. Photograph courtesy The National Trust.

► *T*ales de la *Fontaine* are the subject of a Savonnerie screen, part of a suite of furniture made for Louis XV circa 1740. Musée du Louvre, Musées Nationaux.

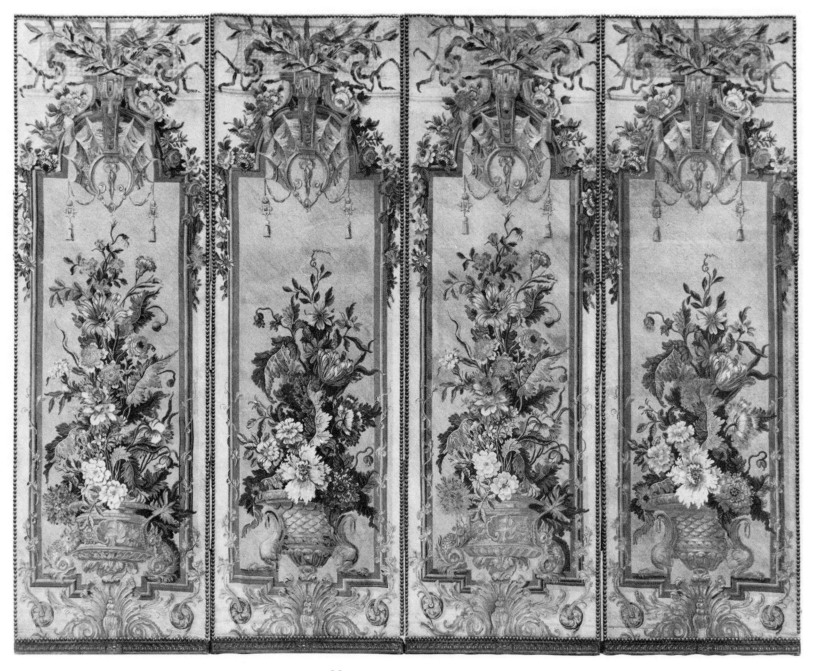

grouping and to protect them from the intense heat of the fire. At the same time they continued to make tall screens to ward off drafts and unsightly views. A photograph of an isolated French screen can be very deceptive; the viewer might assume the screen was meant to be taller than is the actual case, and that it is therefore ill-proportioned and too squat.

The style of a Louis XV screen reflected the rococo influence in the same way other upholstered furniture did. The rigid symmetrical patterns of Louis XIV gave way to scrolls, trellises, shells, acanthus leaves, ribands, and flowers that flowed in a much freer fashion. This applied equally to the frame and to the fabric that covered it. Regrettably, we must rely on sketches, reports, and reproductions of the fabrics, as almost nothing of the splendid products of the Lyon silk manufactories has survived. No scrap of fabric ordered by Louis XV has been found, while only a few of those designed for Louis XVI are known.[35] The Louvre displays a screen paneled with silk after Philippe de Lasalle, the leading Lyon silk designer and manufacturer. He was trained as a painter under Boucher, and his designs usually incorporate naturalistic birds and flowers. The less perishable fabrics have fared better, with a number of the tapestries surviving. In addition to the Savonnerie tapestries already discussed, mention should be made of the ensemble at the Louvre that was made for Louis XV, with chairs and folding screen covered with tapestry from that manufacturer. Screens were frequently covered with panels of Beauvais or Gobelin tapestry, or with the splendid tapestries made at Aubusson. At the Musée Nissim de Camondo in Paris

there is an Aubusson screen that is one of a pair that had formerly been in the Wallace Collection. The four leaves, divided in two by a horizontal traverse, display vases of flowers finely woven on light ground within foliate borders and a blue surround.

Richness and extravagance marked the opening years of the reign of Louis XVI. Not since Louis XIV's days at Versailles had there been such expenditures on furniture. Master *ébénistes* were engaged in the making of splendid furnishings rich in materials, carving, marquetry, gilding, and lavish bronze mounts. The skill of the wood and metal craftsmen was at its apogee. Soon after 1780 there was a reaction toward greater simplicity, but during this period two remarkable screens were made for the royal couple. Perhaps the more famous is the one made for Marie Antoinette's apartments at St. Cloud.

This screen of four leaves with a walnut frame is carved with foliated motifs, the upper corners surmounted with gilt pinecones. This was part of a large suite delivered for the queen's bedchamber and is the result of the collaboration of Jean-Baptiste-Claude Séné, the *maître menuisier;* Guérin, the carver; Chatard, the gilder; and Capin, the upholsterer. The upholstery was of *pekin blanc,* or white silk, painted with chinoiseries and landscapes, and is attached to the frame by a gilt bronze molding.[36] Each of these craftsmen was a master in his field, and their combined efforts demonstrate the complexity and quality of court furniture. Of this suite, the bed has been lost, but the other pieces are at the Musée de Louvre or Musée des Arts Décoratifs. The screen may be seen at the latter museum, with its original fabric

**F**rench
screen of gilded
poplar and walnut
with panels of blue
and silver silk
lampas. Circa 1780.
Wrightsman
Collection, The
Metropolitan
Museum of Art.
Detail on opposite
page.

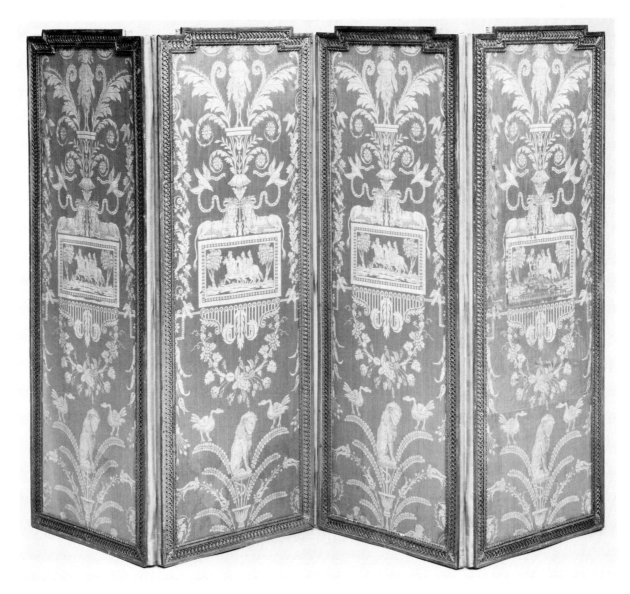

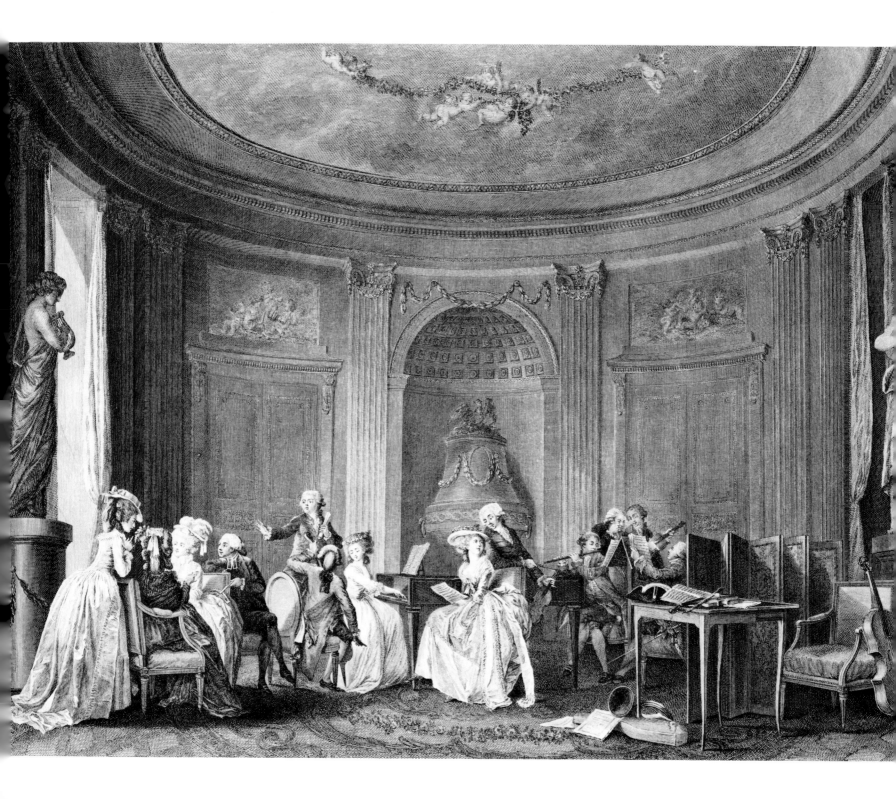

L'*Assemblée au Concert* (The Musicale) and L'*Assemblée au Salon* (Conversations in a Drawing Room), both 1784, are etchings by François Dequevauviller after a painting by Nicolas Lavreince. These two views of eighteenth-century interiors show the placement of screens and their use in social gatherings. The Metropolitan Museum of Art, Harris Brisbane Dick Fund, 1935.

replaced with a satin brocade.

An even more remarkable screen, which was delivered to Louis XVI at Compiègne in 1786, may be seen at the Louvre. The distinction of this screen is that, perhaps at Louis's own suggestion, the frame was made of gilt bronze instead of giltwood as was originally planned, thereby creating a richer and more durable furnishing. Two features distinguish this screen: the beauty of its bronze and the elegance of its silk. At the time of the Revolution, this screen was not sold but was sent to the hotel of the duchesse de l'Infantado and then sent for the use of the Directoire along with all the furniture of the king's chamber. It was found at St. Cloud in 1807 and was still there in 1818, except that the silk had already been changed. It is not known what happened to it from that date until it was found in an antique shop the day after the invasion of Normandy in 1944. It was then missing the green taffeta from the back of one panel and its beautiful original silk from the front. However, the present-day company that has taken over the firm of Pernon, the original supplier, was able to find in their archives the sample of the silk delivered to Louis. They have successfully reproduced the fabric so that one can today see the screen as it originally appeared, with its glorious floral pattern.[37]

The existing excellent record of French furniture is due to the detailed nature of the royal inventories, in which every addition to the furnishings or other treasures was listed, fully described, entered in a day book, and given a catalogue number. Thanks to this, each piece may be identified and information obtained concerning make, materials, and cost, as well

as the disposition of many of the items. New furniture was continually being added to the apartments and state rooms in the various châteaux, and as a consequence, other furniture needed to be relocated or dispersed. The replacement might result from a change in taste or style, normal wear and tear, fading, breakage, or theft. Frequently the king made a gift of some admired piece, and there were certain presents that were obligatory or derived from certain offices of the Crown. A folding screen of red cloth laced with gold and silver was given to Madame de La Mothe as a perquisite to which she was entitled as governess of the *enfants de France*.[38] The disposition of the furniture was controlled by the relative ranking of the châteaux. Versailles received the finest pieces, while Fontainebleau and Compiègne enjoyed precedence over secondary châteaux.

Lazare Duvaux kept a detailed journal recording all transactions occurring in his Paris gallery. In 1750 he noted that Madame la Vicomtesse de Rochechouart, Dowager, sold a screen of gilt bronze mounted with a Meissen figure and Vincennes flowers for 156 livres, and that Madame la Duchesse de Fleury sold a wood screen, which had been reddened and polished and covered with Oriental paper, for 15 livres.[39] Nancy Mitford, in her biography *Madame de Pompadour,* describes Duvaux as the supplier of bibelots who sent "two screens of massive amaranthus wood" to Pompadour at the Hermitage.[40] The other preferred woods of the time were tulip wood and Brazilian rosewood, with mahogany becoming popular only during the latter part of the century.

In the Waddesdon Collection are several notable examples. One is a walnut screen carved with acanthus leaves, rosettes, swags of foliage, roses, and anemones. This screen is forty-nine inches high and hinged to fold both ways, making it very flexible for arranging an intimate enclosure. The patterns in the embroidered nineteenth-century silk echo the motifs of the gilded frame.[41] Two other outstanding screens surviving from the period of Louis XVI are in the Musée Nissim de Camondo. One is of carved wood painted gray with pediments decorated with acanthus leaves and roses. The silk panels of polychromed bouquets on one side, with white bouquets on the other, bear the stamp of Louis Falconet. The other screen is stamped with the name of George Jacob, whose greatest fame was as a chairmaker.[42]

Mario Praz, in *An Illustrated History of Interior Decoration,* traces the treatment of interior space, relying on paintings and engravings of the period for information on the style of furniture and decoration and, just as important, on how the furnishings were placed within a room. An etching of 1784 that was praised in the journals of the time for its ability to "depict very well just what takes place in the best homes"[43] was *L'Assemblée au Salon* by François Dequevauviller. This is believed to be the salon of the duc de Luynes de Chevreuse. In this elegant setting the hosts and guests engage in conversation, reading, game playing, and gossip. In their midst stands a tall, rather undistinguished screen that is of interest for its use in shielding the door rather than for its design. *L'Assemblée au Concert,* the work of the same etcher after a painting by Nicolas Lavreince, illustrates the use of a low, very long screen of at least

**S**creen made in 1786 for the chamber of Louis XVI at Compiègne by Hauré, Guérin, Forestier, Thomire, and Boulard. Frame of gilt bronze with panels of embroidered silk. Musée du Louvre, Musées Nationaux.

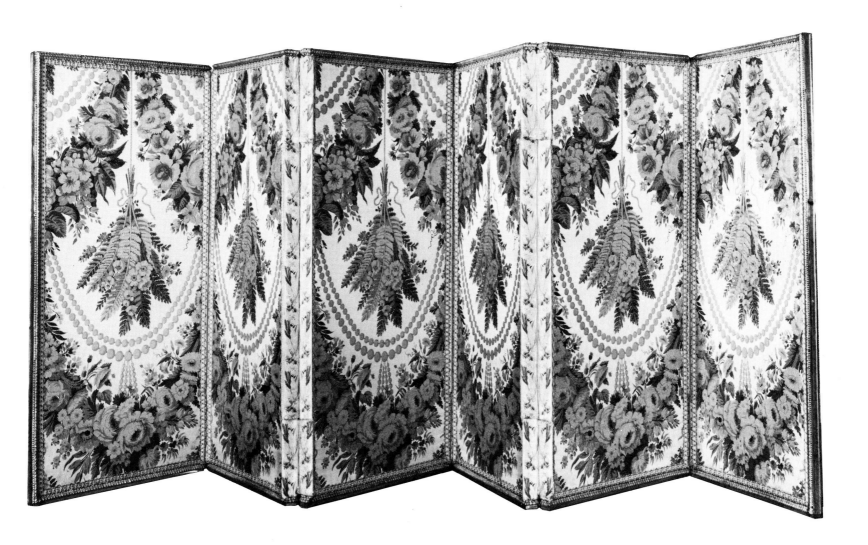

eight brocaded panels folded accordion-fashion and placed in a surprising position that separates the chair and table presumably intended for the cellist from those of his fellow musicians. Praz says that "there is little variety in the background interiors illustrated by genre paintings of the *petits maîtres* that abounded in France at the end of the eighteenth century. Consider, for example, the elegant little paintings of Louis-Léopold Boilly (1761–1845) in which walls are divided by rectilinear frames against which some shadowed painting or piece of furniture can be glimpsed. The foreground is usually marked off by a screen or a hanging and frequently includes a table, a toilette with a still life of objects, and a chair covered with disordered clothing . . . "[44] At the opposite end of the social spectrum is a charming late-eighteenth-century painting by Antoine Ruspal (1738–1811) called *The Dressmaker's Shop in Arles.* Six seamstresses are shown engaged in their trade in a shop in which the bare floors are strewn with scraps and spools of thread and the paint is peeling from the wall. In the background is a tall four-panel screen, shaped not unlike those found in elegant salons but covered instead in ordinary blue-printed cotton with the simple tape edges unglued, revealing the plainest wooden frame.

Differing from England, where the manufacture of screens was geographically centralized, and from France, with its concentration of society and wealth in the environs of Paris, Italy, being composed of many kingdoms, had greater diversity and regional styles, subject to the influence of neighboring or controlling powers. The French influence was the strongest throughout, particularly in Piedmont and Liguria. The Venetians felt the proximity of Germany and Austria, while Sicily and Naples reflected the influence of Spain, but through all these layers the unmistakable spirit of the Italians emerged.

Screens do not seem to have been introduced in Italy until the late seventeenth century. Milder weather, at least in the southern regions, must have been a contributing factor, but their profusion in the eighteenth century limits the validity of attaching too much significance to the climate. As always, taste had to be balanced with comfort, and fashion tipped the scale.

Italy, unlike France, did not claim a host of master craftsmen, nor did it have France's wealth or national unity. William Odom, in his valuable work on Italian furniture, suggests that the impoverished condition was perhaps a blessing and a factor that contributed much of the charm of the Italian furniture. The craftsmen were compelled to use less expensive materials, and partially to compensate for this, they embellished them with more exuberant color and design. The obvious benefit of the lack of a concentration of trade guilds or of a single dominant royal court was that this encouraged the freshness and originality of the individual.

Some Italian craftsmen ventured into and excelled in France, but one notable exception remained in Turin, where he achieved his well-earned recognition. The work of Giuseppe Maria Bonzanigo is on a par with that of the most acclaimed *maîtres* in France, in both the sophistication of his designs and his artistry.

Italian carved, gilded, and painted screen by Giuseppe Maria Bonzanigo. Late eighteenth century. Palazzo Reale, Turin. Photograph Francesco Aschieri.

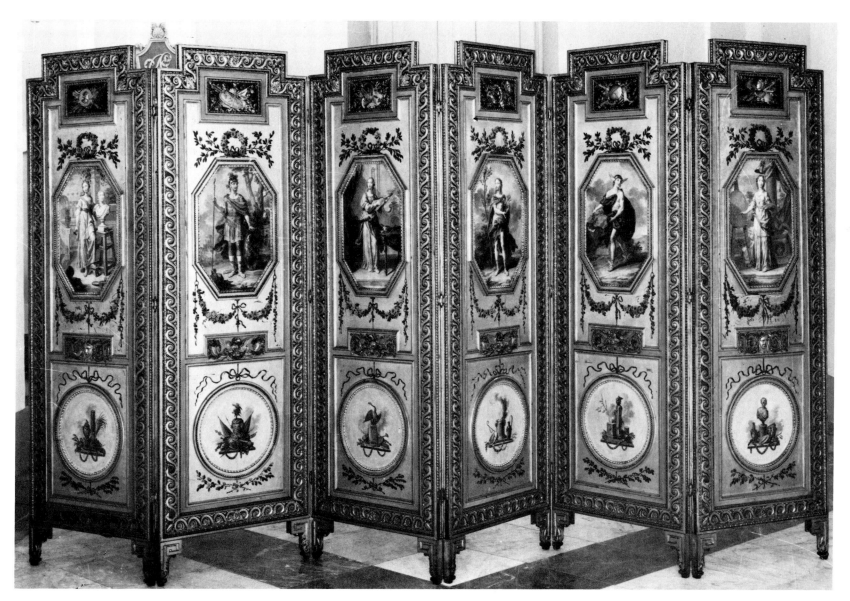

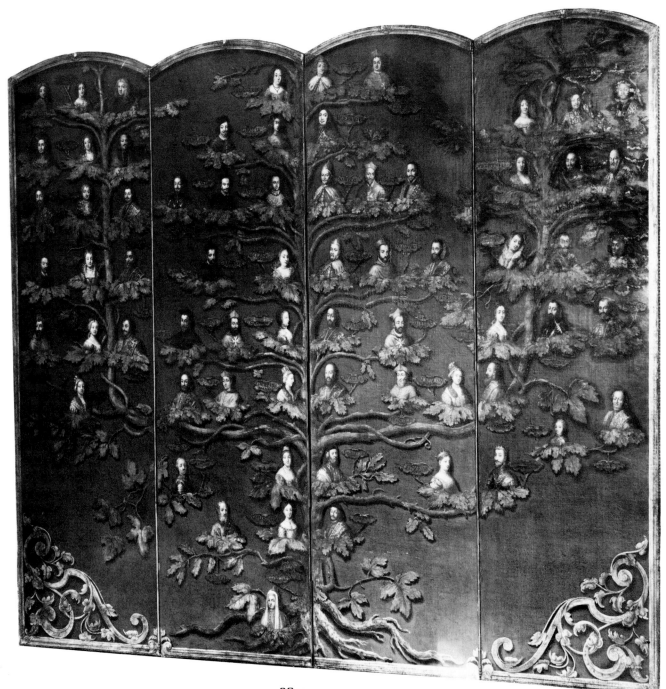

Bonzanigo was born in Piedmont in 1745, settled in Turin in 1773, and executed a considerable quantity of furniture for the royal palaces, including chests, screens, cupboards, and doors. He considered himself primarily a sculptor, and his works were delicately carved with crisp festoons and neoclassic ornaments. While his work resembled that of his French counterparts, it lacked the restraint the French would have imposed. In 1787 Victor Amadeus III (1726–1796) of Sardinia appointed him official woodcarver to the Crown, with a salary of two hundred lire a year. He was deprived of his commission while the French under Napoleon occupied the Piedmont, but after the settlement at the Congress of Vienna he resumed his work for the king of Sardinia.[45] There is a fine example of his work in the Palazzo Reale in Turin. Each of the six panels contains two sections. In the upper portion is a neoclassic figure enclosed in a hexagonal frame that in turn is surrounded by wreaths and swags. The lower sections contain ornaments within circular frames, and the basically rectangular panels are surmounted by smaller rectilinear decorations set within the upper edge. The frame is gilded, but the simplicity of the hinges and the lack of bronze mounts are clues to its Italian origins. In the Reale Palazzina di Caccia at Stupinigi there is a carved and gilded screen by Bonzanigo; its six panels are still covered with their original silk, which is patterned with ribbons and flowers. Perhaps his most ambitious screen is also in that splendid hunting lodge. The bowed top of each of the four panels is surmounted by a wreath, and in the corners are acorn finials. The silk panels repeat the wreaths with their design of intertwining ribbons. Near the top of each panel is a drape of silk fringe and tassels, creating a somewhat excessive effect. This was made for the marriage of Carlo Emanuele IV of Savoy and Maria Clotilde of France in 1776.[46]

A screen produced in Venice in the early years of the eighteenth century has as much historic as artistic interest. It is a painting of a family tree, showing sixty-seven individual portraits of the Cornaro family. The screen apparently was painted from old portraits, as the individual poses, style, and placement bear little relation to each other. This remarkable family produced four doges and eight cardinals. Identified among the portraits is Catherine Cornaro, consort of Joseph II, king of Cyprus, 1460–1473. A genealogist would have great difficulty tracing the lineage, since generous artistic license was employed to fit the family within the framework, but the resulting screen is an intriguing document of portraiture and costume.[47]

Thus the second half of the eighteenth century saw stylistic diversity, with enthusiasts for the rococo, neoclassic, and Gothic motifs. Yet however different their obvious physical characteristics, there existed between them no fundamental opposition. "These three modes of artistic expression possessed in common qualities of design—asymmetry, movement, variety, freedom, spontaneity—by virtue of which the influence of one reinforced that of the others. Singly and together they initiated against the classical ideals of repose, sobriety, and discipline."[48] During this time furniture-design books began to appear, including Thomas Chippendale's *The Gentleman's and Cabinet-Maker's Director,* which provided patterns for

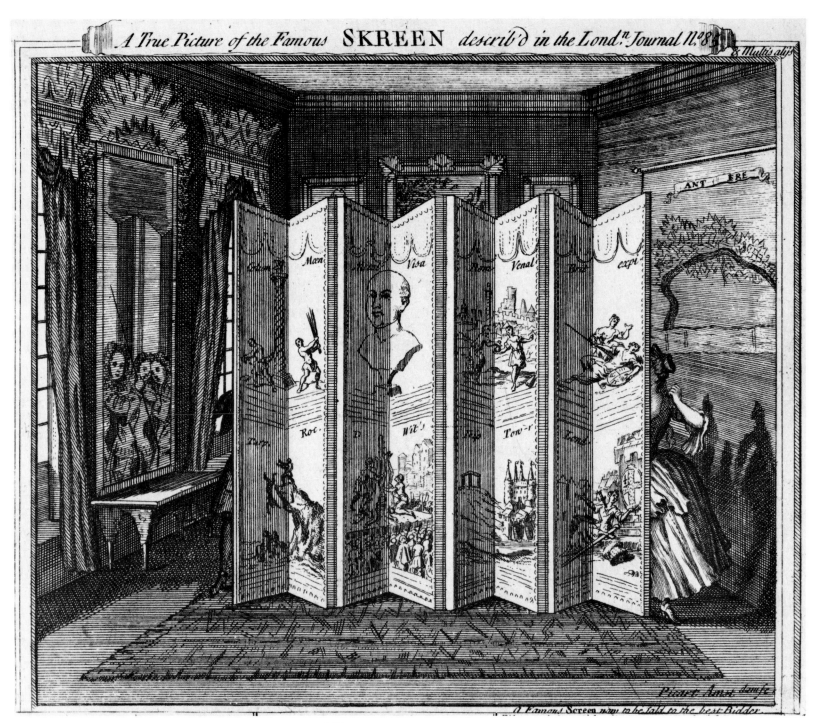

**E**ngraving illustrating the "famous SKREEN" described in the London *Journal* in 1721 in a satirical reference to the South Sea Bubble scandals. Courtesy The Pierpont Morgan Library.

**F**inely carved and gilt screen (1786) made by Giuseppe Maria Bonzanigo. The polychromed garlands of the frame are repeated in the silk that covers the panels. Reale Palazzina di Caccia, Stupinigi.

**S**ix-fold gilt walnut screen (1786) by Bonzanigo, part of a suite consisting also of two sofas and twelve stools. Medallions at the top of each panel are enclosed by intricately carved ribbons and flowers. Reale Palazzina di Caccia, Stupinigi.

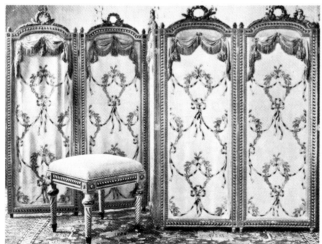

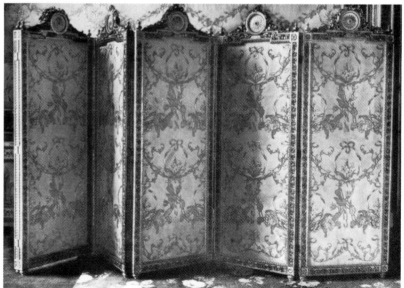

**R**ococo screen by François Boucher, presumably painted as a royal commission, since the central panel bears the fleurs-de-lis. Mid-eighteenth century. Formerly in the Rothschild Collection, Paris. Photograph courtesy P. and D. Colnaghi & Co., Ltd.

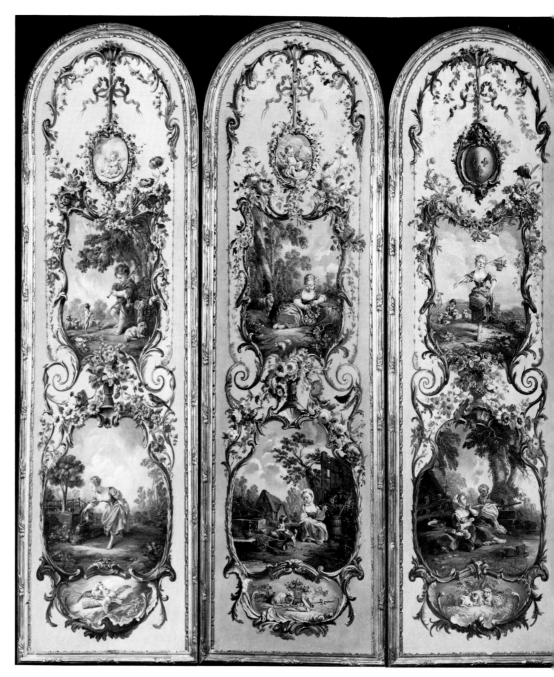

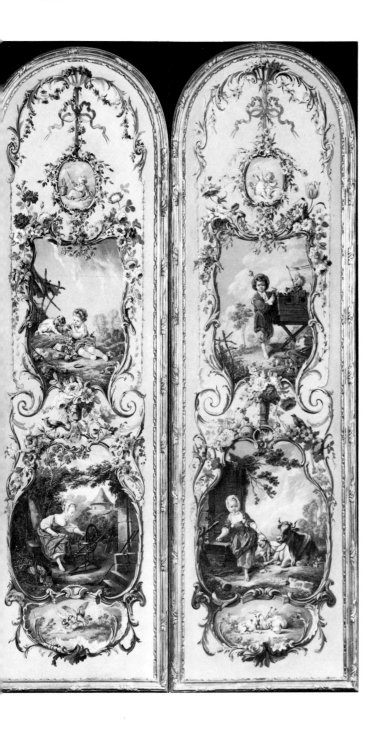

rococo, Chinese, and Gothic tastes. Between 1791 and 1794 Thomas Sheraton published the four parts of *Cabinet Maker's and Upholsterer's Drawing Book,* with *The Cabinet Dictionary* following in 1803. These widely circulated books gave people more choice but at the same time had a crippling effect on individuality, as one could so easily order or imitate the current mode.

Chippendale's *Director* presented the expected patterns for beds, chairs, tables, and bookcases, but it also had designs for many secondary or decorative articles such as hanging shelves, candlestands, mirrors, pedestals, chandeliers, fretwork, and picture frames. Not limited to objects fabricated of wood, it included stove grates and paper hangings as well. It is significant that Chippendale provided designs for fire screens, but even with his closely allied frames and fretwork, no folding screens were included. Examination of Sheraton's book repeats this finding, as do paintings and etchings of the period, leading to the undeniable conclusion that by the end of the eighteenth century the screen was at a low point of popularity as a decorative accessory. The screen continued to be used as a utilitarian object but it was viewed more as an old-fashioned convenience than as a decorative platform. Happily, this period of disfavor was to prove to be merely a phase, and after a short time the screen reappeared with fresh vigor and with some of the ideas of the past reinterpreted, and entered into the artistic movements of the nineteenth century.

# 4. AN EMBARRASSMENT OF ADMIRABLE MATERIALS

**F**urniture in the nineteenth century was to reflect as many changes in taste and artistic movements as did painting or any of the other decorative arts. Empires and industries expanded, causing reevaluation of current social modes and accepted attitudes. This same unrest and vitality stimulated new expression in design areas. During the seventeenth and eighteenth centuries the decoration of screens had been confined to fairly limited materials and predictable subjects. The nineteenth century was to see a broadening of styles, a wider range of materials, and, most important, screens that were an expression of fresh artistic ideas or a reaction to the times. We can see how, as a broad introductory statement for the new century, the design and use of screens reflected the conventions of the previous century, but in combination with new ideas and more imaginative interpretation. Not all these experiments would be judged successful, but they must be viewed as the creative by-products of a rapidly changing age.

Thomas Sheraton (1751–1806), unquestionably one of the most distinguished cabinetmakers at the end of the eighteenth century and the start of the nineteenth, was a great influence on other furniture craftsmen with his *Cabinet-Maker and Upholsterer's Drawing Book*, which appeared in a third edition in 1802. This and *The Cabinet Dictionary* (1803) were followed by his *Cabinet Maker, Upholsterer's and General Artist's Encyclopedia* in 1804. Examination of these style books does not reveal plans for folding screens, although Sheraton did design a folding footstool screen. This piece, while basically a fire

screen, is mentioned because it shows the beginning of flexibility in the design of screens as well as the interest in dual-purpose furniture. Between 1790 and 1830 there was a large increase in the number of patents issued under the heading of furniture and upholstery. This is explained by a writer of 1813: "As it is the fashion of the present day to resort to a number of contrivances for making one piece of furniture serve many purposes it becomes necessary that the complete cabinetmaker should be acquainted with the principles of mechanics."[1]

In his *Dictionary* Sheraton defines a screen as "a piece of furniture used to shelter the face or legs from the fire. Hence, the more common name is fire-screen."[2] He describes the variations of the basic form, including the tripole screen, the cheval screen and the folding fire screen, making no reference to the draft screen.

Other Regency style books confirm the absence of designs for folding screens. In 1818 George Smith published his *Collection of Designs for Household Furniture and Decoration,* a summary of styles as developed by Sheraton, Thomas Hope (c. 1770–1831), and Henry Holland (1745–1806). From 1809 to 1828, Rudolph Ackermann's monthly, *Repository of the Arts, Literature, and Fashions,* appeared, each issue illustrating furniture in the latest smart taste. Richard Brown published a style book in 1822, followed by Peter Nicholson's *Practical Cabinet Maker* in 1826. None of these had designs for folding screens.

Part of the explanation lies in the concept and design of a neoclassical room. Characteristics of the style are formality and symmetry. Chairs, almost

Figures from classical mythology appear on a screen from the second suite of furnishings made by the Gobelins factory for the Grand Cabinet of the emperor at the Tuileries. After the Restoration in 1814, Napoleonic symbols that had formed the design above the figures were replaced by royal helmets and fleurs-de-lis. The screen was designed by Pierre Fontaine and Jacques-Louis David. Musée Mobilier, Musées Nationaux.

always in pairs, were placed against the wall, possibly flanking a great console, with its accompanying mirror or pedestals supporting classical busts. Gone was the comfortable grouping of furniture designed for the more robust gatherings of eighteenth-century drawing rooms. The inhabitants, who had formerly been grateful for the protection of a screen, now substituted for it the empty museumlike quality of a room in which the furniture was placed in a stationary arrangement. A definition of 1826 details a proper drawing room: "It is appropriate to the reception of company and formal visits; hence the style of the furniture should be elegant. The plain surfaces of the walls are frequently embellished with large glasses upon the solid parts between the windows, and still more generously over the chimney piece. The more extensive surfaces should be ornamented with a select choice of paintings adapted to the size of the room. The furniture of drawing rooms consists of commodes, pier-tables, firescreens, vases, bronzes, tables, sofas, couches, chairs, seats, foot-stools, low tables, etc."[3] Folding screens are not included in the inventory of the drawing room or as proper furniture for any of the other rooms.

By the end of the Regency period a number of styles were in evidence and competing for favor, including the neoclassical, neorococo, Elizabethan, Renaissance, and Gothic Revival. Before advancing

through the jumble of styles in England, attention should be turned to France, where the neoclassic period produced some particularly handsome screens.

Many of the screens made in France during the earliest decades of the nineteenth century were fashioned from wallpaper, which had largely replaced wall painting for the decoration of interior spaces. The leading manufacturers were Jacquemart and Bénard, Zuber, and Dufour. During the Revolution the partnership of Jacquemart and Bénard had taken over the firm of the famous eighteenth-century papermaker Réveillon, who had been the unquestioned leading French manufacturer. A paper entitled *The Five Senses* was made in his atelier around 1780. The representations of the senses and the decorative swags and urns were printed in grisaille against a blue-green background.[4] The themes most often appearing after 1800 were mythological tales, figures in classical ruins, and trompe l'oeil drapery or panoramas. While a Directoire or Empire scene might present a pastoral setting with woodlands and trees and possibly a few sheep grazing by a lake, the figures would be positioned amidst a ruined temple or with a crumbling colonnade in the background. A decorative motif of drapery very frequently formed a dado, or ornamentation, above the scenic panel. The lavish use of drapery for interior decoration was an important innovation of the Empire period, and whole sets of wallpaper that resembled fabric were produced. Manufacturers were "producing wallpaper that had every appearance of satin curtains, embroidered and trimmed with lace, folded and pleated in every way, and hung with tassels and decorative ornaments."[5]

The trompe l'oeil papers were being manufactured in many variations by 1810 and were ideally suited for use on screens, either by themselves to imitate drapery or as supplements to scenic papers, thereby bringing the screen to the desired dimensions.

A popular type of Empire screen was one in which allegorical figures were set in a geometric reserve, often hexagonal or octagonal, and possibly embellished with arabesques. The figures, very often painted in grisaille against a dark amber, green, or aubergine background, might represent sculpture, agriculture, architecture, painting, or music. Antique gods and goddesses were also familiar choices.

The scenic papers were extremely elaborate and costly productions. Only top-quality designers were employed and the papers were carefully hand-printed, sometimes requiring as many as two thousand blocks to complete a series. Once cut, the blocks could be used over many years, and figures could be added or deleted to remain current with the latest fashion or to record a recent event. The topics had a certain educational function, often depicting geographical panoramas, historical events, or allegorical tales. Some of the more popular scenic series were *Monuments of Paris, Vues d'Italia,* and *Les Incas,* while *Les Amours de Psyche, Les Voyages d'Antenor* and *Paysages de Telemaque* were favored mythological tales. The series on North America included scenes of the Revolution and natural wonders such as Niagara Falls, as well as views of Boston Harbor. Recent exploration, as illustrated in *The Voyages of Captain Cook,* aroused the imagination in addition to pleasing the eye. Normally, the lengths were "between eight and ten

◄ **A**esthetic-movement screen designed by Selwyn Image. Panels of needlework made at the Royal School of Art are framed by walnut panels. Photograph courtesy Christie's, London.

► **S**atinwood screen designed by A. H. Mackmurdo. The embroidered panels are worked with silk and gold threads. William Morris Gallery, Walthamstow.

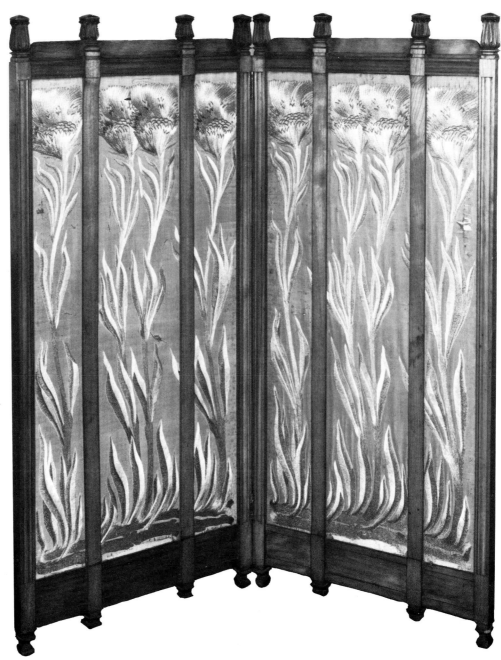

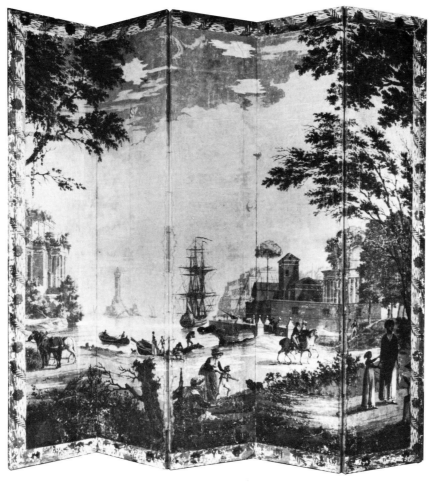

feet high with plenty of allowance for adjustment (for example, expanses of blank sky which could be removed without spoiling the picture) and space for the addition of borders or other ornaments at the bottom. The number of lengths in one set varied from five to thirty or more, and each roll was numbered and sometimes named, to ensure that the right sequence appeared on the walls."[6]

Not all the scenics were done in glorious color. Grisaille was favored during this period, as were shades of sepia and mauve. A harbor scene, part of a series called *Bay of Naples,* was rendered in shades of sepia and cream. This design, instead of being printed in strips, was done in blocks measuring approximately twenty inches square. About two hundred were necessary to complete the whole series. A screen covered with a part of this panorama is framed with a border of stylized leaves and flowers printed in shades of sepia and dark brown. The reverse side is covered with paper in the same tones, printed to simulate blocks.

Mention has already been made of the extensive use of drapery during the Empire period. These fabrics were made by the pre-Revolutionary factories, but the designs were new. Instead of the elaborate intertwining scrolls and floral designs of the

eighteenth century, the new fabrics were more restrained in design, with medallions and geometric forms, as well as Napoleonic motifs such as encircled N's, bees, and eagles, being featured. A screen of Lyon silk velvet stamped with the mark of P. Brion was made in Paris about 1810 for the Petit Appartements at Fontainebleau. The six panels of silk, embroidered with medallions and geometric surrounds containing floral arrangements, are set in a gilded wooden frame. At this time there was a "growing inclination to match the chairs and the screens, both in their carved decoration and in the choice of the material that formed the screening panel. There are some splendid examples of these in all the Napoleonic residences."[7]

The fabrics for the Grand Cabinet of the emperor at the Tuileries were made by the Gobelins, the state tapestry manufactory. About 1810 the Gobelins works had created the first set of tapestries for the emperor, and they had been mounted and placed in the Grand Cabinet, awaiting Napoleon's approval. The screen of six leaves shows this tapestry with symbols of the empire: the Imperial Eagle, the bees, the helmet, the garlands, and cartouches. A month before the entire set of tapestries was to be delivered, Napoleon refused them and ordered another set to be made, one that would express more fully the richness and beauty of his reign. The second set was to be designed by Pierre Fontaine (1762–1853), one of the emperor's chief architects, with the assistance of the premier artist Jacques-Louis David (1748–1825) and the director of French museums Vivant Denon. Gobelins worked feverishly and delivered the completed set two years later. The

screen panels—ornamented with classical figures and gold thread, which represented a triumph of design and skill—were delivered in 1813. At a later date, during the Restoration, the top part of the panels was reworked, with the royal symbols substituted for the imperial symbols.[8] As the Restoration in France replaced the empire, the style of furnishings underwent subtle changes. The Napoleonic emblems disappeared and were replaced by lyres, acanthus leaves, and flowers, and after 1830 the furniture became heavier and more ornate and the colors more intense. The countries of Western Europe were not alone in their delight with neoclassical furniture. Among the treasures of the Hermitage in Leningrad is a collection of Russian furniture in this style. Included is a large four-panel screen of etched glass set in an ornate gilt frame. While the carving is elaborate, the form shows restraint, but is relieved by the rounded tops of the panels and by the finials extending above the fluted columns concealing the hinges. The frame is ornamented with floral and circular motifs enclosing panels of glass etched with a cartouche in a diamond form. This piece was part of a suite executed by Peter Gambs, who from 1836 to 1839 was principal cabinetmaker of furniture intended for the Winter Palace.[9]

Coexistent with the early Victorian period was the industrial expansion, with its proliferation of machine-made furniture. The British architect and designer A.W.N. Pugin (1812–1852) wrote against mass production of furniture, metalwork, and ceramics. He thought the answer lay in looking back to the Middle Ages and the vitality of the true Gothic

style, as may be seen in the decorative details he contributed to Sir Charles Barry's designs for the Houses of Parliament. His views, expounded in *The True Principle of Pointed or Christian Architecture* (1841), encouraged a totality of design that unified every part of a building.[10] Pugin's influence was far-reaching, but the major decorative movements of the remainder of the century evolved from reactions to the Gothicism of the 1840s and 1850s.

Neo-Gothicism was not a style limited to England. A watercolor done by a French artist of the drawing room in the palazzo of the Russian ambassador to Rome reveals a "naïve and pleasing Gothicism," achieved by the pointed arches in the screen, chairbacks, and pelmets. The screen, with its knights, is "disarming in its innocent illusionism. These elements are for dreaming, for escaping into the past."[11]

During this time many observers became alarmed by the badly designed, overwrought, and overornamented objects typical of machine production. Exhibitions were held all over the country to improve the public taste and to raise the standards of design. The International Exhibition held in London in 1862 was hailed as a turning point, and an advance was noted in almost every direction, heralding new lightness and grace, and the disappearance of meaningless ornament.[12]

William Morris (1834–1896) was certainly one of the most influential figures in the decorative field in England in the second half of the nineteenth century, not only for his work—which started with the design of embroideries and wallpapers and expanded into almost all areas, including the creation of stained glass, woven and printed textile designs, carpet designs, ceramic tiles, and bookbindings—but also for his personal philosophy and his close association with the artistic movement of the Pre-Raphaelites. Morris's first embroideries were made in 1855, and he was soon assisted by his wife. Their first effort was a series done for their residence, the Red House. This work consisted of twelve female figures based on Chaucer's *Legend of Good Women*. Dressed in medieval robes, they are united by a running band of flowers and a background of coiling floral stems on a blue serge ground. Only seven of the figures were completed, and three of them survive in a screen that was made up after their removal from the Red House and is on loan to the Victoria and Albert Museum.[13] The embroideries were worked in crewel wool with some silk and gold threads on a coarse linen that was then cut out and applied to a woolen ground. These early embroideries were intended as a substitute for tapestry and were described as such by Henry James when he visited the workshop in 1869. Until about 1880 all of the designs in the shop were supervised by Morris, but after that date his daughter May took charge. Her style was very different in both design and execution, for she worked with silk floss chiefly in darning stitches. Her work is stiffer and has a broader, simpler treatment.[14]

Morris's tapestries were inspired by a journey to France with the artist Edward Burne-Jones, a leader of the Aesthetic movement that guided art and literature in Britain at the time. Overwhelmed by the tapestries he saw there, he resolved to "begin a life in

art," and determined the principle that a tapestry should have "force, purity, and elegance of the silhouette, crispness, and abundance of details." The two men worked together on a number of tapestries, taking as their subject matter the religious themes, mythological and allegorical tales, and medieval stories characteristic of Aestheticism. They did themes from the *Quest for the Holy Grail* from Malory's *Morte d'Arthur*. Morris commented that he "had always noticed in good medieval design a peculiar kind of interest and ornamental quality which is quite lacking in most of those of Renaissance and Modern times." Although they shared an enthusiasm for tapestries, Burne-Jones did not begin to design tapestries for Morris until 1885, and after that time they frequently collaborated. Burne-Jones provided the general composition and figures, while Morris did the decoration of the textile costumes and floral foreground.[15] A wooden screen with stained-glass panels showing medieval figures was also designed by Burne-Jones and is now in the Kunstgewerbemuseum in Cologne.

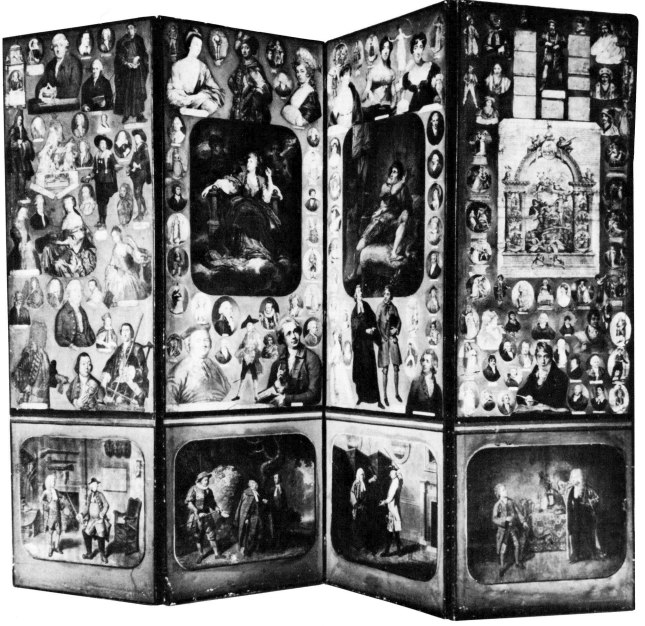

Screen made by Lord Byron circa 1811–1814. The upper section displays approximately 150 mezzotints and engravings of famous actors, actresses, and playwrights. Theatrical scenes from paintings by Zoffany fill the lower sections. Reproduced by kind permission of John Murray.

The reverse side of Lord Byron's theatrical screen displays pictures of boxing matches and portraits of boxing champions such as "Gentleman Jackson." Reproduced by kind permission of John Murray.

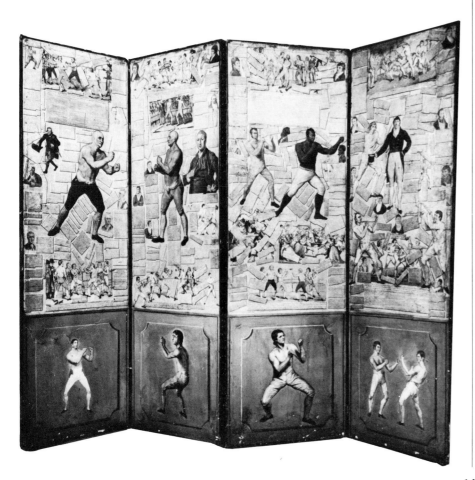

Appalled by the ugliness around him, Morris was eager to start a firm producing all kinds of decorative articles. Morris issued the dictum "Have nothing in your house that you do not know to be useful or believe to be beautiful." He formed a company that bore his name, and he continued to design tapestries and fabrics.

Morris's hostility to machinery continued to develop, culminating in his belief that "real art" can only be made by the people and for the people. His ultimate dream was that machinery would be abolished and the medieval guild system restored, completing the cycle of the Gothic idea of Pugin. Obviously, the machine was not going to become obsolete, but this idea fostered the Arts and Crafts movement of the latter half of the century.

In 1885 an article appeared in *Amateur Work* stating that "it seems but a few years since the folding screen was looked upon as almost an obsolete piece of furniture" but now has reappeared to "make delightful little snuggeries for writing or work." The author explains "that the modern house was so assured of its comfort that it preferred to look upon draughts (if any outspoken visitor suggested their presence) merely as unsought-for ventilation, and felt that health and sanitation . . . was best obtained by sitting in a temperature that, cosmopolitan in its variety, allowed the rich warmth of the tropics on one side with arctic cold on the other, or possibly the diminished size of the average room led to the banishment of the screen." The author laments the rage for small rooms that destroyed the comfortable living room. These small rooms were furnished with a center table that "tyrannically usurped the best part

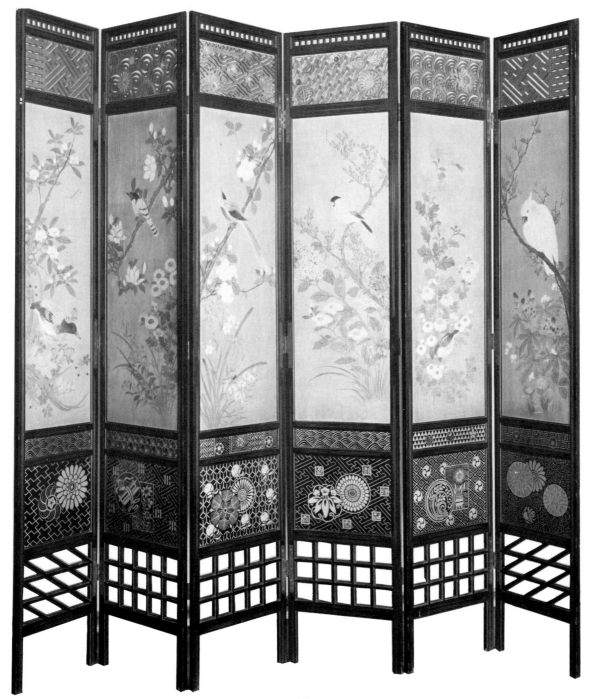

**E**bonized and gilded wood screen with fretwork and japonaiserie paper on the panels. Made by James Forsyth and W. E. Nesfield and presented to Norman Shaw in 1867. Victoria and Albert Museum.

of the room, leaving people and the other furnishings to find a place where they could." He rejoices that by 1885 a democratic age allows room for a quantity of small tables and chairs permitting the occupant to sit where he chooses with the comfortable shelter and cozy nooks afforded by the screen. A room might now have several screens positioned as follows: "Near the door a screen breast-high shut off a corner devoted to one member of the house; here was a writing table, a small bookcase, and easy chair, with the screen itself and the walls, hung with special photographs of friends and drawings." Another part of the room shut off by another screen was devoted to the mistress of the house. "Here files of papers and accounts, newspapers and books, showed that it served as a real workroom, while the fine library itself was in no way spoilt by what if it had been in full view, would have been intrusive and disorderly." In a smaller room a screen might be a draft preventer or "make a cozy nook for the piano or worktable, or serve as a substitute for privacy."[16]

It was clear that the reestablished position of the screen was then secure and the screen itself often homemade, providing as much pleasure in the course of its construction as in its use as a finished product. The article proceeds to give a detailed account of how to construct a screen, suggesting a size six feet high with four leaves that are each two feet wide. The framework might be made of lightweight material but must be properly mortised and braced. The next suggested step was covering the screen with well-sized calico and then with paper, to make a background for pictures. Hinges could be of metal or webbing, and the joints between the folds lined with velvet to entirely exclude the draught. Screens in this state of completion could be obtained at fairly reasonable prices in almost every upholsterer's shop, but since this price far exceeded the cost of materials, it was suggested that the individual make his own frame or have it done by an ordinary jobbing carpenter. One was warned that black-and-white prints mixed with color prints did not harmonize. On no account could the screen be considered successful if the effect was "loud and obtrusive." There must be "carefully planned disorder and an artistic medley."[17] The choice of subject matter offered enormous variety: classic and medieval prints; travel pictures; uniforms and court dress of various periods; famous authors; athletic costumes; ships; birds and animals; or works of art that would be instructive and decorative. The choice was virtually limitless, but the writer warned that modern costume would make the screen look old-fashioned in a few years' time. Many suggestions followed, such as the popular one of portrait arrangements, but it was advised that each fold have its own special class of subject. The panel should be finished off with a black-and-white border—possibly made from an ornamental pattern in a newspaper or from lace—or framed with an apt quotation. The black-and-white screen was particularly recommended, as there was more variety in choices and the finished product harmonized better with the furnishings of the room. Often there would be a black-and-white side, with a reverse of colored pictures. Colored illustrations might cover part of the side, combined with a dado of checkerboard design or

Three panels for a leather screen (1876–1878) painted by Albert Pinkham Ryder. National Collection of Fine Arts, the Smithsonian Institution, gift of John Gellatly.

diagonal stripes.

"Scrap screen pictures could be purchased for this express use. These were printed on a single page and were accompanied by mottoes of the pictures. Japanese design books were sold in oriental shops as was Japanese gold leather paper."[18]

A scrap screen made by his wife, Jane, stands in the library of the Thomas Carlyle house in Chelsea, where Mrs. Carlyle entertained the literary figures of the day. A watercolor of 1881 shows the screen placed in the doorway between the back dining room and the library. It is decorated with prints and engravings, and portraits of men, women, horses, and dogs. "In his years as a widower, Carlyle grew to regard it with something approaching veneration and left it in his will to his niece, Mary Aitkin, 'who best knows the value I have always put upon it and will take best care of it to the end of her life when I am gone.' "[19] This particular screen is of interest for its literary and sentimental associations, not its artistry.

A screen of genuine fascination is one made by Lord Byron that illustrates two of his nonliterary interests: boxing and theatergoing. The screen is a first-class example of the craft of pasting engravings and cutouts onto a screen in a decorative and informative manner, and gives insight into two of Byron's favorite pursuits. "The screen, six feet high, appears to have been decorated as a pastime from 1811 to 1814. On one side the four folds of the screen are covered with portraits of boxing champions and scenes of historic pugilistic battles, cut from contemporary prints and books, and in this, we know, Byron had the help and expert guidance of his friend

John Jackson, the English champion. . . . The reverse side of the screen is more elaborate in arrangement, comprising as it does some hundred and fifty or more mezzotints or line engravings of actors and actresses of the period, besides many of the most notable players in the history of the English stage."[20] Byron identified those portrayed, and the assemblage includes Shakespeare and Garrick, Mrs. Siddons, Edmund Kean, Mrs. Jordan, and John Kemble. At the bottom of the screen are four mezzotint engravings of theatrical scenes from paintings by John Zoffany (1733–1810), who was famous for his English genre paintings. The entire history of this screen has been recorded, from its inception through its various journeys until it was bought by Byron's friend and publisher, John Murray.

Returning to the mid-part of the century, we can see another style growing out of the influence of Pugin. His work on the Houses of Parliament had a great influence on younger architects, two of these being W. Eden Nesfield (1835–1888) and Richard Norman Shaw (1831–1912). Individually or together, these two men made enormous contributions to the development of architectural taste and to the Victorian country house. They traveled throughout England designing houses and reviving traditional crafts, often enlivening them with new touches. Some of Nesfield's favored motifs were birds and plants in vases carved in panels above doorways, zodiacal symbols, and heraldic devices carved by the cabinet-maker and sculptor James Forsyth (1827–1910). An ebonized wood-and-gilt screen decorated with fretwork and panels of Japanese paper was, in all probability,

◄ *La Princesse du Pays de la Porcelaine,* by James McNeill Whistler. One of several paintings by Whistler done in a japonaiserie spirit and with a screen forming the background. Courtesy of the Smithsonian Institution, Freer Gallery of Art.

► *Classical Figures* (1897–1898), by Thomas Wilmer Dewing. Courtesy of the Detroit Institute of Arts, gift of Mr. and Mrs. James O. Keene in memory of their daughter Mae Long.

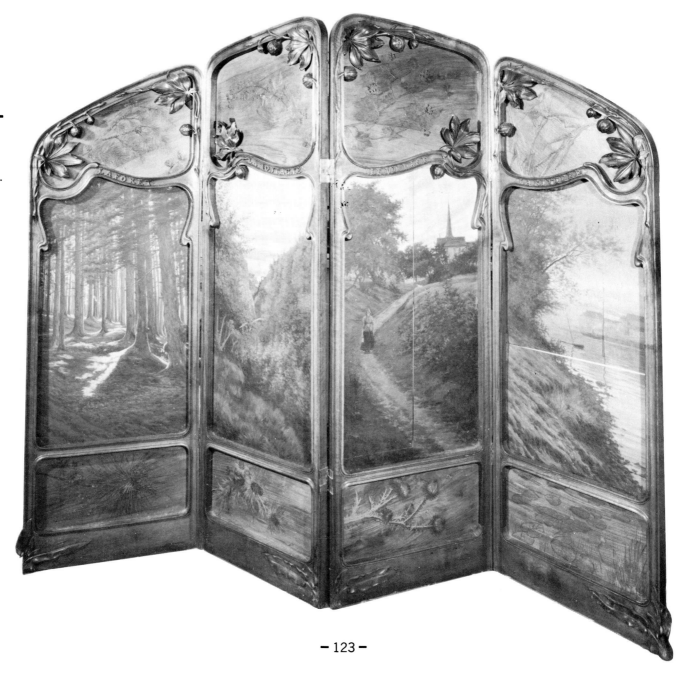

◄ **T**hree-panel
Art Nouveau screen
decorated with a
landscape by Steiner.
Photograph A.
Chadefaux.

► **F**our-fold
screen by Louis
Majorelle with
landscapes painted
by Girarder.
Photograph A.
Chadefaux.

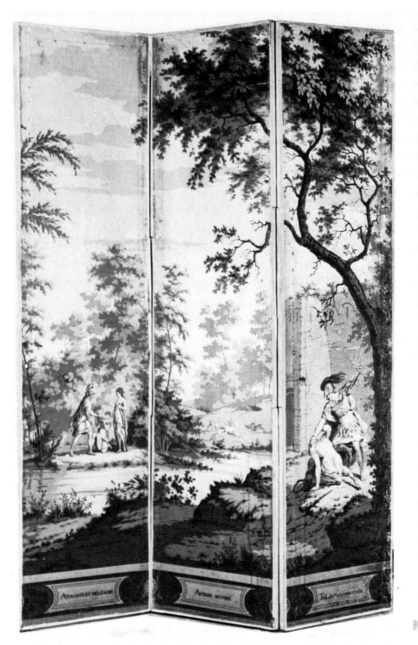
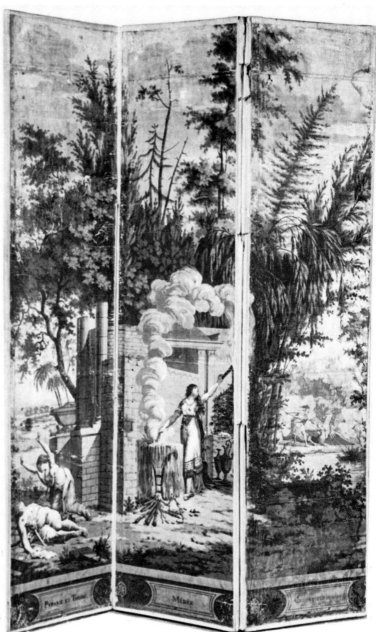

created by Nesfield and Forsyth and then given to Shaw as a wedding present in 1867. When one considers the complexities of the Victorian houses being designed by Nesfield and Shaw and others, it becomes apparent that screens were a necessity. These houses were complicated because "they had to contain so many people . . . but mainly because the activities and interrelationships of their occupants were so minutely organized and subdivided. . . . The largest houses had fifty or more indoor staff . . . and children had their retinue of governesses, tutors, nannies, and nursery maids. A great country house at its busiest might contain 150 people. It was considered undesirable for children, servants and parents to see, smell, or hear each other except at certain recognized times and places."[21] Screens, strategically placed, prevented the unwelcome view of numerous children or of servants performing their domestic chores. Social propriety required the division of the sexes between meals, each having his or her own domain. A screen positioned in a doorway shielded the ladies from the gazes of bachelors as they passed the parlors on their way to the billiard room.

"Art furniture" made in the decades of the 1860s and 1870s showed an emphasis on historic styles. People described themselves as specializing in "Art Decoration," "Art Embroidery," or "Art Furniture," a category set aside from that of the ordinary cabinetmaker. Books and periodicals on interior decoration became numerous by the seventies, two of the best known being Charles Lock Eastlake's *Hints on Household Taste in Furniture, Upholstery and Other Details* (1868) and Bruce J. Talbert's *Gothic Forms*

*Applied to Furniture* (1873). Periodicals featured labels such as Tudor, Jacobean, Gothic, or Anglo-Japanese. The term "art furniture" covered anything "that possessed remarkable simplicity and quietness of old work together with great picturesqueness and quaintness."[22]

One new, or renewed, source of inspiration was the Japanese influence, which reappeared at this time. After almost two hundred years the trade restrictions imposed in the seventeenth century had finally been lifted, and Japanese products began to flow again into the Western world. The London International Exhibition of 1862 was the first major showing of Japanese crafts, and it started a furor. Firms such as Liberty and Company, which had its beginnings as an importer of Japanese goods, designed whole rooms in this mode. A dining room with ceiling and walls covered with various Japanese gold and leather papers, and with a carpet ornamented with an Oriental border, was typical decor. Liberty published richly illustrated books containing examples of chairs, overmantels, screens, and cabinets, plus hints on interior decorating. "Their work is as a rule simple, light and elegant as well as modest in price. The illustrations of screens are particularly spirited and crisp examples of design."[23]

Another style of screen praised by Liberty as being exceedingly artistic was the Moucharaby latticework from Egypt. One was advised that these were especially effective combined with Arabic cabinets, camphor or sandalwood tables, punkahs, and stained-glass windows of flowered design and splendid color, further emphasized by rich Turkish

embroideries and Eastern patterned ceiling papers. These riches prompted one designer of the eighties to say, "At no time was the furnishing and decoration of houses so easy as at present. . . . There is now an embarrassment of admirable materials."[24]

The Oriental influence was pronounced everywhere. Stylish rooms displayed at least one Japanese object or some ornament decorated with Japanese motifs. To supplement the flow of imported goods, and as a result of their overwhelming popularity, the West began to create its own derivative style, broadly based on Japanese principles instead of on strict imitation. This interpretive style, called "japonaiserie," became the nineteenth-century equivalent of the earlier chinoiserie invention. Japanese fans were favored by the ladies, whose parlors contained Japanese screens placed near tables displaying Oriental porcelains or lacquer boxes. Mario Praz tells us that the taste for japonaiserie began about 1856 and that by 1878 it was so widespread a critic complained, "It is no longer a fashion, it's an infatuation, a folly."[25]

During the latter half of the nineteenth century several of America's most distinguished artists commenced painting screens, introducing to this country an art form that is continuing to flourish today. Foremost among these early artists was James McNeill Whistler (1834–1903). From 1871 to 1872 he painted a screen entitled *Blue and Silver: Screen, with Old Battersea Bridge*. It is a nocturnal view of the Thames with the tower of Chelsea Church, a pier of Old Battersea Bridge, and part of Albert Bridge, then under construction. The screen consists of two panels in a frame that is decorated with flowers painted by the artist. The "lovely and beloved screen that stood in the yellow dining-room" of Whistler's house was left behind when Whistler went to Paris in 1892 and it was kept in the artist's studio until his death. It was bequeathed to the Hunterian Art Gallery at the University of Glasgow, where it is now located.[26] Although Whistler painted only one screen, he more than any other artist of the period made important use of the screen as the setting against which to place subjects for portraits and as backgrounds for compositions. One of his paintings, entitled *The Golden Screen* or *Caprice in Purple and Gold*, shows a lady dressed in Oriental robes, seated in front of a screen painted with a Japanese court scene. The screen was an essential element of the painting, since it was not only the entire background but also unified the various elements. Another of his works, *La Princesse du Pays de la Porcelaine*, shows a figure dressed in Oriental costume and holding her fan, while standing in front of a floral Japanese screen. This painting was sold to Frederick R. Leyland, who had commissioned it for his dining room, the Peacock Room, possibly the most famous of Japanese-style interiors designed entirely by Whistler and now in the Freer Gallery in Washington, D.C. Perhaps the Peacock Room was also the intended site of *Blue and Silver*, as Leyland had commissioned the screen as well.

Thomas Wilmer Dewing (1851–1938) was greatly influenced by his friend Whistler and had close associations with Whistler's patron Charles Lang Freer and with Freer's friend and business partner, Colonel Frank Hecker. Dewing admired

Whistler's work and may have seen his screen when he visited Whistler's London studio. The first two screens painted by Dewing are similar in form to Whistler's, both being two-fold with a continuous composition. This pair, entitled *Four Sylvan Sounds,* was painted for Freer in 1896–1897. The following year Hecker commissioned a pair of screens called *Classical Figures* for his own house. These screens were painted in muted tones and did not appear to their best advantage in their intended setting. Two years later Dewing painted a third pair of screens, *Morning Glories* and *Cherry Blossoms,* in atypical tones of bright yellow-green and blue-violet. Women are the subject of these screens; Dewing clothed them in classical robes and attempted to portray them as exalted figures.

Other paintings of the latter part of the century in which the Oriental screen is the essential feature of the background are Whistler's *Girl in Front of a Screen;* J.J.J. Tissot's (1836–1902) *Late Nineteenth-Century Interior with Children Playing Hide and Seek,* in which the screen provides the shelter; and Jules Emile Saintin's (1829–1894) *Distraction,* which was warmly received when it was exhibited in 1875 and which features Japanese fan, plate, and screen. John Singer Sargent's (1856–1925) painting of the *Daughters of Edward Boit,* commissioned in 1883, shows the girls playing on the floor in front of a screen and large Oriental jars. A photograph of the interior of Sargent's own studio in Chelsea some thirty years later shows his continuing affection for the screen, with a large Oriental one dominating one end of that room. It appears that Sargent did not paint a complete screen but did do one panel, collaborating with five other artists, in the making of a six-panel screen that is now in the Gulbenkian Collection in Lisbon.

Albert Pinkham Ryder (1847–1917) painted a number of screens from approximately 1875 to 1887 for the English firm of Cottier and Company. The National Collection of Fine Arts in Washington, D.C., has three leather panels painted for a screen depicting children and rabbits. The panels are separate but related by the repetition of the theme. Another screen by Ryder was apparently intended as a table screen, since the height of each panel is only twenty-seven inches. Another curiosity of this screen is that Ryder painted only two panels, with the third painted by a contemporary, Homer D. Martin. The panels are gilded leather and have a landscape theme; Ryder's are entitled "A Stag and Two Does" and "A Stag Drinking," while Martin's panel is called "Beech Trees Near a Pool."[27] Ryder never dated his paintings, so it is impossible to be precise about these screens. However, at the same time that he, Sargent, and Whistler were painting in a fairly traditional manner in England, on the Continent Europeans were creating screens that incorporated new techniques and embodied new ideas that anticipated the next century.

The folly of the 1870s became a madness during the 1880s and by the 1890s had spent itself, some of the decorative elements becoming transformed and flowing into the creation of the Art Nouveau style. The stylistic characteristics of Art Nouveau are quite distinct from those of japonaiserie, but it would not have developed without the inspiration of the

Japanese. The features of japonaiserie most often adopted by Art Nouveau were the use of exotic birds such as peacocks with their plumage dramatized and exaggerated for decorative effect, foliage rendered in a more abstract manner, and the tendency toward greater asymmetry. In the peak of Art Nouveau, symmetry was almost completely abolished, the style being dominated by swaying lines that became increasingly patterned and less supportive of any form as well as by foliage that lost its attempt at realism by the excessive intertwining of stems, leaves, and tendrils and by figures that abandoned structure and independent stability. The peacocks remained popular, but were rivaled by cranes, guinea fowls, herons, and bats. Birds and animals became threatening and suggestive of decadence and malevolence. The delicate Oriental ladies in their flowing robes dissolved into limpid female forms, usually nude, whose hair swirled modestly over the body, becoming almost indistinguishable from the tendrils of the foliage and from the curving forms of the object itself. The symmetrical and formal foliage of the Arts and Crafts movement was now transformed into a tortuous, unpredictable form that provided an elaborately contorted background.

The exposition at Turin in 1902 occurred during the peak of the style, and a number of screens made by craftsmen throughout Europe were presented. In some of the screens, the emphasis was on the ornate carving of the panels, often with insets of glass. In others, foxes or wild monkeys might suggest evil, with the palms and chrysanthemums of earlier popularity replaced by long-stemmed lilies or swaying poisonous oleanders. People were not frequently represented except as decorative elements, such as in a screen showing a girl picking grapes. She is included so that her hair may be entangled with the vines, and the two together form the framework of the screen. Also in the exhibition was a screen by Carlo Bugatti (1856–1940). Bugatti, whose name is more often associated with the automobiles designed by his family, had been designing furniture in Milan since 1885. The screen shown in the exhibition was made of painted vellum, polished copper, and carved and painted wood, topped by silk tassels. The screen was part of a suite of furniture.[28]

A screen made in Prague and shown in the exhibition presents the old theme of knights and dragons, but the knight is no longer romantic and gallant; the current feeling is sinister, and the scene is dominated by the evil of the dragon and the threatening birds hovering overhead.

Art Nouveau had two aspects; one was an outgrowth of its predecessors, and the other, with more simplified, sculptural lines, looked toward the future. However, the Art Nouveau style was short-lived. It reached its peak by the end of the century, and lingered on during the first decade of the twentieth century. It had been an outgrowth of attempts during the latter part of the nineteenth century to encourage individual crafts and design in opposition to the ugliness of mass-produced art and furniture, but as Art Nouveau became more popular, the design and quality became poorer, and the very elements it had been intended to combat overtook and destroyed it. But Art Nouveau had served its purpose by demonstrating that it was not necessary to turn to the past for designs, and for the individual artist it opened up a new awareness of the potential for creativity in design.

**N**amban screen
depicting harbor
scene. Edo
(Tokugawa) period,
seventeenth century.
Courtesy of the
Smithsonian
Institution, Freer
Gallery of Art,
Washington, D.C.

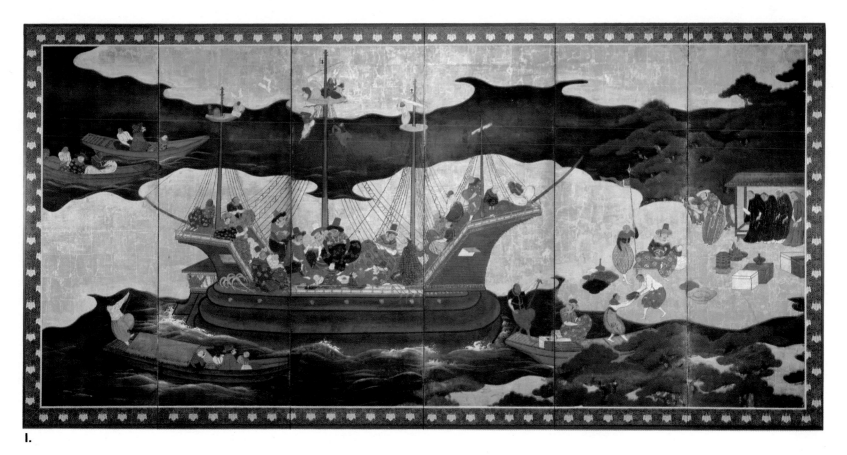

I.

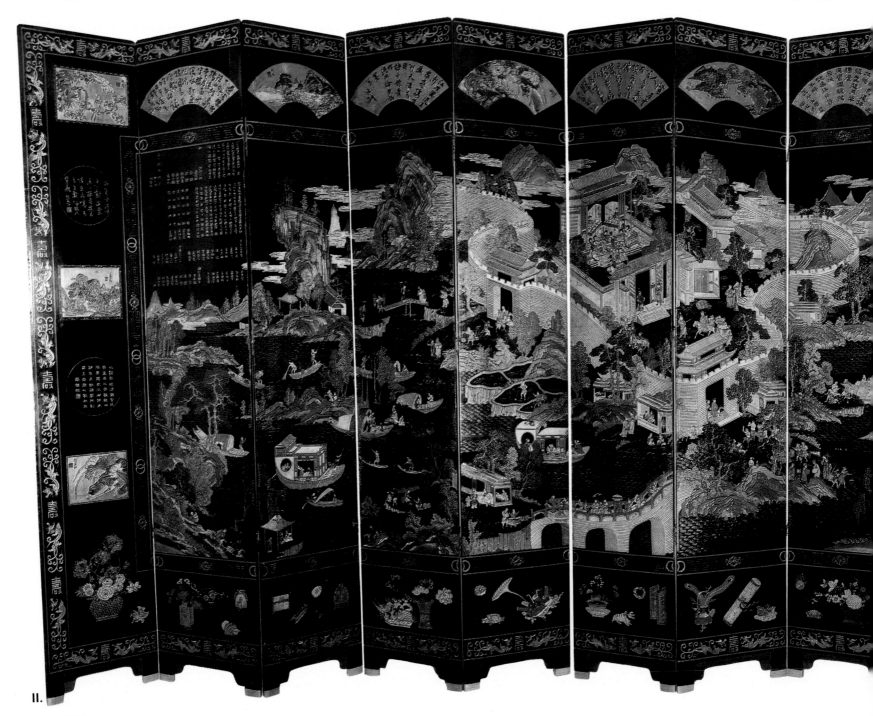

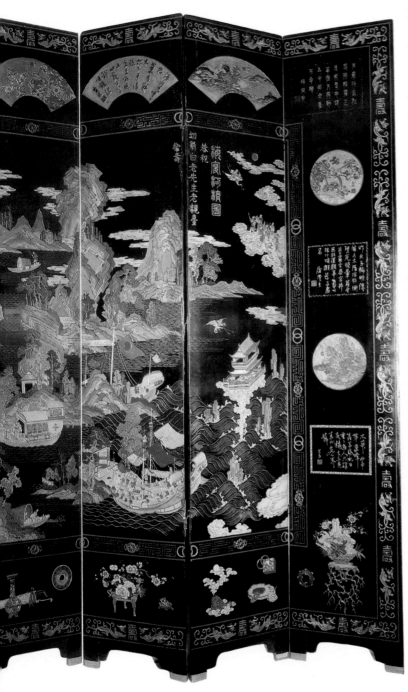

**Plate II.**
Twelve-fold Coromandel screen with a scene of a birthday celebration. Borders display fans and other objects. The calligraphy in the medallions includes poems and the names of the guests. The reverse of this screen is shown on page 29. Private collection, New York.

**Plate III.**
Savonnerie screen, one of an identical pair. French, eighteenth century. Collection F.-G. Seligmann, Paris. Photograph by Jacqueline Hyde.

III.

**Plate IV.**
Detail of embossed and painted gilt leather. Flemish, circa 1710–1720. Leather treated in this manner was made throughout Europe in various patterns and colors for use in screens. Victoria and Albert Museum.

IV.

131

**Plate V.**
**N**apoleonic emblems
decorate a tapestry
screen that was part
of the suite of
furnishings supplied
by the Gobelins for
the Grand Cabinet of
the emperor at the
Tuileries about 1810.
Musée de Louvre,
Musée Nationaux.

**Plate VI.**
**W**allpaper screen
with panels
representing
"Winter," "Europe,"
"Asia," "Africa,"
"America," and
"Summer." French,
early nineteenth
century. The Art
Institute of Chicago,
gift of Paul
Rosenberg.

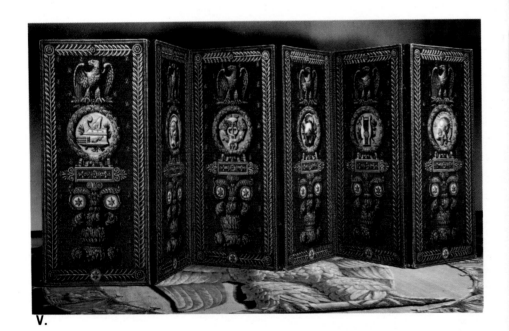

V.

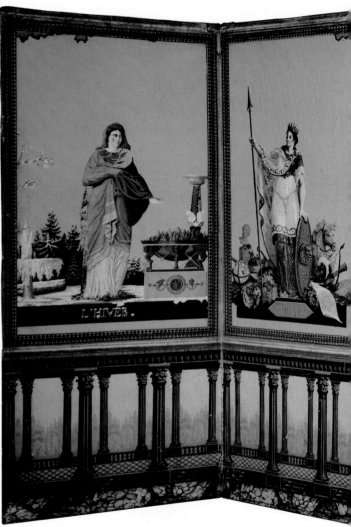

L'HIVER.

VI.

132

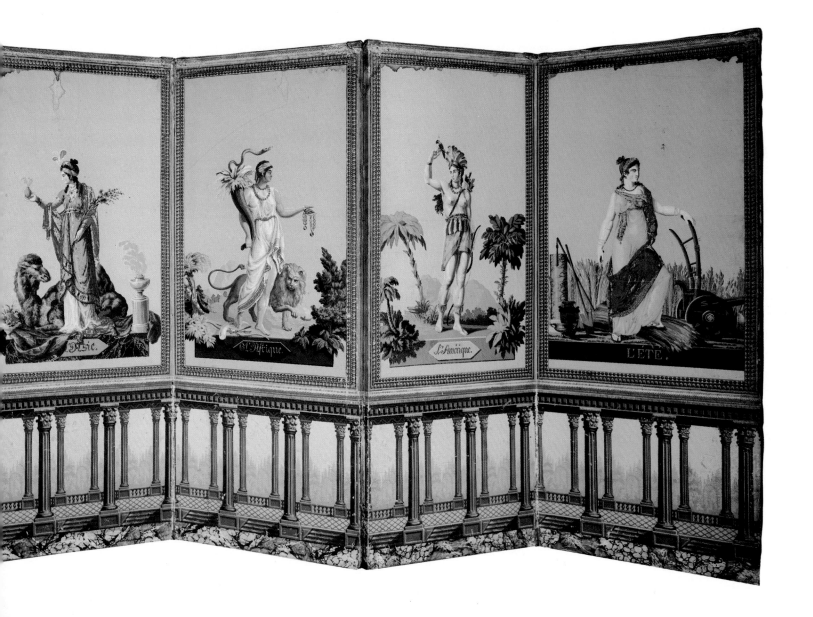

133

**Plate VII.**
*Blue and Silver: Screen with Old Battersea Bridge* (1871–1872), painted by James McNeill Whistler, who also decorated the framework with flowers. Hunterian Art Gallery, University of Glasgow, Birnie Philip bequest.

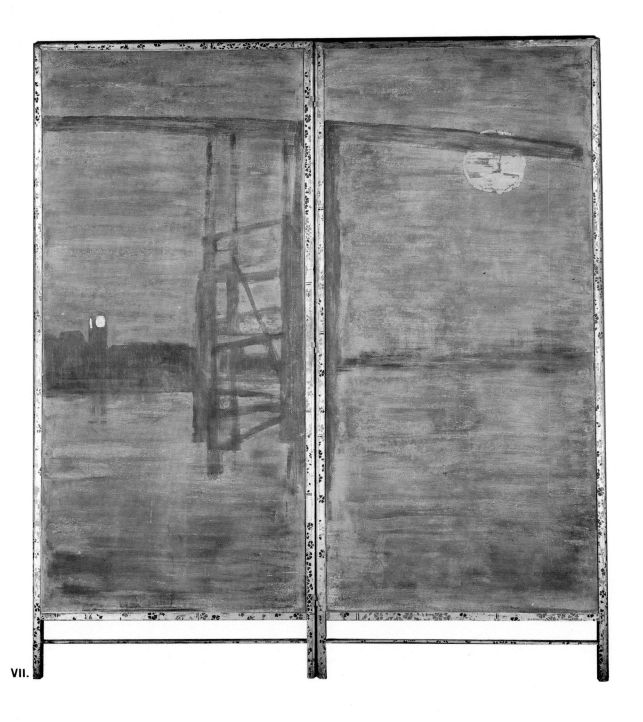

VII.

**Plate VIII.**
*Le Tryptique de Pont-Aven* (1891), a Breton scene painted by Paul Sérusier. Courtesy Bellier Collection, Paris.

**Plate IX.**
*La Place Vintimille* (circa 1908), a five-part screen painted by Edouard Vuillard. Collection Mrs. Enid A. Haupt, New York.

**Plate X.**
*The Red Screen* (1906), by Odilon Redon. Collection State Museum Kröller-Müller, Otterlo, the Netherlands.

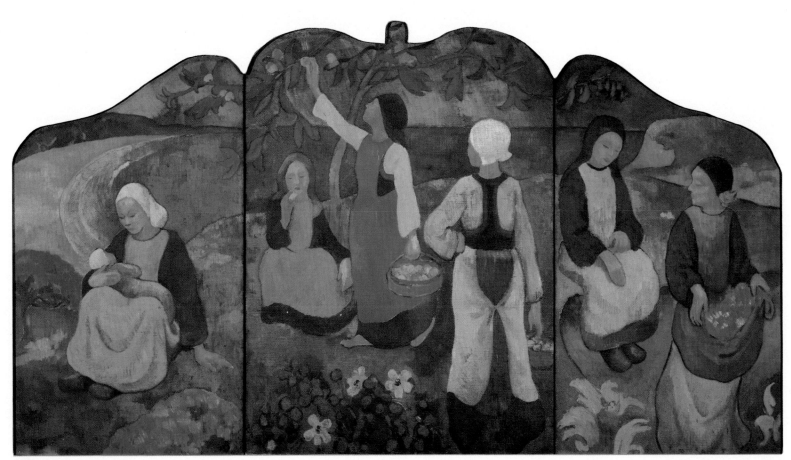

VIII.

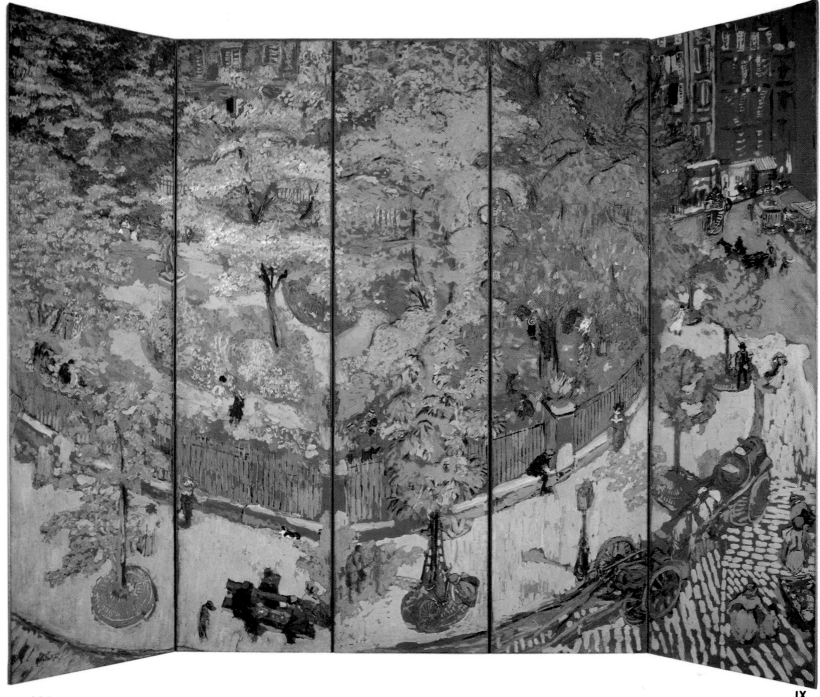

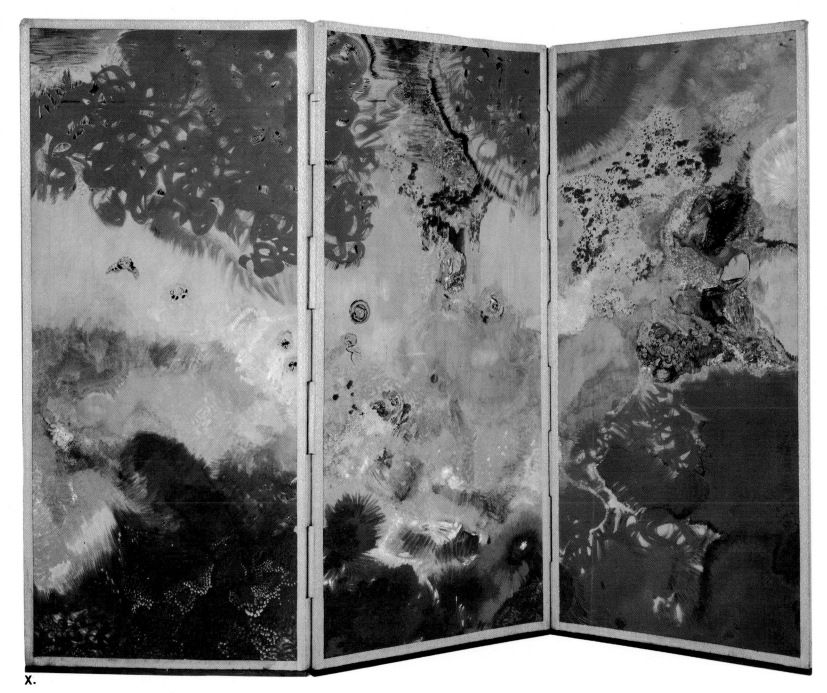

X.

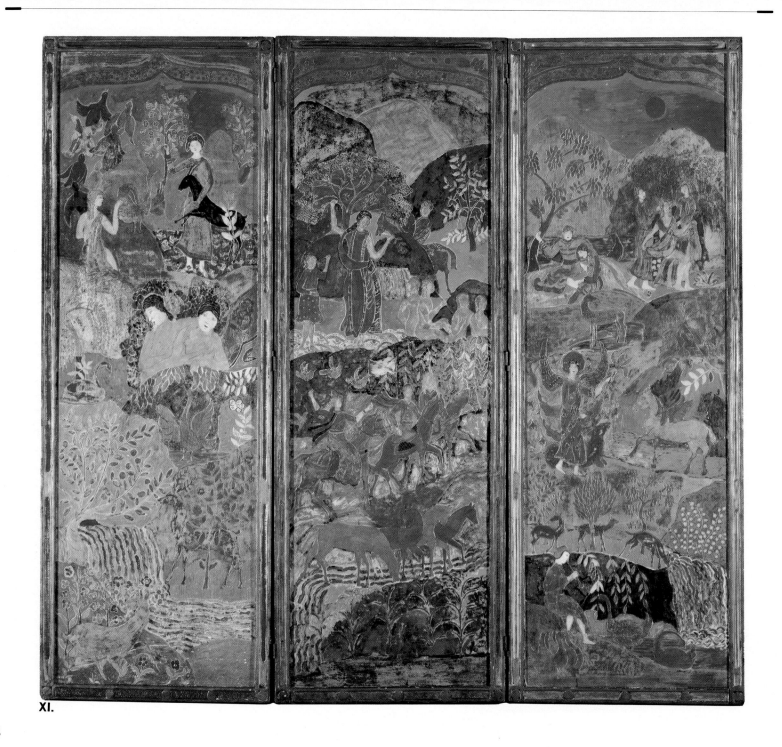

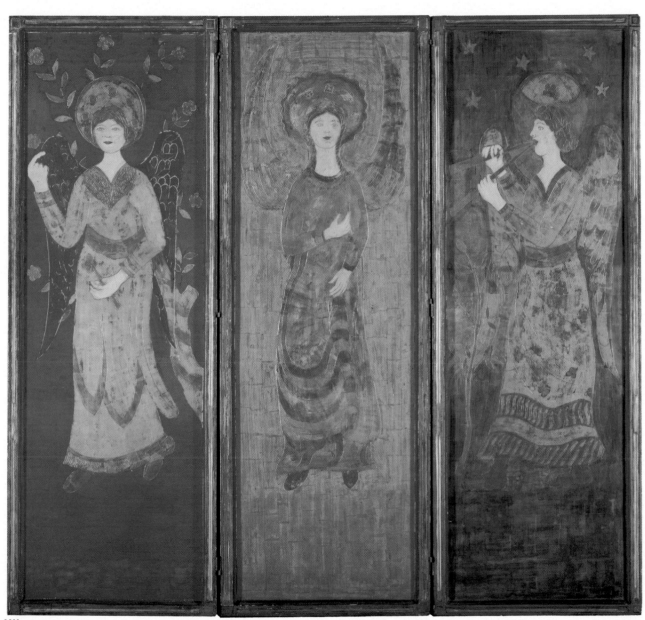

**Plate XI.**
*Screen* (1916–1917), by Charles Prendergast. The three panels are oil and gesso on wood with gold leaf. Collection Mrs. Marjorie Phillips, Washington, D.C.

**Plate XII.**
**R**everse of the screen opposite.

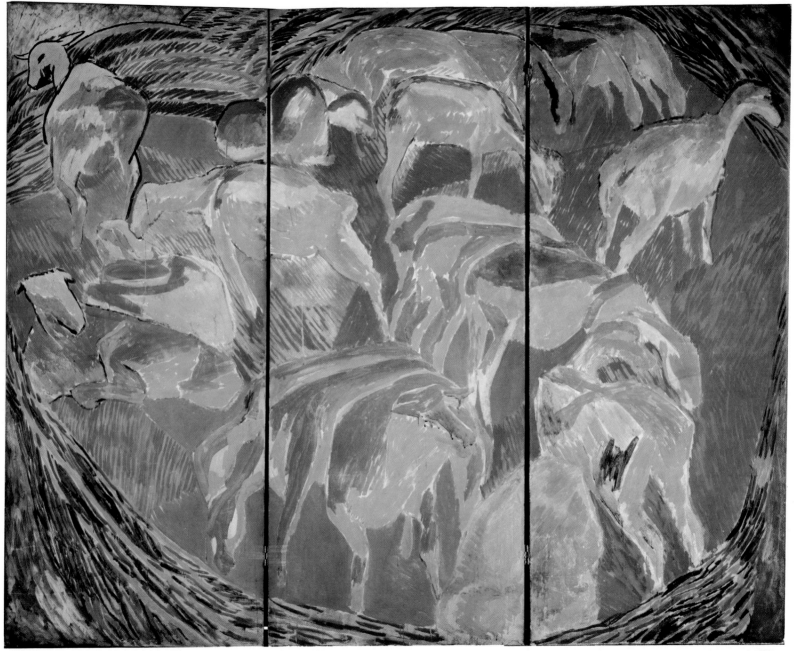

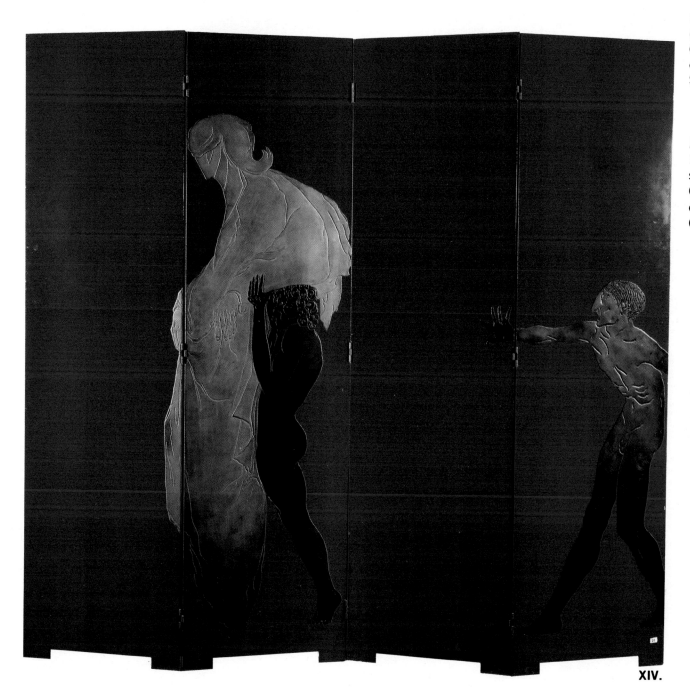

**XIV.**

141

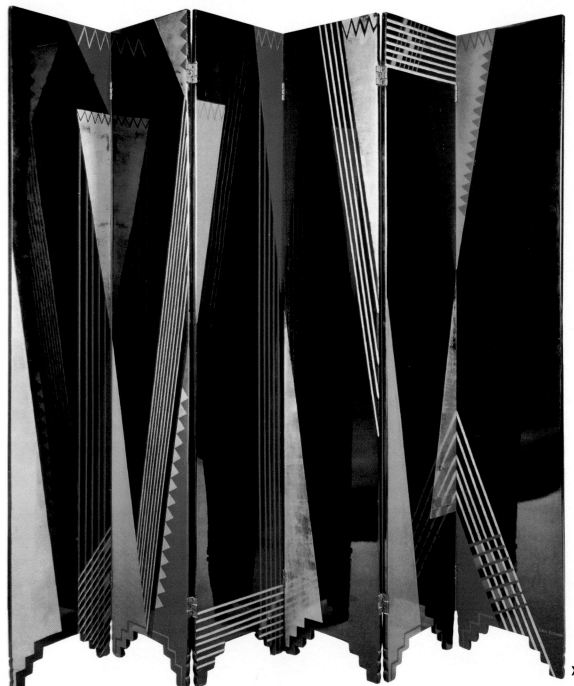

**Plate XV.**
Untitled red, black,
and gold lacquer
screen (circa 1925),
by Jean Dunand.
Photograph courtesy
Philippe Garner.

XV.

142

**Plate XVI.**
*Two White Mountain Goats* (1932), by Charles Baskerville. Cooper-Hewitt Museum, the Smithsonian Institution's National Museum of Design; gift of Charles Payson.

XVI.

# 5. DECORATION INTO ART

Toward the end of the nineteenth century a notably important new development was emerging from the confusion of crafts and styles that had coexisted—often competitively, usually unsuccessfully—and were, mercifully, frequently short-lived. Up to 1890 the screen, with rare exception, had been made by craftsmen, was usually decorated by an unknown or relatively minor artist, and fell into the classification of furniture. Screens had existed primarily as functional objects, and although they were often decorated with extraordinary skill or lavishness, the decoration occurred as a result of wanting to beautify a utilitarian object. As the twentieth century approached, technology had advanced to the point that it created a more comfortable environment, thereby reducing the practical function of screens, so that one might have expected them to be relegated to attics or antique shops. Improvements in central heating and in building techniques, such as insulating materials and storm windows, reduced unwelcome drafts and made it possible to maintain the desired temperature. The advent of air conditioning increased the level of "climate control," with the construction of buildings that not infrequently had permanently sealed windows. It is therefore surprising that the screen was not then considered an old-fashioned object, soon to be forgotten. Instead, something quite different happened. The screen, while maintaining its old-fashioned form, embarked on a new role—that of an expanded decorative accessory and an artistic medium on which many of the most prominent and distinguished designers and artists would demonstrate their talents. Screens, decorative panels, and murals began to be viewed as enlarged platforms that would permit the artist to release the painting from the confines of the easel picture, enabling him to paint with the freedom of the new age, and, with the advent of the professional interior decorator, the screen also became a valuable device for achieving mood, harmony, or unity within an interior space.

By 1890 the artistic excitement of Europe was centered in France, where painters and writers were protesting the stodginess of the Second Empire and the analytical attitude of Impressionism. A group of artists and fellow students, aware of mutual attitudes and dissatisfactions, formed what came to be called the Nabis, from the Hebrew word for "prophet." Led by the painter Paul Sérusier (1863–1927), they had been converted by the work of Gauguin and aspired to new goals. Among those in the newly formed group were Edouard Vuillard (1868–1940), Pierre Bonnard (1867–1947), Armand Séguin (1869–1903), and Maurice Denis (1870–1943). This remarkable group of men belonged to the intellectual world, were influenced by Baudelaire and Mallarmé, and involved themselves in the activities of literary and theatrical circles. They were well aware of earlier artistic movements, such as the Pre-Raphaelites, but tended to disassociate themselves from that group, although some of the Nabis' work bears a striking resemblance to that of Burne-Jones and Rossetti.[1]

The Nabis thought the Pre-Raphaelite work intelligent and delicate but disapproved of its restrained use of color. Whistler, however, while acclaimed by the Pre-Raphaelites for his use of

Japanese arabesques instead of medieval inspirations, was also a strong influence on the Nabis, and Bonnard became known as *le nabi très japonais.* It is astonishing to read of the breadth of activities of this group in numerous decorative areas, especially in theatrical designs, posters, and book illustrations. The work of Paul Sérusier, the founder of the group, shows the extraordinarily close and dominant influence of Gauguin, with whom he worked in Brittany. His paintings are set within this framework, wherein "he took contemporary scenes and endeavored to render them eternal by seeking to bring out the latent beauty through the ageless costume of the Breton."[2] In 1891 Sérusier painted a decorative triptych, *Le Triptyque de Pont-Aven,* that represents a "kind of Eden, at the side of the original sea, where six young Bretonnes taste the pastoral peace of a Golden Age."[3] The form of the screen, with its undulating lines, echoes the embracing forms of the shoreline and the gently curving contours of the women's bodies, clothed in aprons and bonnets that continually repeat the flowing line.

For the Nabis, easel painting was a minor art; their first love was the decorative panel. Regarding Vuillard, we are told that "his ambition . . . was not to paint easel works, but to decorate walls, to produce works in the same category as the fresco, the tapestry, the stained-glass window, or theatrical decor."[4] "The painter's work begins where the architect decides his work is finished. Give us walls and more walls to decorate. Down with perspective."[5] Vuillard received inspiration for his decorations from contemporary artists, Japanese prints, and Art Nouveau works. He also derived ideas for wall decorations from the works of William Morris and the Pre-Raphaelites. He desired to create an overall flatness so as not to destroy or penetrate the nature of the surface he was decorating. In spite of a professed preference for larger decoration, he was simultaneously doing easel paintings and portraits. For Vuillard the portrait remained inseparable from the decor surrounding the sitter; he saw the curtains, furniture, and walls as an extension of the artist's personality.[6]

In addition to his decorative panels, wall paintings, and screens, he did sets for the Comédie des Champs-Elysées in 1913 and collaborated with Bonnard on other productions.

Pierre Bonnard also experimented with screens in the 1890s. He felt that painting must have style, imagination, and changing shapes, and that one should not strive after the objective truth of nature but should impose one's own personality. Maurice Denis, a fellow Nabi, said that "art is a caricature,"[7] an idea Bonnard espoused. Bonnard specialized in decorative work before he became an easel painter, portraying the life of the bourgeoisie. In his studio at 28 rue Pigalle he painted scenes of his neighborhood, parks, and domestic subjects. Between 1891 and 1902 he created four screens, three portraying bourgeois scenes and the fourth a more mystical theme.[8] *Femme au Jardin,* painted in 1891, consists of four female figures, one on each panel, in unrelated poses or activities. The panels are rather unimaginatively called "Woman in Spotted Dress," "Seated Woman with Cat," "Woman in Checkered Dress," and "Woman in Blue Cape."

To be fully appreciated this screen should be

*Femme au Jardin* (1891), by Pierre Bonnard. The four panels are titled "Woman in Spotted Dress," "Seated Woman with Cat," "Woman in Checkered Dress," "Woman in Blue Cape." The stylization of the figures and the details of nature suggest Japanese and Art Nouveau influences. Oil on canvas. Collection Mrs. Florence Gould. Photograph courtesy Wildenstein and Co., Inc.

*T*he
*Pleasures of Life*
(1890–1891), by
Armand Séguin.
Private collection.

seen in color, for the fresh yet muted tones perfectly balance the contrasting patterns and create a pleasing motion and harmony.

A few years later Bonnard painted a screen of vignettes of Parisian activities, a combination of street and park scenes. Each panel is independent of the others and after being exhibited together in 1948 were later separated, misplaced, and altered.[9] *Promenade des Nourrices, Frise des Fiacres* (Nursemaids Strolling, Freize of Hackney Cabs) repeats these same themes. A string of horse and cabs proceeds across the screen near the top, while gossiping nursemaids and their charges, happily engaged in hoop rolling, occupy the foreground. The empty spaces and diagonal lines suggest an Oriental composition. One panel bears his signature, and another is initialed "PB." In 1902 Bonnard painted a six-leaved screen different in feeling and subject from his earlier ones. This screen is more visionary, a strange combination of caricature and illusion. In the lower part of the panels whimsical rabbits, sparsely drawn, frolic against a barely suggested background. Suspended above them is a nebulous area in which embracing figures are visible yet blur into the surrounding ether.

This last screen of Bonnard's is closer in spirit to those painted by Odilon Redon (1840–1916), a senior member of the Nabis. Redon's work is extraordinary in its complexity, showing many of the influences that helped form Vuillard's work. Of all the Nabis he gave vent to the greatest expression of fantasy and dreams, strongly influenced by Edgar Allan Poe's aphorism that "all certitude lies in dreams."[10] Redon's decorative works, including framed pictures, folding screens, and mural paintings, number over one hundred. "This is the least known aspect of his work and deserves to be best known. In the literature on the painter, with one exception, it is not mentioned at all."[11] Speaking of his folding screens a biographer says, "Nothing would be calculated to afford a better idea of Redon's work in colour, of its compass, modernity and decorative foundations."[12] During the years from 1901 to 1912 Redon painted a total of sixteen screens. The subjects of these screens are poetic and imaginary expressions. The subject matter ceases to dominate and becomes irrelevant to the inventive use of color. He employed symbolist imagery with avant-garde use of color to transform the subject into a glorious colorful fantasy. In 1906 he painted *The Red Screen* for his friend and patron André Bonger. Here Pegasus, a favorite subject, ascends from a cloud of glowing color—predominately reds, infused with light and vitality. This brilliant use of color is all the more extraordinary in a man who made somber, introspective black-and-white lithographs during the creative years of his youth. A work called *Buddha Screen* reflects Redon's involvement with religious, fantastic, and mythological subjects. He was fascinated with Eastern beliefs and intended this screen to be implicitly religious. In this screen he paints the Buddha as mysteriously obscure, sitting under a tree amidst a profusion of flowers.[13] Titles of other screens include *Flowering Tree, Flowers, Plants, Oriental Carpet Fantasy, Undersea World, Spring, Day, Night,* and *Spring and Flower Goddess.*[14]

The work of one other French artist of the late nineteenth century must be noted, even though the

style of his painting was totally different from those in which his compatriots were working at that time and indeed from that of his own later work. Very early in his career, about 1860, Paul Cézanne (1839–1906) painted an exceptionally large screen (eight by fourteen feet) for his father's study. It is entitled *Feuillage et Scènes Champêtres* (Foliage and Country Scenes) and is in the tradition of French and English eighteenth-century screens. The six panels show figures enjoying country life amid the landscape of Aix-en-Provence. Each of the trees in the background is painted separately and the figures are confined to individual panels in deference to the limitations of the screen form, but they are all then unified by a wide floral border. The reverse side is painted with grotesques.[15] At this time Cézanne and Emile Zola were engaged in an active correspondence, and the painting represents themes of some of the poetry contained in the letters.

The Swiss artist Paul Klee (1879–1940) also painted a landscape screen as one of his early works. It is a five-panel screen, untitled, of the Aare landscape. In his diary of June 1904 he wrote, "Once I suddenly found myself by the shore of the Aare. . . . What a sight suddenly appeared; this emerald green water racing along and the shore golden in the sun! . . . Now it lay before me in all its splendor—shattering!"[16] Klee's style was to alter radically in his more mature years, and, as in the case of Cézanne, it is surprising to discover this early traditional screen.

In America two brothers whose links with the Nabis were well established were working in a similar style. Maurice Prendergast is the better known, but his brother Charles (1862–1948) excelled in the decorative arts. Starting as a framemaker for his brother, Charles progressed to painted and gilded gesso panels and made at least two screens. In 1916 to 1917 he made an opulent screen, which is a compilation of at least a dozen images. This screen was one of the early purchases of Duncan and Marjorie Phillips, founders of the Phillips Collection in Washington. "While his motifs were drawn from a wide range of exotic sources—Egyptian reliefs, Japanese screens or lacquer, Persian rugs and miniatures—his compositional techniques were very simple. Favorite tree forms, figures and groups were used repeatedly in different combinations."[17] A characteristic of his style was an indifference to logical relationships of scale and position, and the tendency to organize the picture in registers and horizontal planes. There is a marvelously varied rhythmic pattern. Costumes, flowers, fowl, and animals glow with his color and mastery of diapering, as well as with the modulations of different shade of gold leaf.[18] The theme of Eastern figures and the winged horse, and the use of radiant color, are closely allied to the work of Redon, while the superb use of gesso and gilt recalls the screens of an earlier period.

At the time Redon and Prendergast were working in France and the United States, respectively, a vigorous center for the decorative arts was developing in England: the Omega Workshops. This group, organized by the art critic Roger Fry (1866–1934), opened its doors in July 1913. Here, for the first time, the public could see tables and

Screen by Charles Prendergast. Private collection, New York.

*Provençal Valley*, an Omega Workshops screen made by Roger Fry in 1913. Private Collection. Photograph courtesy Richard Shone.

**F**igures of women in an abstract landscape painted by Vanessa Bell. This untitled screen was exhibited at the opening of the Omega Workshops in 1913. Photograph courtesy Victoria and Albert Museum.

chairs, pottery, carpets, and curtains in which the then outrageous principles of Cézanne and Gauguin were translated into applied art. Fry's primary objective was the formation of a studio where young artists could work and receive a minimum weekly payment. There they could sell their work anonymously under the name of the Omega Workshops.[19]

The Workshops' most obvious precursor was Morris and Company, which in its later years had deteriorated into a firm that merely produced arts and crafts articles and ornamentation, having lost its real sense of design. Fry, on the other hand, wanted to promote good design and bring the artist and designer into a closer relationship with the craftsman. Unlike Morris he had no objection to using the machine to achieve these goals. Like their predecessors, the artists involved with the Workshops had vital literary connections but of a totally different orientation, and this association cannot be separated from their work or activities. Omega Workshops was located at 33 Fitzroy Square, in the heart of Bloomsbury. Active in its circle were Lady Ottoline Morrell, Virginia Woolf, Clive and Vanessa Bell (Virginia Woolf's sister), Duncan Grant, James and Lytton Strachey, Wyndham Lewis, and, of course, Fry. Four of these members produced a number of screens.

In March 1913 Fry organized the first Grafton Group Exhibition, which showed, among many others, works by Vanessa Bell, Fry, Lewis, and Grant. Among the objects of the applied art was a screen by Duncan Grant (1885–1978) "decorated with brilliant blue sheep which created a stir, though *The Times* critic was quickly appreciative in spite of its color."[20]

The public was shocked by the distortions but conceded that "even outraged aesthetic virtue might admit that the general effect of the exhibition was gay, even though it be the gaiety of determined evil doing."[21] Duncan Grant, while central to the Bloomsbury group, was also circulating among the artistic world of Paris. He had lived in Paris as a young man and visited the exhibitions of the Impressionists. In 1909 he met Gertrude Stein and visited Matisse's studio. At that time his large unstretched canvas for *La Danse* was in his studio.[22] *The Blue Sheep Screen* (1912) immediately calls to mind that painting. The screen, both in color and form, suggests Matisse, and the movement of the sheep within the circular form is very similar to that of the dancers.

In the Omega opening Fry included "tables and chairs, fabrics, bedspreads, clothes, large decorative curtains, screens, designs for murals, and a miscellany of pots, parasols and pencil boxes. . . . Screens were a feature with one by Wyndham Lewis called *Circus*—showing a slim little acrobat balancing on a strong man's shoulders next to a curly-haired woman with a whip and a clown beyond [all painted with artistic license]. (But how much wit there is in those figures, Roger told an interviewer. 'Art is significant deformity.') A screen by Duncan [Grant] showed two long-waisted figures carrying a great blue pail across the four red panels as though part of some oriental procession. Another by Vanessa [Bell] showed four women crouching against a tent and tree-like landscape rising to a point from a dark pool below."[23] The representation of objects, reduced to Cubist shapes and planes, and the distortion of color, such as

the women painted a strong acid green, caused disturbance and comment among the viewers. The other colors are vermilion, gold, blue, and black, creating a bold and unified composition, but not one that would gain ready acceptance at that time. One of the screens for sale was Grant's *Lily Pond Screen,* with its swirls of red, yellow, and green paint on a black ground. It is almost impossible at this time to appreciate the shock these colors produced when the screen was first shown. Spontaneity and freedom of treatment spelled decadence, dreadful taste, and every kind of loose behavior.[24]

At the time of the Omega Workshops other events were occurring that had their impact on the group. Diaghilev's Ballet Russe was enjoying well-deserved acclaim, and its dramatic use of color and its exotic images were especially suitable for large-scale decoration. "Dancers and acrobats were a particular feature, as for example in Wyndham Lewis's screen shown at the opening of the workshop."[25] Grant painted a screen inspired by the theater and dance, with a harlequin figure, ballet dancers, and a musician. The Theâtre de Vieux Colombier was started in the same year, and Jacques Copeau was the producer. He commissioned Grant to design the costumes and screens for a French production of *Twelfth Night.* Grant completed the costumes, some made from Omega fabrics, and the scenery. The production received high praise and, later, after World War I, went to New York, where screens painted by Grant were added to the decor.[26]

The second Grafton Group Exhibition opened the next year, following the excitement of the Omega opening. Included in the show was a screen painted by Roger Fry entitled *Provençal Valley.* He had visited Provence the previous year, where he discovered a valley at Aramon near Avignon that became the subject for the screen.[27]

The Omega Workshops was a short-lived affair, closing its doors in 1919 due to changing tastes, lack of new artists, and the burden that trying to run a business placed on creative people. A sale in June scattered its contents, but the artists continued painting fabrics, pottery, and murals. The fame of Vanessa Bell and Grant continued to grow, and in 1932 the Lefevre Gallery installed a complete room decorated with murals by Bell and Grant. The opening was celebrated at a party given by Virginia Woolf and her sister. The room was widely reviewed in the press, and Cyril Connolly called it "a rare union of intellect and imagination, colour and sound, which produced in the listener a momentary apprehension of the life of the Spirit."[28] At the end of the room was a small three-panel screen painted by Bell that showed three seminude female forms of quasi-classical inspiration with musical instruments. After the exhibition it was bought by Virginia Woolf.

Duncan Grant continued to paint screens throughout his long and productive life. His *Character from the Italian Comedy,* painted in 1964, may have been his last screen, but he continued to work until his death in 1978. At a retrospective exhibition of his work he was credited with having translated the idioms of Cubism and Fauvism into the decorative arts.[29]

During the early decades of the twentieth century a revival of a highly esteemed medium was occurring: the technique of lacquering. The richness

*Lily Pond Screen* (1914), by Duncan Grant. This oil-on-canvas screen bears the Omega mark at the bottom of the right panel. Courtauld Institute of Art (Fry Collection). Photograph courtesy Victoria and Albert Museum.

and depth of the lustrous lacquer surface was to be as highly admired as in the seventeenth century, but the treatment of the surface and the decoration were to be completely contemporary. Black remained the most popular background color, but during the 1920s it was rivaled by a brownish-red color called "tango." A hard dark green and olive were popular, as were the ocher shades, these colors being obtained by the addition of vegetable dyes.

Lacquer screens became particularly popular in France during the twenties. Several artists are recognized as masters of the craft, among them Jean Dunand (1877–1942), a Swiss, and Eileen Gray (1879–1976), an Anglo-Irish. Both lived in Paris, Dunand showing his work there in the Exposition Internationale in 1900. He started his career as a sculptor but soon made his reputation with his metal-work. He worked with Japanese craftsmen, exchanging his knowledge as a coppersmith for their secrets of lacquerwork. His early work is mainly vases made of chased metals—copper, pewter, steel, and silver. He soon experimented with surface color for these objects, and in so doing developed the decorative colors, motifs, and materials he would also use on his screens. His chosen colors were the browns and greens of patinas, and one of his favored surface treatments was incrustation, using soft metals, such as gold, silver, or nickel, and pouring them into cavities cut in the surface of the background material. The designs are sometimes halfway between naturalism and abstraction (stylized flowers and vegetables), while others are strictly geometrical (dotted, vertical, or parallel lines, spirals, or checkered patterns). He is credited with the revival of the Oriental art of

**F**our-panel lacquer screen (circa 1925), by Jean Dunand. Female figures in a setting of geometric patterns and stylized floral designs. Photograph courtesy Philippe Garner.

A continuous scene of waterfowl at the water's edge, set against a gold background, spans two seven-panel screens by Jean Dunand. Photograph courtesy Didier Aaron, Inc.

**F**orty panels of black lacquer are ranged on metal rods on a screen by Eileen Gray, one of several variations that use different numbers of panels. Some versions have white blocks instead of black. Private collection. Photograph courtesy Philippe Garner.

inlaying minute particles of crushed eggshell into the surface of the lacquer before it dried. Each piece was set in by hand and separated by the thinnest thread of lacquer. This decoration was used on screens and illustrates his meticulous and patient craftsmanship. Sometimes he would juxtapose flat areas against brilliant areas, or create the tactile interest of *lacque arraché* by adding coarse earth to the lacquer, then smoothing it with a spatula.[30] Two screens made in collaboration with Jean B. Soundbinine exemplify this technique at its best. The screens, entitled *Pianissimo, Screen of Fallen Angels,* and *Fortissimo, Screen of Soaring Angels,* were commissioned by the Guggenheim family and are of monumental scale. The background is a deep blue-green dusted with gold in subtle geometric forms that suggest rays. The encrusted gold figures stand out in high relief, as do the gold-and-brown boxlike forms below them that represent skyscrapers. The sky contains swirls of clouds formed by crushed, almost pulverized eggshell that was applied as the layers of lacquer were built up. Many of Dunand's designs were inspired by the decorative Cubists such as Robert Delaunay, African art, japonaiserie and the pyramid forms reflecting the then current fashion for Egyptian design. In 1921 a group show by Dunand, Jean Goulden, Paul Jouve, and François-Louis Schmied was held in Paris, displaying a large number of their screens. Usually Goulden and Jouve drew the designs that Dunand transposed into lacquer. They combined the talents of designer, painter, enamelist, furnituremaker, and lacquerer. It is hard to separate the work of each, but together they produced a prodigious quantity. Favorite subjects were animals, such as a silver rabbit with

eyes inlaid in opaline or a jungle scene with wild beasts and birds of prey.[31]

Dunand worked with the top fashion designers of the period—Vionnet, Schiaparelli, and Boulanger—creating belts, buckles, bracelets, and even a hat with eggshell-and-lacquer decoration. He employed as many as one hundred craftsmen in his studio, and was commissioned to design large lacquer panels for the *Normandie* in 1935. The walls of the smoking room of the luxury liner were covered with panels of carved lacquer, twenty-two feet high and twenty-seven feet wide, depicting various sporting activities. To avoid the lacquer being damaged by the ship's movement, the panels were divided into smaller sections.[32] Dunand was assisted in this work by his son Bernard, who also made screens and was awarded a grand prize at the Exposition Internationale in Paris in 1937.

Eileen Gray learned the art of lacquer from Sougawara, the same teacher who had taught Dunand, but their work bears little similarity. Whereas Dunand's screens, which were created for their decorative effect, could be called Art Deco, Eileen Gray was firmly opposed to the term. Gray approached her screens with an architectural point of view and thought of them as part of a whole decorative scheme. In 1928 she opened a gallery in rue du Faubourg St.-Honoré that offered lacquer screens and furniture, as well as a complete decorative service.[33]

In 1913 the couturier Jacques Doucet commissioned a four-panel lacquer screen later entitled *Le Destin.* This allegorical scene of a youth gazing in anguish at the destiny that burdens another youth, himself unaware of the load he is carrying, uses

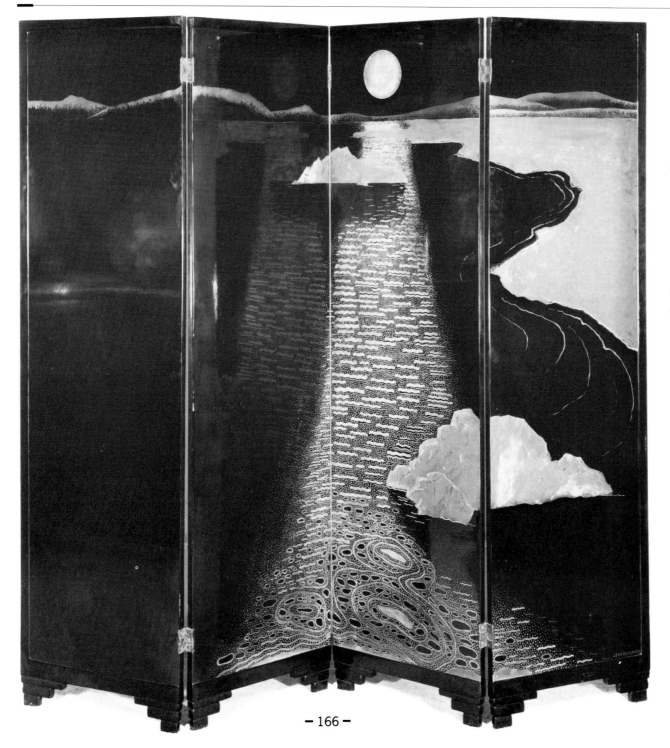

*M*oonlight (circa 1926), by Jean Dunand. The black lacquer background is decorated with silver and matte lacquer. Photograph courtesy Didier Aaron, Inc.

broad areas of undecorated lacquer. The figures are green-bronze and silver on a red ground, and the reverse side is boldly decorated with black and silver in geometric patterns.

Miss Gray believed that "lacquer should be seen as a new material, divorced from all association with the Chinese Coromandel screens or Louis XV furniture." In her attempts to create interiors devoid of the least historical references and even of ornament derived from nature, she evolved a personal decorative idiom based on geometrical shapes, carried out in *les tons fauves et nocturnes*—a style so individual as to appeal only to a limited public but nevertheless anticipating the modernism of the latter years of the 1920s.[34] A screen made in 1923 was described by Roy Strong, director of the Victoria and Albert Museum, as "fabulously chic, most sophisticated."[35] This screen is black lacquer on one side with a red ground on the reverse side, decorated with scoring and areas of applied silver leaf and bronze. It stood in the artist's apartment until her death in 1976 and is now in the collection of the Victoria and Albert.

A late screen of Miss Gray's is illustrative of a whole new concept. It consists of twenty-eight panels of black lacquer mounted in rows on four vertical brass rods, seven panels to a row. Each of these rectangles is the same: a plain lacquer panel with a slightly recessed panel in the center. The bricks are mounted on the rods in such a way that their position may be changed, and the screen forms a free-standing three-dimensional sculpture. It embodied the idea that light and space can be active components of a work of art—a very advanced idea for 1924. This screen was designed for the apartment of Suzanne Talbot, one of the most successful modistes in Paris. The walls were paneled in the same material. Gray made two variations on this screen by adding horizontal rows and varying the size of the panels, and also created screens using white instead of black bricks. Shortly after completing these screens Gray left the decorative arts for a career in architecture. She formed with Le Corbusier and others the Union des Artists Modernes, which thought of furniture as being inseparable from its surroundings, an integral part of the way architecture functioned.[36]

The works of Dunand and Gray, while different from each other, illustrated a developing trend and the beginning of a whole new concept in which the screen played a significant role. This was partly triggered by the opening of the 1925 Paris exhibition, Internationale des Arts Decoratifs et Industriels Modernes, the importance of which it is difficult to exaggerate. It was the first exhibition of an international scale in over a century in which the decorative arts were the sole feature. The exhibits were limited to representations of contemporary life with no inspiration from any decorative style of the past. It was from this exhibition that the term "Art Deco" came into being. Prominent among the displays were screens, the creation of which was praised and encouraged by an emerging new professional—the interior decorator.

The exhibition brought together the creative work of the day and caused excitement among the exhibitors and viewers. The work of fashion and textile designers, furniture and carpet designers, and book, wallpaper, and poster designers all came together to heighten the potential of each. An

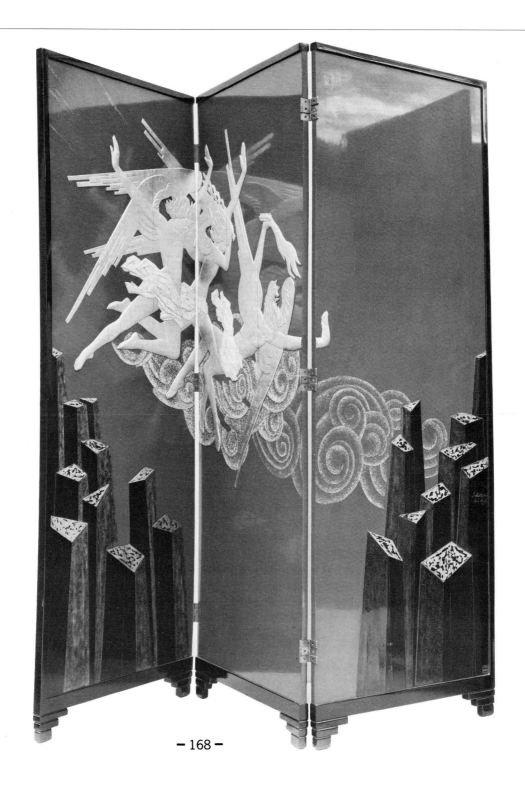

Pair of three-paneled lacquered wooden screens (1925–1926), by Jean B. Soundbinine and Jean Dunand. *Left: Fortissimo, Screen of Soaring Angels. Right: Pianissimo, Screen of Fallen Angels.* The Metropolitan Museum of Art, gift of Mrs. Solomon R. Guggenheim, 1950.

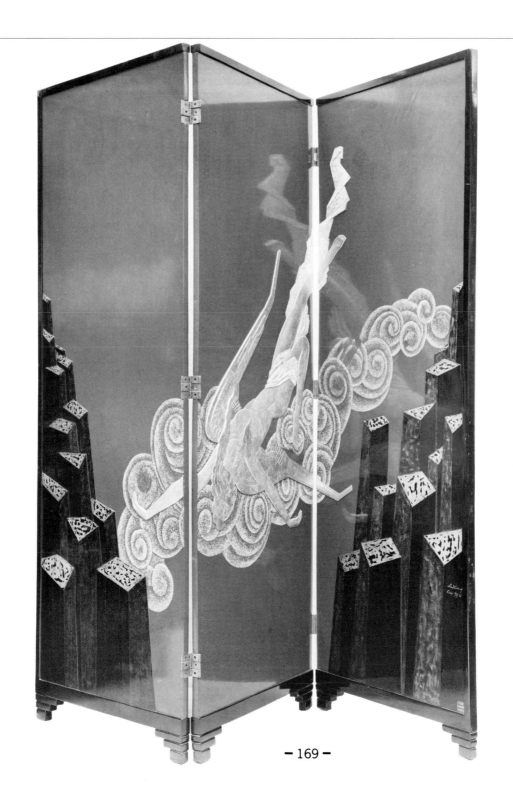

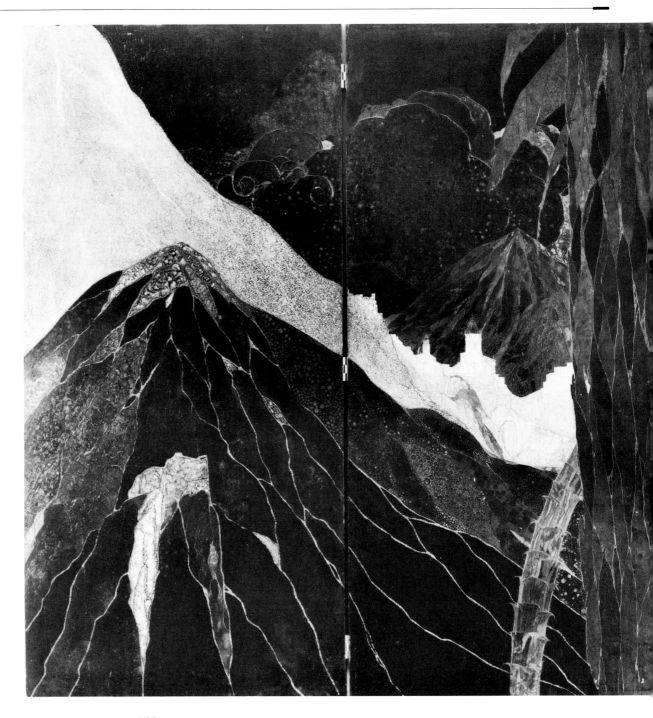

Three-panel lacquer screen inlaid with crushed eggshell (1928) by Gaston Priou. The Brooklyn Museum, Frank C. Babbott Fund.

American who was talented in several fields was Donald Deskey, who designed furniture, rug patterns, and fixtures for Radio City and the executive lounge for the New York World's Fair in 1939. His screens have typically bold designs of geometric forms. Sonia Delaunay (1885–1979) was one of those artists whose talents were expressed in fashion and textile design, rugs, posters, and book designs as well as in painting. In the exhibition of 1925 she exhibited her own creations, including her unique woolen tapestry coats, displayed before a four-panel screen that had each panel covered with a different geometric fabric of her design. That same year she established the Boutique Simultanée, where she sold her creations to forward-thinking women.[37]

Both she and her husband, the painter Robert Delaunay, had been somewhat influenced by the Futurist painters in Italy, active from 1909 until the end of World War I. Giacomo Balla (1871–1958), one of the leaders of the movement, attempted to portray the dynamic character of the twentieth century by painting in a manner that represented several aspects of form in motion simultaneously. He completed at least two screens, both full of action and vitality, and designed several more.[38]

The collaboration of designers and artists resulted in two screens made by Jean-Michel Frank (1895–1941), who was one of the most fashionable and gifted designers and decorators in Paris. He worked with Diego and Alberto Giacometti, who produced furniture in bronze for him. Frank designed a screen covered with plaster; on each of the three panels was mounted a plaque with figures representing Dance, sculpted by Diego Giacometti.

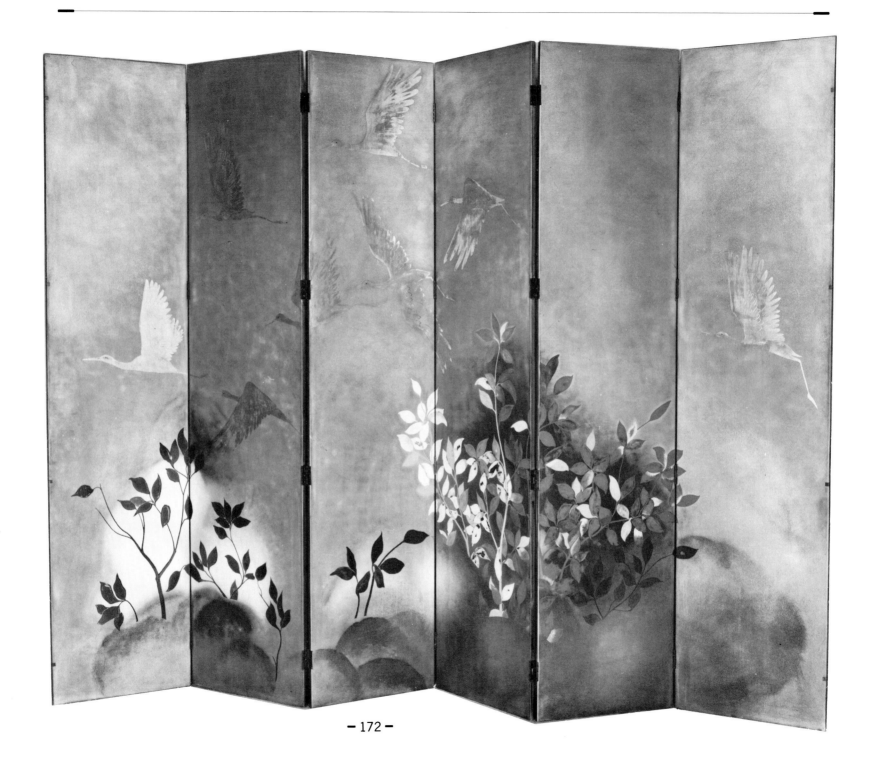

Frank made another screen, which was then decorated with a surreal trompe l'oeil landscape painting by Salvador Dali in 1936.[39] Another well-known collaboration between Frank and Dali was a Parisian ballroom decorated by Frank that contained a pink satin setee designed by Dali in the shape of Mae West's lips.[40]

Between the years 1928 and 1933 the French artist Yves Tanguy (1900–1955) is known to have painted at least three screens reflecting supernatural moods stemming from subconscious forces. The illusion of limitless space is broken by forms that seem to drift or float through the atmosphere. Tanguy makes use of thin lines to suggest perspective, leading the eye further into the landscape. However, a distinction must be made between Tanguy, who was solely interested in his subjective painting as art, and Dali and others, who worked with designers.[41]

An additional factor in the need for interior design was the appearance of a new type of patron: the commercial client. Office buildings and stores were being built in the Art Deco style, and businesses were eager to have these spaces furnished in a compatible manner, one that would also promote their new image of being in tune with the times in the thriving twenties. Merchants engaged the services of top designers to make screens that would serve as backgrounds for displays and help promote their merchandise. Screens were also placed inside the shops to create interesting panels or walls. Parallel lines and rectangles form the geometric design of a glass screen made by the design firm Bariller, LeChavallier and Hanssen in 1928. This screen was installed in Bally's main shoe store in Paris that was

designed by Robert Mallet-Stevens.[42] The sixteen panels of this screen make it even larger than the twelve-fold Coromandels, and while it is in form a folding screen, having lost its mobility it was obviously intended to be a decorative fixture.

A look at some of the screens made during the twenties illustrates this burst of energy and imagination. The creations of the ironwork master Edgar Brandt (1880–1960) were among the leading attractions at the 1925 Paris exhibition. His screen *L'Oasis,* made of iron, brass, copper, and other metals, was, as one critic commented, "almost a kind of larger jewelry."[43] His screens included the full repertoire of naturalistic conventions, his flowers and leaves formed and accented with contrasting metals. He continued to work within this style until the thirties, when he showed more interest in geometric forms. José-Maria Sert (1876–1945), one of the most prolific mural painters of the era, was doing commissions for his native Spanish cathedrals, designing sets for Diaghilev, and doing innumerable private commissions in Spain, France, and the United States. He painted a number of smaller decorative panels and screens, and was a master of exaggerated perspective and trompe l'oeil. His subjects ranged from eighteenth-century ballrooms to fountains, from palms and obelisks to Chinese jugglers.

Though the conditions of the exhibition forbade borrowing styles from the past, they did not exclude borrowing themes. André Mare was one who created new design with the aid of tradition. A screen done by Mare in 1922 was of unusual construction, having been made of lacquer over parchment and bronze. The four panels appeared very contemporary: the

*L'Oasis.*
Edgar Brandt combined iron, brass, copper, and other metals in this screen shown at the 1925 Paris exhibition. Photograph courtesy Philippe Garner.

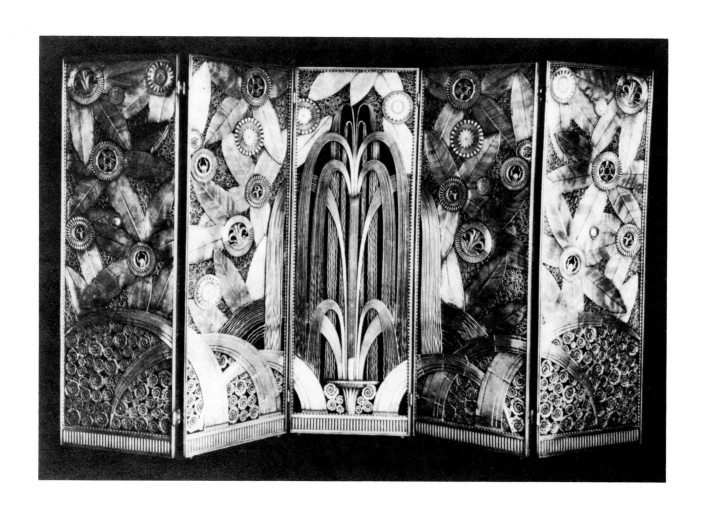

*The Gardens*
(1923–1924), a Beauvais
tapestry screen with
polychrome decoration on
a gray background by Paul
Véra. The Metropolitan
Museum of Art.

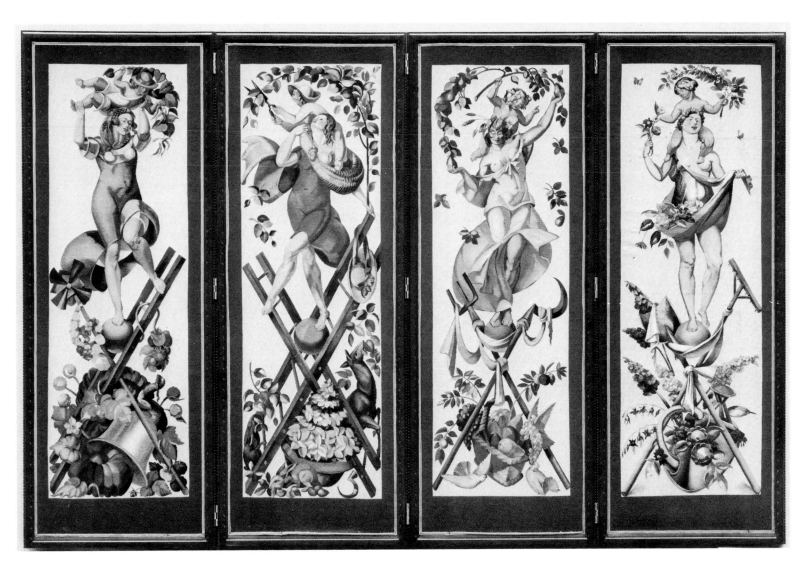

Cubist figures were painted vivid pink or brown against a strong yellow background and the foliage was stylized in the flattened manner of the times, creating an effect similar to that achieved in the metal screen by Brandt. However, a second glance shows how traditional this screen is. The proportions of the four-panel form are conventional, and the color, which seems startling at first, appears less so when the strong shades of earlier tapestry are recalled. The most interesting element to study is the design. In the center of each panel is a human form, standing amid foliage and scampering animals, and above the heads of the figures are medallions composed of leaves, flowers, and ribbons, which are surrounded by musical instruments and plumage—themes and forms so familiar to the eighteenth-century screen but here painted in colors inspired by the Ballet Russe and Chinese and Persian art.

An associate of Mare, Paul Véra, designed a tapestry screen woven at Beauvais in 1923 on the same theme. It is interesting to note that for fifty years the famed tapestry firm had suffered hard times, and that in 1917 its new director decided that salvation lay in employing designers who created contemporary art. Véra, skilled in architectural and garden design as well as in many fields of the applied arts, was a leader of the modern movement. *The Gardens,* shown at the 1925 Paris exhibition, was a remarkable accomplishment, as the art of tapestry design had long been neglected. An article in the Bulletin of the Metropolitan Museum of Art acknowledges the influence of the eighteenth century. The design includes flowers, fruits, and garden utensils happily combined with the forms of women and children. "But here the resemblance stops. The scale is bolder, the modeling more forceful, and in the choice of colors, which form a rich, fully orchestrated harmony, there is a greater range of hues."[44] It is important to note that many of those whose work was shown in the 1925 Art Deco exhibition were active in many areas, as has already been illustrated, and as prolific as they were inventive. It would be futile to try to explore or encompass all the experimental ideas and techniques the artists employed; this mere sampling of their work will have to suffice to suggest the fertility of the decorative field.

The vitality of new design and the concept of interior decoration, so evident in France, simply did not exist in England or the United States in the early 1920s. Until that time those who wished to redecorate relied on their own ideas or taste, or consulted one of the large firms whose primary customers were commercial companies. These firms, dealing in antiques and reproductions, fostered the conviction that "taste" stopped at 1800. No schools of interior design existed, nor were decorative arts, mural painting, or furniture and textile design treated as separate subjects in the art schools. A forward-looking book of the twenties predicts that the present dull treatment will be replaced by "rooms that are extremely clever."[45] "Unfortunately some of the rooms resulted in considerable hideousness as a result of a lack of knowledge combined with an excess of enthusiasm."[46] Some decorators relying on their innate sensibilities did achieve a reputation, and their advice was sought. It soon became an acceptable profession for women, and their careers were advanced by proper social connections. One or two

**M**irrored screen designed by Syrie Maugham. Photograph courtesy Victoria and Albert Museum.

successes that were well publicized, plus a prominent and rich patron, and they were catapulted to the forefront of a profitable new career. Among the most famous of these ladies in England were Elsie de Wolfe, Syrie Maugham, and Lady Sibyl Colefax. Mrs. Maugham is credited with inventing the colorless room; her White House in Chelsea was widely acclaimed in 1929. Her widely discussed monotone drawing room contained two screens placed adjacent to each other. One was a striking tall screen made of very narrow panels of mirrors set in chromium-plated frames, and the other a low eight-fold lacquered white screen that concealed a grand piano. The mirror screen proved to be a "hazardous piece of decoration as the composition holding the long thin strips of mirror in position tended to melt if the room became warm, and pieces of glass would fall off without any warning."[47] Sibyl Colefax blended the traditional and the modern, creating an atmosphere of comfort and taste with glazed chintzes and antiques. An interior of her design in 1938 featured a French trompe l'oeil wallpaper screen of the drapery designs of the Empire period.

In May 1930 *Architectural Review* announced a competition intended to interest architects in the practical aspects of interior decorating. The rules of the competition required the contestants to design decorations and furnishings for an imaginary client. A prize-winning entry submitted by Paul Nash, a designer and the author of a book on interior design, was a folding screen of tennis netting. In its setting, the screen suggested a division of space, creating the illusion of a wall. It defined a spatial relation

yet denied privacy, protection, or even a surface for decoration—the essentials of earlier screens. Obviously, netting was not a common material, but this illustrates the breadth of materials with which designers experimented. Old favorites such as glass, calfskin, and lacquer continued to be used, but the list was extended to include vellum, ivory, shagreen, colored mirrors, and suede, and even reached back to include straw, reminiscent of the earliest wicker screens.

The London firm of A. J. Rowley specialized in making decorative plaques, panels, screens, and picture frames of variously colored natural woods. Two artists whose designs for Rowley received special recognition were William Arthur Chase and Frank Brangwyn. An example of Chase's work is a three-panel screen with ovals of marquetry set in ebonized wood. The intricacy and sharp detail is achieved by the contrasting wood. Set within an architectural and landscape fantasy is a girl with a large basket on her head, an elephant with a howdah, and a boy leading a cheetah.[48]

In the meantime America had not kept pace with Europe, spending most of her efforts on physical and industrial expansion rather than on the arts. There were no exhibits from the United States in the 1925 Paris exhibition because, as simply explained by an American decorator, "we had no decorative art. Not only was there a sad lack of any achievement that could be exhibited, but we discovered that there was not even a serious movement in this direction and that the general public was quite unconscious of the fact that modern art had been extended into the field of business and industry."[49] Up to this time taste had been focused on antiques or reproductions of period

pieces. The Metropolitan Museum of Art aroused interest and educated the public by exhibiting in New York some of the work of designers who had shown in Paris, including that of Dunand and Brandt. Stimulated by what they saw and by subsequent competitions, Americans rather belatedly embraced the modern movement. While many considered the style impersonal or dehumanized, the public, encouraged by numerous magazine articles, displays, and model rooms in department stores and by an innate spirit of wanting to be with the times, grew to accept it. Always interested in the latest styles and aware of the rapidly changing social scene, Americans wanted rooms that reflected their present life-style. The rapid rise of decorators and home-furnishing magazines provided ample suggestions for redoing interiors and exerted social pressure for the reader to be *au courant.* The interior designers were leading advocates of screens and applauded their decorative value. "It is nearly always true that when a room 'needs something,' that something is a screen," proclaims a 1929 article on "the charm of screens," praising their ability to draw attention away from unattractive architectural features, to conceal undesirable activities, and to focus attention.[50]

A new technique was the development of the photomural screen. Two made for the company National Studio show *A Mountain Scene* and *Sailboat on Moonlight Waters.* The firm proclaimed that "photomurals make dramatic decorations . . . and are especially happy in modern settings as they give a sense of space and endless vistas." The illusion they created was so satisfactory that "you could, in short, spend your vacation at home if you had screens such as these about you."[51] Screens might be painted for

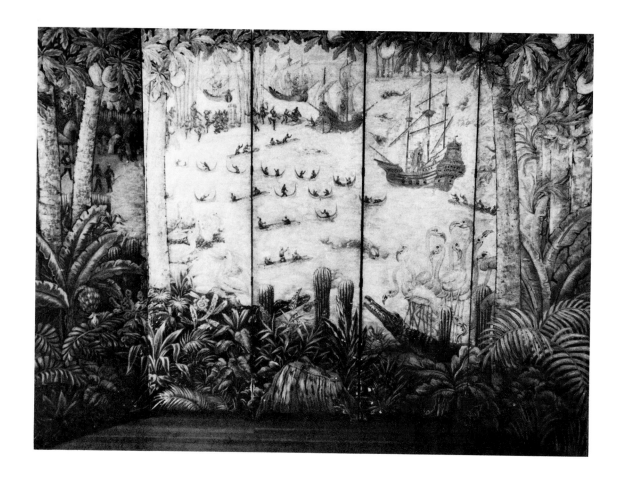

**V**izcaya Bay (1922), by Robert Winthrop Chanler. A scene of the departing ships is painted in soft colors, with grays and greens predominating. The screen remains at Vizcaya, the former James Deering estate.

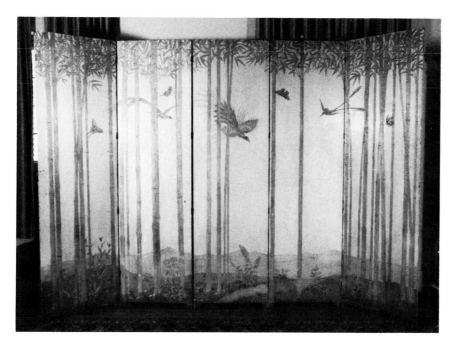

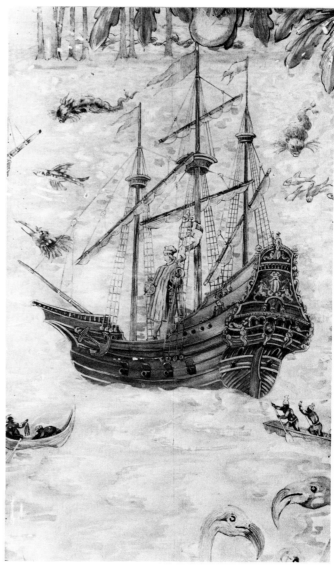

the sportsman, such as a screen of two polo players, advertised as "grand for the man who dotes on violent equestrian exercise," or a scene of mountains, pines, and stream, "romantic glamour appealing to the man who likes to hunt and fish in wild and far-off places."[52]

Ansel Adams, the famed photographer of natural beauty, has made a number of screens using enlargements of his photos mounted on the simplest frames, which are actually just invisible supports for the photograph. In a screen made from a photo of a snow-covered bough exhibited at the Museum of Modern Art in New York, the lack of frame emphasized the beauty of the photography and heightened the sense of the boundlessness of nature.

An American artist renowned for his screen painting was Robert Winthrop Chanler (1873–1930), who had traveled extensively throughout the world as a youth. He reported that he felt the discovery of a Coromandel screen in a shop in Paris had had the greatest influence on him, awakening his creativity with its inventive vitality, stylization, and fantasy.[53] His subject had no earthly limits, ranging from *Deep Sea Fantasy* to *Celestial Fantasy.* His style varies almost as much as his subjects, and while some are contemporary in feeling, others have echoes of earlier screens. A huge screen of phoenixes and peacocks is a direct descendant of japonaiserie, and in his *Vizcaya Bay* we see old Spanish galleons, or *naos*, reminiscent of the seventeenth century sharing a panel with cranes, alligators, and jungle foliage. An article of 1929 applauds the work of Chanler, "whose famous giraffes have stretched their necks in all the most important museums of the world."[54]

Charles Baskerville (1896–   ) continued to paint screens and murals for the houses of wealthy and prominent Americans. He frequently used animals as the subjects of his work, which was highly acclaimed by decorators. His *Mountain Goats* was painted in colors that "are daring, yet not flamboyant," and a screen of *Gazelles* is painted on a yellow background with green, blue, and gray tones.[55] He placed stalking pumas amid cacti on a silver leaf background to create an exotic mood, or colorful elephants with riders inspired by travel in India. The influence of African art is seen in *Congo Leda,* which was exhibited in the Brooklyn Museum in 1931. The burgundy lacquer background has been rubbed with silver to give it highlights. The figures have been partially built up with gesso, and *Leda* is adorned with silver jewelry and ivory beads. Baskerville's most prominent lacquerwork were the large panels with scenes of the Everglades that were made for the S.S. *America.*

Experimentation with new materials continued. In 1932 a magazine article described a "very brilliant Monel metal screen," exclaiming over the effectiveness of the patterns of parallel and diagonal lines and its lights and shades. Another article, in 1929, told of a screen, made of sheets of zinc secured over cork, that was very portable and took "sunlight or electric light charmingly, having almost the effect of silvery gray taffeta."[56]

It is perhaps a coincidence that Synchromism, the first American avant-garde painting movement to attract attention in Europe, was also a stimulus in the United States for screens to be painted by artists who

*S*pirit of *Christmas*
(1915–1920), by Carl Newman.
Oil and tempera on fiberboard.
National Collection of Fine
Arts, the Smithsonian Institution,
gift of Anna McCleery Newton.

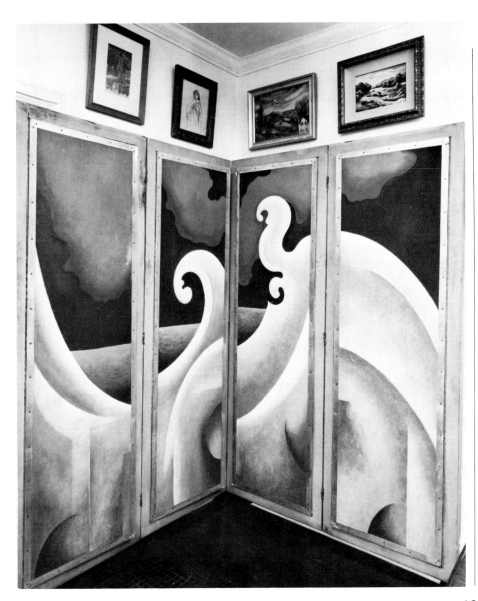

**S**creen with an Abstract Sea Motif (1925), by Thomas Hart Benton. Private collection.

dedicated their lives to "pure" art as opposed to commercial decorative art. It is more probable, however, that American artists, being influenced by artists throughout Europe, recognized the potential of painting on a larger surface. Synchromism literally means "with color," and it was one of the earliest attempts to create paintings composed of abstract shapes and color.[57] It was founded in America in 1913, and the circle widened to include artists on both sides of the Atlantic. Thomas Hart Benton (1889–1975), more than any other American painter, was directly influenced by the movement. He said the Synchromists had intensified color planes by "abandoning completely the usual colors of nature, replacing them with highly saturated spectral colors and had extended them into an area of purely 'abstract' form."[58] The baroque rhythms of Synchromist paintings attracted him even more than the color, and their influence is obvious in *Screen with an Abstract Sea Motif* (1925). However, Benton, not being able to repudiate all representational art, soon abandoned the movement. As he said, he "quit Synchromism because I just couldn't paint George Washington as a rainbow"[59] and went on to paint his famous genre scenes. In Benton's screen one easily perceives the waves, sea, and sky, and responds to their rhythms, but in a screen painted by Carl Newman (1858–1932) that was called *Spirit of Christmas,* the forms have become so abstract they defy recognition.

An international movement grew up in the late twenties in Paris, partly as a protest to some of the modern painting of that time. The Neo-Romantics, or Neo-Humanists, as they were called, wished to

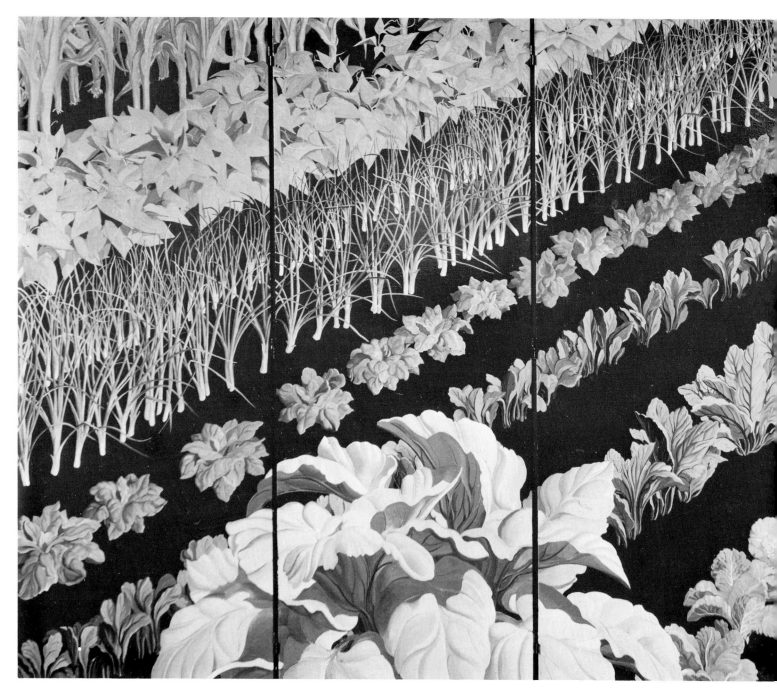

*T*ruck *Garden* (1931), by Alison Mason Kingsbury. Photograph courtesy of the artist.

"reestablish a concern with man and his emotions as well as his intelligence and . . . opposed the tendency to be interested in form and color per se."[60] The leaders were Christian Bérard (1902–1949), a Frenchman, and Pavel Tchelitchew (1898–1957) and Eugene Berman (1899–1972), Russians who immigrated to Paris and later moved to New York. Christian Bérard is best known for his work for the theater. During his career he designed sets and costumes for the ballets of George Balanchine and the Ballet Russe de Monte Carlo, and for numerous theaters in Paris. He also collaborated on many projects with Louis Jouvet and Jean Cocteau. Bérard painted murals, decorative panels, and screens. He also executed designs for scarves, pottery, furniture, and book illustrations, and later did work for *Vogue.* Bérard created a number of screens—which he gave to friends—on which he painted single figures.[61] These figures are slightly modeled and placed against a white background. Each figure is powerfully delineated and emits a sense of energy. His favorite colors for the stage were pale pink, yellow, green, blue, "furious" red, and gray, the same colors he used in his screens.

Eugene Berman's work shows remarkable theatricality and a wide range of influences. In 1944 he made two 3-fold screens of original designs mounted on a plain background, the themes being architectural fantasies, portraits, and figures. A critic wrote, "His subject again and again is a kind of nostalgia for an elegance that existed only in the imagination, a world of myth and a noble scrap heap of imperial or ducal decline and fall. . . . Ragged boys and tattered women, torn fishing nets and battered

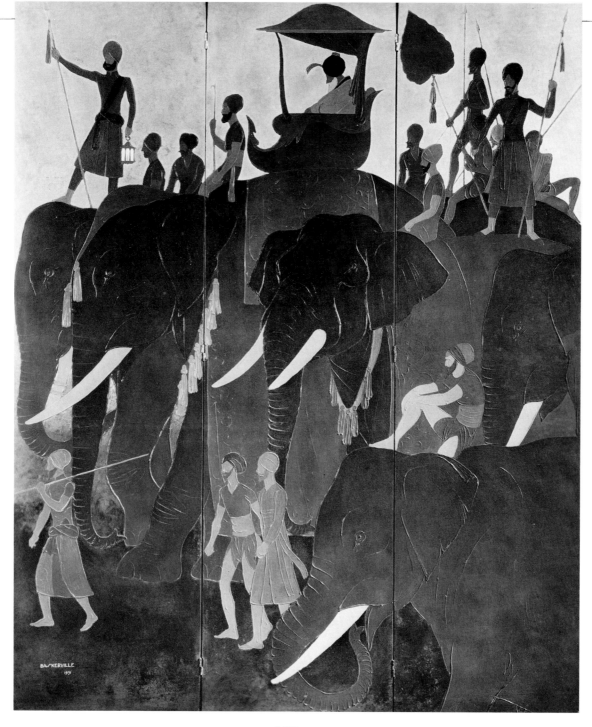

***P****umas,*
beige and turquoise
on silver leaf (1934),
by Charles Baskerville.
Photograph courtesy
of the artist.

doors, broken columns and arches and statues, blasted trees and ruined palaces are the props, not the subjects of his pictures. His world is an occupied and somehow livable ruin."[62]

Marie Laurencin (1885–1956) also created a screen for the ballet. In 1947 she painted a four-panel screen entitled *Le Château de la Belle au Bois Dormant* (The Castle of the Sleeping Beauty) for the Ballet de Monte Carlo. A second screen of Laurencin's, not made for the ballet, is a red four-panel wooden lacquer frame with canvas inserts decorated with paintings of women.

Marc Chagall (1887– ), an artist whose work defies easy categorization, made a lithograph screen in 1963. This was only the second time a lithograph had been specifically designed for a screen, with the artist mindful of the form and uses of the screen, and that the work would be issued in numbers. This screen followed a precedent established by Bonnard's *Promenade des Nourrices,* and anticipated a trend that would expand. The imaginary figures and images of the Chagall screen are printed in twelve colors on a varnished paper mounted on a simple frame. One hundred copies of the original were printed and then the plates were destroyed.[63]

During the sixties the phenomenon of multiples greatly increased, providing the opportunity for an enlarged segment of art collectors and enthusiasts to acquire a work of art supervised by the artist and bearing his signature. A growing number of artists commissioned silkscreens made of their work to be printed in limited editions. These, like earlier engravings, enabled patrons who could not afford a painting to own a facsimile, and also helped supply the public's demand for contemporary art at a time when prices for original work were also multiplying. Jim Dine (1935– ), who gained acclaim as one of the earliest American Pop artists, made a five-panel screen entitled *Landscape* in 1969. Each panel was an original silkscreen, each a different color. There are panels of mottled blue, yellow, and green, one of black and white dots, and one has a rainbow effect of the primary colors. The screen was printed in a limited edition of thirty.

Jack Beal (1931– ) is an American artist also making screens using silkscreen methods but in a style totally different from Dine's. In 1977 Beal made *Rowboat Screen,* a multicolored serigraph with shades of blue, blue-green, blue-gray, and gray predominating the image of his strangely empty rowboat tranquilly afloat amid the water lilies. The angles, shadows, and lines of the boat create an interesting balance with the angles of the screen, and the very large size of the screen helps extend a visual invitation for the viewer to enter the boat.

At the present time the creation of screens continues. Two artists whose work is especially interesting are Jack Youngerman (1926– ) and Lucas Samaras (1936– ). Youngerman's screens *Two Blues* and *Blue Green Linen* are extraordinarily beautiful and express the ageless quality of the finest Japanese screens. They express a contemporary spirit with their abstraction and yet at the same time remind one of the Japanese principle of screenmaking with their superb sense of color, asymmetric rhythms, and movement. A two-fold aluminum screen called *Tabriz* (1980) is black with bold cutouts, obviously denying the earlier concept that a screen should

*Paravent*
(1963), by Marc
Chagall. Colored
lithograph printed in
twelve colors and
issued in an edition
of one hundred.
Photograph courtesy
Christie's Ltd.

provide privacy or protection. Lucas Samaras has also done a screen for his own use in which he has employed a cutout technique, and once again has shown the transformation of a form from a functional device to an art form.

In England David Hockney (1937–  ) has used the screen both as a background and essential prop in a painting, and also has specifically painted screens using large sheets of pressed paper pulp. A painting of the art curator and writer Henry Geldzahler shows him studying paintings hung on a screen that partly encloses him. Unlike pictures or portraits of the eighteenth century, in which the screen served merely as a backdrop, here it dominates the picture, dwarfing the subject and making of objects on the screen as clearly recognizable as the figure itself. In 1979 Hockney produced his *Paper Pools* series, a collection of large pictures, with one actually made into a screen. The theme is swimming pools, and he creates an extremely pleasurable sensation of water, sun, and motion printed in large areas of pure flat color. According to his dealer, André Emmerich, he conceived of this whole series as screens because he could best create the desired effect by printing on these large sheets of paper before putting the pieces together. This idea, of the pieces making the whole, is the opposite of many earlier screens, which were designed as a whole and then cut into the necessary segments.

The discussion of contemporary artists painting screens could be considerably expanded and deserves continued attention. The resurgence of interest in the screen only proves the vitality of this form, which has survived the advances of technology, the changing concepts of interior space, and the fickleness of taste.

Modification of form and function, innovative techniques and materials, fluctuations of style and interpretation, and, above all, the inspiration and creativity of the artist have met the challenge of the screen and predict its viability for the future—always "in the newest taste."

◄ *Landscape Screen* (1969). Screen print on linen in five parts on stretchers, by Jim Dine. © Jim Dine, 1969. Photograph courtesy Petersburg Press.

► *Rowboat 1977*. Silkscreen by Jack Beal mounted on a folding screen. The serigraph is one of an edition of twenty-four made for this purpose. Photograph courtesy Brooke Alexander, Inc., New York.

*T*wo Blues
(1978), a four-panel
screen by Jack
Youngerman. Oil on
linen. Courtesy
Washburn Gallery,
New York.

*T*abriz
(1980), by Jack
Youngerman.
Aluminum with bold
cutouts. Courtesy
Washburn Gallery,
New York.

# NOTES

## CHAPTER 1

**1.** Hugh Honour, *Chinoiserie*, p. 72.
**2.** George Macaulay Trevelyan, *Ramilles*, p. 62.
**3.** Yoshitomo Okamoto, *Namban Art of Japan*, p. 25.
**4.** "Namban Art," International Exhibitions Foundation Catalogue, p. 59.
**5.** Sherman Lee, Introduction to *Japanese Screens*, p. 4.
**6.** Elise Grilli, *The Art of the Japanese Screen*, p. 133.
**7.** In the mid-eighteenth century featherwork was again being used for screens. Mrs. Montagu, who had already adorned a room in her London townhouse with feather hangings, writes a friend in 1750, "How does your feather screens . . . ?" Percy Macquoid and Ralph Edwards, *Dictionary of English Furniture*, p. 56.
**8.** Grilli, p. 151.
**9.** Ibid.
**10.** Honour, p. 43.
**11.** Macquoid and Edwards, p. 56.
**12.** Honour, p. 71.
**13.** Margaret Jourdain and R. Soame Jenyns, *Chinese Export Art in the Eighteenth Century*, East India Company Letter Book, Appendix D.
**14.** Ibid.
**15.** Ibid., p. 37.
**16.** Ibid., fn. 4, p. 16.
**17.** Herbert Hall Mulliner, *The Decorative Arts in England*, opposite p. 35.
**18.** Mallett and Company Brochure, London.
**19.** *The Burlington Magazine*, C. T. Loo advertisement, December 1972, p. xli.
**20.** *Ham House Inventory*, n.p.
**21.** Beverly Sprague Allen, *Tides in English Taste*, p. 208.
**22.** G. Jackson-Stops, "Erddig Park, Clwyd II.," *Country Life*, April 13, 1978, p. 972.
**23.** Honour, p. 135.
**24.** Brenda Greysmith, *Wallpaper*, p. 50.
**25.** Victoria and Albert Museum, Collection of Trade Cards.
**26.** Nancy McClelland, *Historic Wallpapers*, p. 107.
**27.** Honour, p. 71.

**28.** John Stalker and George Parker, *A Treatise of Japaning and Varnishing*, p. xvi.
**29.** F.J.B. Watson, *The Wrightsman Collection*, vol. I, p. 174.
**30.** Ibid., p. 229.

## CHAPTER 2

**1.** Margaret Jourdain and R. Soame Jenyns, *Chinese Export Art in the Eighteenth Century*, fn. 2, p. 13.
**2.** Hans Huth, *Lacquer of the West*, p. 38.
**3.** Ibid., p. 36.
**4.** Oliver Impey, *Chinoiserie*, p. 117.
**5.** Huth, p. 27.
**6.** Herbert Cescinsky, *English Furniture of the Eighteenth Century*, p. 180.
**7.** John Stalker and George Parker, *A Treatise of Japaning and Varnishing*, p. xvi.
**8.** Huth, p. 23.
**9.** Ibid., p. 26.
**10.** Hugh Honour, *Chinoiserie*, p. 66.
**11.** Huth, p. 31.
**12.** *The China Trade and Its Influence*, Metropolitan Museum of Art Catalogue, 1941, p. 89.
**13.** Huth, p. 76.
**14.** Ibid., p. 74.
**15.** Ibid., p. 78.
**16.** Ibid., p. 81.
**17.** "An Eighteenth Century Screen," *The Connoisseur*, April 1953, p. 66.
**18.** Hans Huth, "Chinoiserie Gilt Leather," *The Burlington Magazine*, July 1937, pp. 25–35.
**19.** Ibid.
**20.** Honour, p. 118.
**21.** Ibid., p. 117.
**22.** William Odom, *A History of Italian Furniture*, p. 179.
**23.** Ibid., p. 181.
**24.** H. Belevitch-Stankevitch, *Le Goût Chinois en France*, p. 86.
**25.** Grosvenor House Antiques Fair catalogue, 1935, n.p.
**26.** Honour, p. 55.

27. Belevitch-Stankevitch, p. 257.
28. J. Boulenger, *L'Ameublement Français au Grand Siècle,* p. 22.
29. Ibid., p. 67.
30. Ibid., p. 139.
31. Adolf Riechwein, *China and Europe,* p. 35.
32. Honour, p. 96.
33. Gustave Macon, *Château de Chantilly,* plates 40, 41.
34. Geoffrey DeBellaigue, *Furniture, Clocks, Gilt and Bronzes,* p. 624.
35. Honour, p. 81.
36. *The World,* no. 26, June 28, 1753, quoted in William W. Appleton, *A Cycle of Cathay,* p. 107.

**CHAPTER 3**

1. Mark Girouard, *Life in the English Country House,* p. 38.
2. Percy Macquoid and Ralph Edwards, *Dictionary of English Furniture,* p. 56.
3. Mario Praz, *An Illustrated History of Interior Decoration,* p. 53.
4. Horace Walpole, *The Letters of Horace Walpole,* vol. V, p. 425.
5. *Inventory,* Hardwick Hall, n.p.
6. Girouard, p. 94.
7. *Inventory,* Hardwick Hall, n.p.
8. Horace Walpole, *Visits to Country Seats,* p. 30.
9. James Orchard Halliwell, *Ancient Inventories of Furniture,* n.p.
10. Macquoid and Edwards, p. 56.
11. Oliver Millar, *Inventories and Valuation of the King's Goods, 1649–51,* n.p.
12. Eugene Emmanuel Viollet-le-Duc, *Dictionnaire Raisonné du Mobilier Français,* p. 196.
13. Jacques Romain Boulenger, *L'Ameublement Français au Grand Siècle,* p. 12.
14. Ibid., p. 13.
15. John Waterer, *Spanish Leather,* p. 28.
16. Ibid., p. 116.
17. Victoria and Albert Museum, Trade Card Collection.
18. Waterer, p. 66.

19. Brenda Greysmith, *Wallpaper,* p. 50.
20. Victoria and Albert Museum, Trade Card Collection.
21. Phyllis Ackerman, *Wallpaper, Its History, Design and Use,* p. 57.
22. Lond^n Journal, no. 85, March 11, 1721, p. 580.
23. Macquoid and Edwards, p. 64.
24. H. J. Mayo, "The Antique Dealers Fair and Exhibition at Grosvenor House," *The Connoisseur,* October 1935, p. 226.
25. Built by M. de Boulongne; entire salon sold on May 27, 1893.
26. Jean Ferré, *Watteau,* vol. IV, p. 1210.
27. *The Frick Collection: An Illustrated Catalogue. The Paintings,* vol. II, p. 141.
28. John Cornforth, "Wallington, Northumberland II," *Country Life,* April 23, 1970, pp. 922–26.
29. Macquoid and Edwards, p. 61.
30. George Savage, *French Decorative Art 1638–1793,* p. 30.
31. Pierre Verlet, *French Royal Furniture,* p. 38.
32. Ibid., p. 33.
33. Ibid., p. 34.
34. Horace Walpole, *The Letters of Horace Walpole,* vol. II, p. 133.
35. Verlet, p. 40.
36. F.J.B. Watson, *Louis XVI Furniture,* p. 150.
37. Pierre Verlet, *Le Mobilier Royal Français,* vol. 2, p. 143.
38. Verlet, *French Royal Furniture,* p. 44.
39. Savage, p. 169.
40. Nancy Mitford, *Madame de Pompadour,* p. 176.
41. Geoffrey DeBellaigue, *Furniture, Clocks, Gilt and Bronzes,* p. 625.
42. Musée Nissim de Camondo Catalogue, Paris, n.p.
43. Praz, p. 160.
44. Ibid., p. 166.
45. Hugh Honour, *Cabinet Makers and Furniture Designers,* p. 182.
46. Giuseppe Morazzoni, *Il Mobile Neoclassico Italiano,* p. 19.
47. Victoria and Albert Museum, Photographic Archives.
48. Beverly Sprague Allen, *Tides in English Taste,* p. 102.

# CHAPTER 4

**1.** Christopher Gilbert, *Late Georgian and Regency Furniture,* p. 51.

**2.** Thomas Sheraton, *The Cabinet Dictionary,* p. 302.

**3.** Peter and M. A. Nicholson, *The Practical Cabinet Maker,* p. 6.

**4.** Nancy McClelland, *Historic Wallpapers,* p. 118.

**5.** B. Greysmith, *Wallpaper,* p. 96.

**6.** Ibid.

**7.** Serge Grandjean, *Empire Furniture 1800–1825,* p. 78.

**8.** Stephane Faniel and Pierre Levallois, *Les Merveilles du Louvre,* vol. II, p. 434.

**9.** T. Sokolova and K. Orlova, *Russian Furniture in the Collection of the Hermitage,* plates 31, 174.

**10.** Hugh Honour, *Cabinet Makers and Furniture Designers,* p. 242.

**11.** Mario Praz, *An Illustrated History of Furnishing,* p. 340.

**12.** Elizabeth Aslin, *The Aesthetic Movement,* p. 33.

**13.** Barbara Morris, "Victorian Embroidery," *The Connoisseur Concise Encyclopedia of Antiques,* vol. 4, p. 161. There is some difference of opinion concerning this screen. Aymer Vallance (*The Decorative Art of Sir Edward Burne-Jones,* London: H. Virtue and Co., Ltd., 1900) writes that Burne-Jones undertook a set of designs for Chaucer's *Legend of Good Women,* which were made into a screen for the earl of Carlisle. He also states that Burne-Jones did a set of embroideries, *The Four Seasons,* which was made into a screen (p. 16).

**14.** Ibid., p. 162.

**15.** Linda Parry, "The Tapestries of Edward Burne-Jones," *Apollo,* November 1975, p. 325.

**16.** Joseph W.G. White, "Screens: Folding and Otherwise," *Amateur Work,* 1885, vol. V, p. 15.

**17.** Ibid., p. 17.

**18.** Ibid., p. 74.

**19.** *Thomas Carlyle House,* National Trust for Places of Historic Interest or Natural Beauty, London, 1975, p. 22.

**20.** H. Clifford Smith, "Byron's Pictorial Screen," *Country Life,* November 30, 1945, p. 960.

**21.** Mark Girouard, *The Victorian Country House,* p. 20.

**22.** Aslin, p. 62.

**23.** J. Moyr Smith, *Ornamental Interiors,* p. 144.

**24.** Ibid., p. 208.

**25.** Praz, p. 376.

**26.** Andrew Young et al., *The Paintings of James McNeill Whistler,* p. 85.

**27.** Lloyd Goodrich, *Albert P. Ryder,* p. 115.

**28.** I. Bennett, "Italy and Spain," from *The Encyclopedia of Decorative Arts,* edited by Philippe Garner, p. 258.

# CHAPTER 5

**1.** Charles Chassé, *The Nabis and Their Period,* p. 16.

**2.** Ibid, p. 52.

**3.** Marcel Guicheteau, *Paul Sérusier,* p. 65.

**4.** Chassé, p. 64.

**5.** Andrew C. Ritchie and William S. Lieberman, *Edouard Vuillard,* p. 20.

**6.** Chassé, p. 12.

**7.** Ibid, p. 13.

**8.** Jean and Henry Dauberville, *Bonnard,* vol. I, pp. 125 and 217.

**9.** This screen was exhibited in 1948 in New York and Cleveland. Sometime after that date it was disassembled, and three of the panels had not yet been rediscovered when the catalogue raisonné was written in 1965. During that time the signed panel, called *"La Promenade,"* had been cut down on the bottom from 160 cm to 128 cm.

**10.** John Rewald, *Odilon Redon, Gustave Moreau, Rodolphe Bresdin,* p. 30.

**11.** Klaus Berger, *Odilon Redon,* p. 96.

**12.** Ibid.

**13.** Richard Hobbs, *Odilon Redon,* p. 110.

**14.** Berger, p. 204. A complete list and description of Redon screens is given.

**15.** Lionello Venturi, *Cézanne, Son Art—Son Oeuvre,* vol. II, plate 1.

**16.** Felix Klee, *Paul Klee,* p. 128.

**17.** Amy Goldin, "The Brothers Prendergast," *Art in America,* March/April 1976, p. 89.

**18.** Ibid.
**19.** Quentin Bell and Stephen Chaplin, "The Ideal Home Rumpus," *Apollo,* October 1964, p. 284.
**20.** Richard Shone, *Bloomsbury Portraits,* p. 99.
**21.** Ibid.
**22.** Ibid, p. 57.
**23.** Ibid, p. 105.
**24.** Ibid, p. 109.
**25.** Ibid, p. 104. This screen originally appeared with four panels, but when it was the subject of an article in *Apollo* in October 1964, it had been reduced to three.
**26.** Shone, p. 125.
**27.** Ibid, p. 180.
**28.** Ibid, p. 239.
**29.** Denys Sutton, Introduction to *Duncan Grant,* Wildenstein Gallery Catalogue, 1964, n.p.
**30.** Philippe Garner, "The Lacquer Work of Eileen Gray and Jean Dunand," *The Connoisseur,* May 1973, p. 3.
**31.** Yvonne Brunhammer, *Jean Dunand/Jean Goulden Catalogue,* Galerie de Luxembourg, p. 42.
**32.** Martin Battersby, *The Decorative Thirties,* p. 26.
**33.** Garner, "The Lacquer Work of Eileen Gray and Jean Dunand," *The Connoisseur,* May 1973, p. 3.
**34.** Martin Battersby, *The Decorative Twenties,* p. 44.
**35.** Roy Strong, quoted in *The Daily Telegraph,* London, June 1, 1978.
**36.** Alain Lesieutre, *The Spirit and Splendor of Art Deco,* p. 134.
**37.** Jacques Damase, *Sonia Delaunay, Rhythm and Colours,* p. 205.
**38.** Virginia Dortch Dorazio, *Giacomo Balla,* plates 203, 220.
**39.** Leopold Diego Sanchez, *Jean-Michel Frank,* p. 209.
**40.** Battersby, *The Decorative Thirties,* p. 153.
**41.** Kay Sage Tanguy, *Yves Tanguy, Un Recueil de Ses Oeuvres,* p. 82. Also, letter from A. F. Petit, Galerie André-François Petit to author, November 10, 1981.
**42.** Thomas Walters, *Art Deco,* p. 10.
**43.** Battersby, *The Decorative Twenties,* p. 38.
**44.** Joseph Breck, "A Modern Beauvais Tapestry Screen," *The Metropolitan Museum of Art Bulletin,* November 1932, p. 239.
**45.** Battersby, *The Decorative Twenties,* p. 132, quoting John Gloag.
**46.** Ibid.
**47.** Battersby, *The Decorative Thirties,* p. 76.
**48.** Victoria and Albert Museum, Photographic Collection.
**49.** Battersby, *The Decorative Twenties,* p. 152.
**50.** [Signed "R.W."] "The Charm of Screens," *International Studio,* August 1929, p. 44.
**51.** "Fantastic Screens Become A Panorama of Travel," *Arts and Decoration,* June 1937, p. 18.
**52.** "Screens for the Sportsman," *Arts and Decoration,* June 1938, p. 33.
**53.** Ivan Narodny, *The Art of Robert Winthrop Chanler,* p. 11.
**54.** *International Studio,* "The Charm of Screens," August 1929, p. 48.
**55.** "Fantastic Screens Become A Panorama of Travel," *Arts and Decoration,* June 1937, p. 18.
**56.** "Screens As a Medium for Colorful Background," *Arts and Decoration,* July 1929, p. 50.
**57.** Gail Levin, *Synchromism and American Color Abstraction,* p. 31.
**58.** Ibid., p. 32.
**59.** Ibid., p. 33.
**60.** Baird Hastings, *Christian Bérard,* p. 17.
**61.** Hastings, p. 34. Screens were given to Denise Bourdet, Mademoiselle Elsa Schiaparelli, Roland Caïlloux.
**62.** Russell Lynes, Introduction to *The Graphic Work of Eugene Berman,* edited by Eugene Berman, p. ix.
**63.** Gérald Cramer, *Marc Chagall, Paravent,* n.p.

# BIBLIOGRAPHY

Ackerman, Phyllis. *Wallpaper, Its History, Design and Use.* New York: Tudor Publishing Co., 1938.

Ackermann, Rudolph. *Repository of the Arts, Literature, and Fashions,* London, 1804.

Allen, Beverly Sprague. *Tides in English Taste.* Cambridge, Mass.: Harvard University Press, 1937.

Appleton, William Worthan. *A Cycle of Cathay.* New York: Columbia University Press, 1951.

Aslin, Elizabeth. *The Aesthetic Movement.* London: Paul Elek, 1969.

Bacou, Roseline. "The Bonger Collection." *Apollo,* November 1964, p. 398.

Battersby, Martin. *Art Nouveau.* Middlesex: The Hamlyn Publishing Group, 1969.

————. *The Decorative Twenties.* London: Studio Vista, 1969.

————. *The Decorative Thirties.* London: Studio Vista, 1969.

Belevitch-Stankevitch, H. *Le Goût Chinois en France.* Paris: Jean Schemit, 1910.

Bell, Quentin, and Chaplin, Stephen. "The Ideal Home Rumpus." *Apollo,* October 1964, p. 184.

Berger, Klaus. *Odilon Redon: Fantasy and Color.* Translated by Michael Bullock. New York: McGraw-Hill, 1965.

Boulenger, Jacques Romain. *L'Ameublement Français au Grand Siècle,* Paris: Les Arts Graphic, 1913.

Boynton, Lindsay, ed. *Hardwick Hall Inventories of 1601.* London: W. S. Maney and Sons Ltd.

Breck, Joseph. "A Modern Beauvais Tapestry Screen." *The Metropolitan Museum of Art Bulletin,* November 1932, p. 239.

Brinton, Christian. *The Robert Winthrop Chanler Exhibition.* New York: Kingore Gallery, 1922.

Brown, Richard. *Rudiments of Drawing Cabinets and Upholstery Furniture.* London, 1822.

Brunhammer, Yvonne. Introduction to *Les Années 25* Catalogue. Paris: Musée des Arts Decoratifs, 1976.

————. *Jean Dunand/Jean Goulden.* Catalogue. Paris: Galerie du Luxembourg, 1973.

Burr, Grace. *Hispanic Furniture.* New York: Archive Press, 1964.

Calmettes, M. Fernand. *La Manufacture des Gobelins.* Paris: Imprimerie Nationale, 1912.

Cash, Margaret, ed. *Devon Inventories of the 16th and 17th Centuries.* Devon and Cornwall Record Society. Torquay: The Devonshire Press, 1966.

Cescinsky, Herbert. *English Furniture of the Eighteenth Century.* London: George Routledge & Sons Ltd., 1911.

Chassé, Charles. *The Nabis and Their Period.* Translated by Michael Bullock. New York: Praeger, 1960.

Chiesa, Giuseppe. *L'Arredamento in Italia, Il Seicento.* Milan: Görlich Editore, 1973.

Chippendale, Thomas. *The Gentleman's and Cabinet-Maker's Director,* 1762. Reprint of 3rd ed. New York: Dover Publications, 1966.

Clouzet, Henri. *Le Papier Print en France.* Paris: Les Edition G. Van Oest, 1931.

Colombo, Silvano. *L'Arte del Mobile in Italia.* Milan: Bramante Editrice, 1975.

*Connoisseur, The.* The Connoisseur Complete Encyclopedia of Antiques. Edited by L. G. G. Ramsey. London: National Magazine Co., 1962.

*Connoisseur, The.* The Connoisseur Concise Encyclopedia of Antiques. Vols. I–V, 1954–61. Edited by L. G. G. Ramsey. London: National Magazine Co.

Cramer, Gérald, ed. *Marc Chagall, Paravent.* Geneva: Galerie Gérald Cramer, 1963.

Damase, Jacques. *Sonia Delaunay, Rhythm and Colours.* Greenwich, Conn.: New York Graphic Society, 1972.

Dauberville, Jean and Henry. *Bonnard.* Catalogue raisonné. Paris: Editions J. and H. Bernheim-Jeune, 1947.

DeBellaigue, Geoffrey. *Furniture, Clocks, Gilt and Bronzes.* The James A. de Rothschild Collection at Waddesdon Manor. Edited by Anthony Blunt. Vols. I and II. London: National Trust for Places of Historic Interest or Natural Beauty, 1967.

*Description of the Villa of Horace Walpole at Strawberry Hill.* Printed by Thomas Kirgate, 1774.

Dorazio, Virginia Dortch. *Giacomo Balla.* New York: Wittenborn and Co., 1969.

Dossie, Robert. *Handmaid to the Arts.* London: A. Millar, 1796.

Downing, Andrew Jackson. *The Architecture of Country Houses.* New York: D. Appleton & Co., 1861.

Eberlein, Harold P. *The Practical Book of Italian, Spanish and Portuguese Furniture.* Philadelphia: J. B. Lippincott Co., 1927.

Faniel, Stephane, and LeVallois, Pierre. *Les Merveilles du Louvre.* Paris: Hachette, 1958.

"Fantastic Screens Become a Panorama of Travel." *Arts and Decoration*, June 1937, p. 18.

Ferré, Jean. *Watteau.* Catalogue raisonné. Madrid: Editions Artistique Athéna, 1972.

Lord Fisher, The. "Far Eastern Lacquer Screens." *Apollo*, June 1952, p. 164.

*Frick Collection: An Illustrated Catalogue, The. The Paintings*, vol. II. New York: The Frick Collection, 1968. Distributed by Princeton University Press.

Garner, Philippe. *The Encyclopedia of Decorative Arts, 1890–1940.* London: Phaidon Press Limited, 1978, and New York: Van Nostrand, 1978, p. 163.

————. "The Lacquer Work of Eileen Gray and Jean Dunand." *The Connoisseur*, May 1973.

Gere, Charlotte. *Marie Laurencin.* New York: Rizzoli, 1977.

Gilbert, Christopher. *Late Georgian and Regency Furniture.* London: Country Life Books, The Hamlyn Publishing Group Ltd., 1972.

Girouard, Mark. *Life in the English Country House.* London, England, and New Haven, Conn.: Yale University Press, 1978.

————. *The Victorian Country House.* Oxford: Clarendon Press, 1971.

Gloag, John. *A Short Dictionary of Furniture.* London: George Allen and Unwin Ltd., 1952.

————. *Simple Schemes for Decoration.* London: Duckworth and Co., 1922.

————. *A Social History of Furniture Design.* London: Cassell, 1966.

Goldin, Amy. "The Brothers Prendergast." *Art in America*, March/April 1976, pp. 86–93.

Goodrich, Lloyd. *Albert P. Ryder.* New York: George Braziller, 1959.

Grandjean, Serge. *Empire Furniture 1800–1825.* New York: Taplinger Publishing Co., 1966.

Greysmith, Brenda. *Wallpaper.* London: Studio Vista, 1976.

Grilli, Elise. *The Art of the Japanese Screen.* New York: John Weatherhill Inc., 1970.

Guicheteau, Marcel. *Paul Sérusier.* Paris: Editions Gide, 1976.

Halliwell, James Orchard. *Ancient Inventories of Furniture, Pictures, Tapestry, Plate illustrative of the Domestic Manners of the English in the Sixteenth and Seventeenth Centuries.* London, 1854.

*Ham House Inventory* of Household Goods of the Rt. Hon. countess of Dysart at Ham House. 1727.

*Hampton Court Palace*, estimates for furniture, upholstery, etc., for Hampton Court Palace, signed by the earl of Montagu. 1699.

Harris, John. *Regency Furniture Designs.* London: Alec Tiranti, 1961.

Hastings, Baird. *Christian Bérard.* Boston: Institute of Contemporary Art, 1950.

Hillier, Bevis. *Art Deco.* London: Studio Vista, 1968.

Himmelheber, George. *Biedermeier Furniture.* Translated and edited by Simon Jervis. London: Faber & Faber, 1974.

Hobbs, Richard. *Odilon Redon.* London: Studio Vista, 1977.

Honour, Hugh. *Cabinet Makers and Furniture Designers.* New York: Putnam, 1969.

————. *Chinoiserie.* London: John Murray, 1961.

Huth, Hans. *Lacquer of the West.* Chicago: University of Chicago Press, 1971.

Impey, Oliver. *Chinoiserie.* London: Oxford University Press, 1977.

Jackson-Stops, G. "Erddig Park, Clwyd II." *Country Life*, April 13, 1978, p. 972.

Jourdain, Margaret. *English Interior Decoration.* London: B. T. Batsford, 1950.

————. *Regency Furniture 1795–1830.* London: Country Life Ltd., 1965.

————. "English Firescreens and Folding Screens." *Apollo*, December 1942, pp. 148–49.

Jourdain, Margaret, and Jenyns, R. Soame. *Chinese Export Art in the Eighteenth Century.* London: Country Life Ltd., 1950.

Joy, Edward Thompson. *English Furniture.* London: B. T.

Batsford Ltd., 1967.

———. *The Country Life Book of English Furniture.* London: Country Life Ltd., 1964.

Klee, Felix. Introduction to *Paul Klee, A Retrospective Exhibition.* New York: The Solomon R. Guggenheim Museum, 1966.

Latham, Robert, and Matthews, William, eds. *Diary of Samuel Pepys.* London: G. Bell and Sons, 1970.

Law, Ernest. *Kensington Palace Inventory.* London: G. Bell and Sons, 1899.

Lee, Sherman. Introduction to *Japanese Screens.* Catalogue. Cleveland: The Cleveland Museum of Art, 1977.

Lenygon, Francis. *Decoration in England 1640–1760.* London: B. T. Batsford Ltd., 1927.

Lesieutre, Alain. *The Spirit and Splendor of Art Deco.* New York: Paddington Press, 1974.

Levin, Gail. *Synchromism and American Color Abstraction.* New York: George Braziller, 1978.

Levy, Julien, ed. *Eugene Berman.* New York: The Viking Press (A Studio Book), 1966.

Lofts, Norah. *Domestic Life in England.* London: Weidenfeld and Nicolson, 1976.

Lynes, Russell. Introduction to *The Graphic Work of Eugene Berman,* edited by Eugene Berman. New York: Clarkson N. Potter, 1971.

McClelland, Nancy. *Historic Wallpapers.* Philadelphia: J. B. Lippincott, 1924.

Macon, Gustave. *Château de Chantilly.* Parc-St.-Maur: A. Garcet, 1925.

Macquoid, Percy, and Edwards, Ralph. *Dictionary of English Furniture.* Vol. III, rev. ed. London: Country Life Ltd., 1954.

Millar, Oliver, ed. *Inventories and Valuation of the Kings Goods, 1649–51.* London: Walpole Society, Robert Maclehose, 1960.

Mitford, Nancy. *Madame de Pompadour.* New York: Harper & Row, 1954.

Morazzoni, Giuseppe. *Il Mobile Neoclassico Italiano.* Milan: Editore Görlich, 1955.

———. *Il Mobile Genovese.* Milan: Edizione Luigi Alfieri, 1949.

Mortimer, Raymond. *Duncan Grant.* Harmondsworth, Middlesex: Penguin Books, 1944.

Mulliner, Herbert Hall. *The Decorative Arts in England.* London: B. T. Batsford, 1924.

"Namban Art." Catalogue. *International Exhibitions Foundation,* 1973.

Narodny, Ivan. *The Art of Robert Winthrop Chanler.* New York: William Helburn, 1922.

Nicholson, Peter and M. A. *The Practical Cabinet Maker, Upholsterer, and Complete Decorator.* London: H. Fisher Son & Co., 1826.

Norbury, James. *The World of Victoriana.* London: The Hamlyn Publishing Group Ltd., 1972.

Odom, William. *A History of Italian Furniture,* 2nd ed. New York: The Archive Press, 1967.

Okamoto, Yoshitomo. *Namban Art of Japan,* New York: John Weatherhill, Inc., 1972.

Olligs, Heinrich. *Tapeten.* Braunschweig: Klinkhardt & Biermann, 1970.

Parker, James. *The Wrightsman Galleries* Catalogue. New York: The Metropolitan Museum of Art, 1979.

Parry, Linda L. A. "The Tapestries of Edward Burne-Jones." *Apollo,* November 1975, pp. 324–28.

Phillips, R. Randal, and Woolrich, Ellen. *Furnishing the House.* London: Country Life Ltd., 1921.

Powys, Mrs. Philip L. *Passages from the Diaries of Mrs. Philip Lybbe Powys.* Edited by Emily J. Climenson. London: Longmans Green & Co., 1899.

Praz, Mario. *Conversation Pieces.* London: Methuen & Co. Ltd., 1971.

———. *An Illustrated History of Furnishing.* Translated by William Weaver. New York: George Braziller, 1964.

———. *An Illustrated History of Interior Decoration.* Translated by William Weaver. London: Thames & Hudson, 1964.

Pugin, Augustus Welby Northmore. *Gothic Furniture.* London: Ackermann, 1835.

Reichwein, Adolf. *China and Europe.* London: Routledge and Kegan Paul Ltd., 1968.

Rewald, John. *Odilon Redon, Gustave Moreau, Rodolphe Bresdin.* The Museum of Modern Art in collaboration with The Art Institute of Chicago. New York: Doubleday, 1961.

Ritchie, Andrew C., and Lieberman, William S. *Edouard Vuillard*. New York: Museum of Modern Art, 1953.

Sanchez, Leopold Diego. *Jean-Michel Frank*. Paris: Editions du Regard, 1981.

Savage, George. *Concise History of Interior Decoration*. London: Thames and Hudson, 1966.

————. *French Decorative Art 1638–1793*. London: Allen Lane/Penguin Books Limited, 1969.

"Screens as a Medium for Colorful Background." *Arts and Decoration*, July 1929, p. 50.

"Screens for the Sportsman." *Arts and Decoration*, June 1938, p. 33.

Sheraton, Thomas. *Thomas Sheraton's Complete Furniture Works*. Compiled and edited by N. I. Bienenstock. New York: Towse Publishing Co., 1946.

————. *The Cabinet Dictionary*. London: W. Smith, 1803.

Shone, Richard. *Bloomsbury Portraits*. Oxford: Phaidon, 1976.

Sitwell, Sacherverell. *Conversation Pieces*. London: B. T. Batsford, 1969.

Smith, George. *Collection of Designs*. Edited by Charles F. Montgomery and B. N. Forman. New York: Praeger, 1970.

Smith, J. Moyr. *Ornamental Interiors*. London: Crosby, Lockwood and Co., 1887.

Soby, James Thrall. *Tchelitchew*. New York: Museum of Modern Art, 1942.

————. *Yves Tanguy*. New York: Museum of Modern Art, 1955.

Sokolova, T., and Orlova, K. *Russian Furniture in the Collection of the Hermitage*. Leningrad: The Hermitage, 1973.

Souchal, Genevieve. *French Eighteenth-Century Furniture*. London: Weidenfeld and Nicolson, 1961.

Stalker, John, and Parker, George. *A Treatise of Japanning and Varnishing*. 1688. Reprint. London: Alec Tiranti, 1971.

Sutton, Denys. Introduction to *Duncan Grant*. Catalogue. London: Wildenstein Gallery, 1964.

Tanguy, Kay Sage. *Yves Tanguy, Un Recueil de Ses Oeuvres*. New York: Pierre Matisse Gallery, 1963.

Trevelyan, George Macaulay. *Ramilles*. London: Longmans Green & Co., 1932.

*True Inventory of his Grace the Duke of Louderdale's Goods in Ham House, taken the 4th of August, 1679*.

Urquhart, Elizabeth. "Chinese Coromandel Screens." *Antiques*, May 1922, p. 307.

Venturi, Lionello. *Cézanne, Son Art—Son Oeuvre*. Paris: Paul Rosenberg, 1936.

[Signed "R.W."]. "The Charm of Screens," *International Studio*, August 1929, pp. 44–48.

Verlet, Pierre. *French Furniture and Interior Decoration in the Eighteenth Century*. London: Barrie and Rockliff, London: 1967.

————. *Le Mobilier Royal Français*. Paris: Librarie Plon, 1955.

————. *French Royal Furniture*. London: Barrie and Rockliff, 1963.

Viollet-le-Duc, Eugene Emmanuel. *Dictionnaire Raisonné du Mobilier Français de l'Epoque Carlovingienne à la Renaissance*. Paris: A. Morel, 1865.

Walpole, Horace. *The Letters of Horace Walpole*. Edited by Paget Toynbee. Oxford: Clarendon Press, 1903–05.

————. *Visits to Country Seats*. Edited by Paget Toynbee. Vol. XVI. Oxford: Oxford University Press, 1928.

Walters, Thomas. *Art Deco*. London: Academy Editions, 1973.

Waterer, John. *Spanish Leather*. London: Faber & Faber, 1971.

Watson, Francis J. B. *Louis XVI Furniture*. London: Alec Tiranti, 1960.

————. *The Wrightsman Collection, vol. I*. New York: The Metropolitan Museum of Art, 1966. Dist. by New York Graphic Society.

Wharton, Edith, and Codman, Ogden. *The Decoration of Houses*. New York: Charles Scribner's Sons, 1898.

White, Joseph William Gleeson. "Screens: Folding and Otherwise." *Amateur Work*, vol. V, 1885, pp. 15–19, 70–75.

Young, Andrew McLaren; MacDonald, Margaret; and Spencer, Robin; with the assistance of Miles, Hamish. *The Paintings of James McNeill Whistler*. New Haven, Conn.: Yale University Press, 1980.

INDEX

NUMERALS SET IN ITALICS INDICATE PAGES WITH ILLUSTRATIONS.